D0607736

50 PHOTOS
YOU SHOULD KNOW

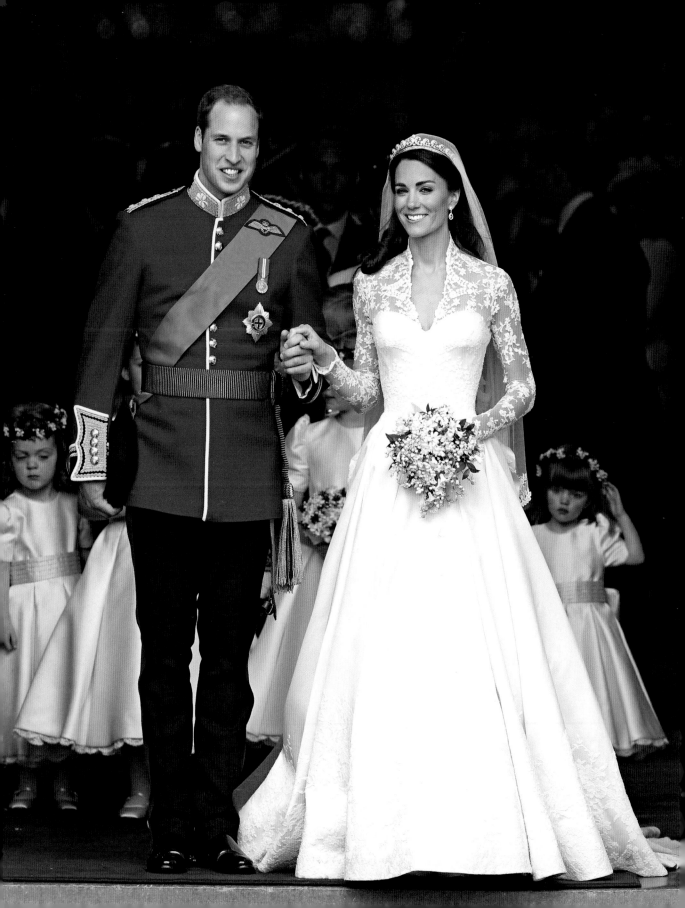

50 PHOTOS
YOU SHOULD KNOW

Brad Finger

Prestel

Munich · London · New York

Prestel Verlag, Munich
A member of Verlagsgruppe Random House GmbH

Prestel Verlag
Neumarkter Strasse 28
81673 Munich
Tel. +49 (0)89 4136-0
Fax +49 (0)89 4136-2335

www.prestel.de

Prestel Publishing Ltd.
4 Bloomsbury Place
London WC1A 2QA
Tel. +44 (0)20 7323-5004
Fax +44 (0)20 7636-8004

Prestel Publishing
900 Broadway, Suite 603
New York, NY 10003
Tel. +1 (212) 995-2720
Fax +1 (212) 995-2733

www.prestel.com

The Library of Congress Control Number: 2011945267
British Library Cataloguing-in-Publication Data: a catalogue record for this book is available from the British Library; Deutsche Nationalbibliothek holds a record of this publication in the Deutsche Nationalbibliografie; detailed bibliographical data can be found under: http://dnb.d-nb.de

Prestel books are available worldwide. Please contact your nearest bookseller or one of the above addresses for information concerning your local distributor.

Project management by Claudia Stäuble, Franziska Stegmann
Copyedited by Jonathan Fox, Barcelona
Production by Astrid Wedemeyer
Cover and Design by LIQUID, Agentur für Gestaltung, Augsburg
Layout by zwischenschritt, Rainald Schwarz, Munich
Origination by ReproLine Mediateam
Printed and bound by Druckerei Uhl GmbH & Co. KG, Radolfzell

Verlagsgruppe Random House FSC®-DEU-0100
The FSC®-certified paper Hello Fat Matt produced by mill Condat has been supplied by Deutsche Papier.

FSC
www.fsc.org
MIX
Paper from
responsible sources
FSC® C004229

Printed in Germany

ISBN 978-3-7913-4611-3

CONTENTS

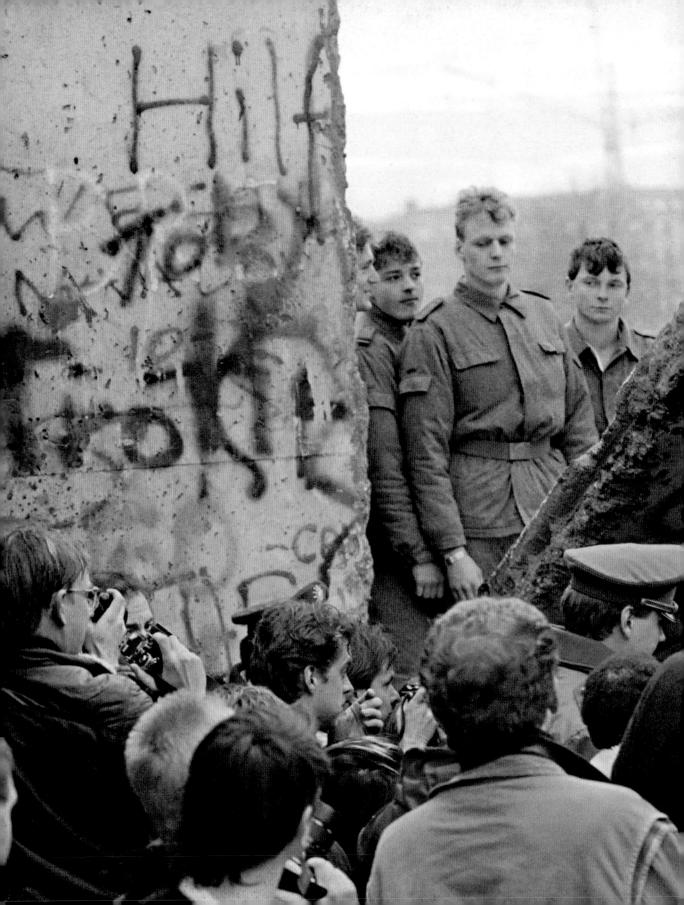

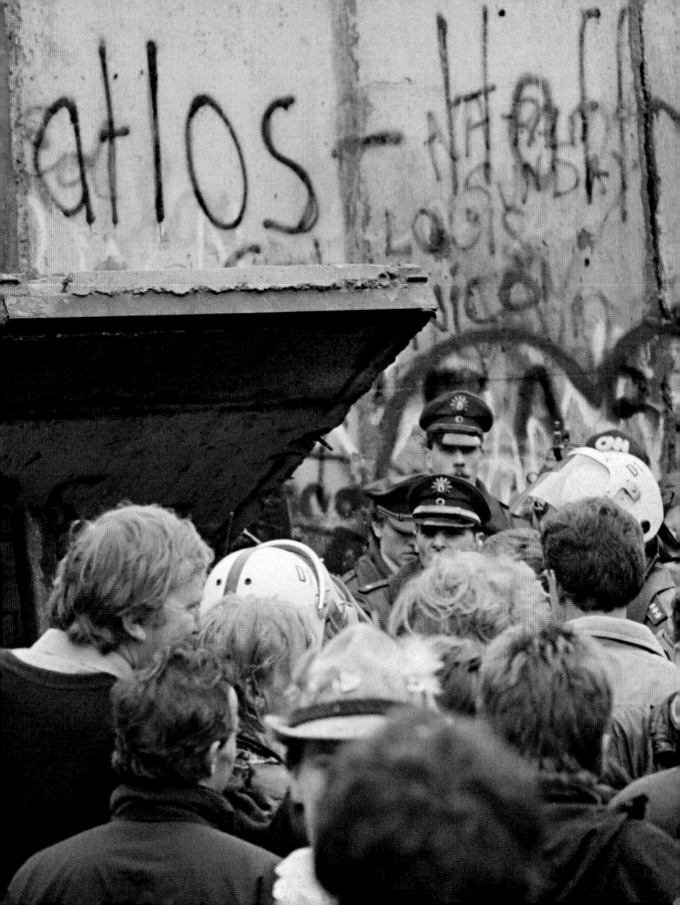

1762 Jean-Jacques Rousseau, *Of The Social Contract,
Or Principles of Political Right*

1773 Boston Tea Party

1789–99 French Revolution

1750 1755 1760 1765 1770 1775 1780 1785 1790 1795 1800

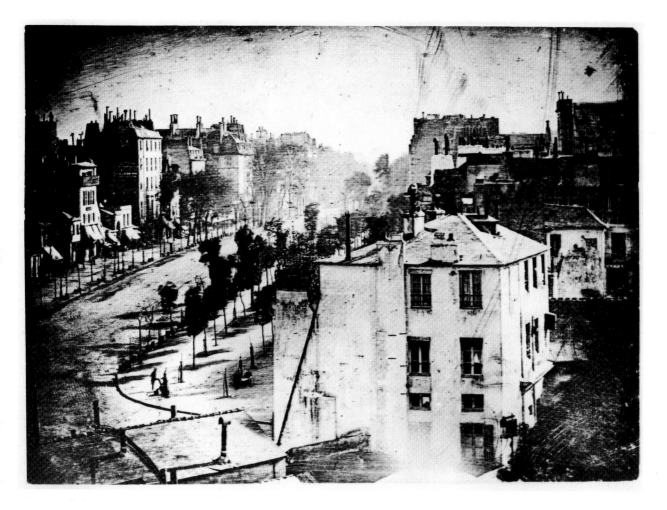

Louis-Jacques-Mandé Daguerre, View of the Boulevard du Temple, Paris, 1838

1804 Napoleon Bonaparte becomes
French emperor

1821 Charles Baudelaire is born

1848 French Revolution
(February Revolution)

1808 Goethe, *Faust*

1815 Napoleon defeated at Waterloo

1830 Eugène Delacroix, *Liberty Leading the People*

1855 Courbet's *Realism*
exhibition

1805 1810 1815 1820 1825 1830 1835 1840 1845 1850 1855

VIEW OF THE BOULEVARD DU TEMPLE, PARIS

Louis Daguerre may not have invented the photograph, but his innovations and flair for publicity helped make photography a worldwide phenomenon. Daguerre's lustrous images were the first photos to achieve widespread distribution, and they offered a new way for people to see the world.

Louis-Jacques-Mandé Daguerre (1787–1851) had spent his early life as an artist, showman, and theatrical designer. He helped develop the early nineteenth-century diorama. This traveling theater-in-the-round used highly detailed trompe-l'oeil paintings on linen—as well as clever backlighting—to make the audience believe they were viewing three-dimensional nature. But by the 1820s, Daguerre began experimenting with processes that could "reproduce" nature more quickly and effectively than his labor-intensive paintings.

Daguerre set up a partnership with Joseph Nicéphore Niépce, a wealthy inventor who had developed the technique of heliography, or "sun writing." It involved coating a pewter plate with a sticky substance called bitumen of Judea. The plate was then placed in a camera obscura, which could project the image of an object or scene onto the plate. After letting the coated plate remain exposed to light for several hours, it was then removed and washed with a mixture involving lavender oil. Over time, the image that the camera obscura had projected onto the plate would appear in permanent, if rather hazy, form. For Daguerre, this must have seemed a magical process. The camera obscura had long been used by artists as a drawing aid. But now it could be harnessed to produce images that made nature and time stand still. Daguerre quickly set out to refine Niépce's sun writing technique. Soon he observed that by using different materials—copper plates coated with iodized silver—he could produce pictures of startling detail and richness. The diorama maker had found a new "canvas" on which his images could be captured.

Daguerre's first experiments with his technique were somewhat tentative. His earliest known photograph, *Still Life in Studio* (1837), has the look of a traditional painting. It shows a carefully arranged group of plaster casts and other "artistic" objects, a scene reminiscent of seventeenth-century still lifes. But Daguerre would soon explore more extemporaneous shots. In early 1839, he pointed the camera out of his apartment window in Paris, over the busy Boulevard du Temple, and simply let the instrument photograph what it "saw." The result was a cityscape rendered in unprecedented detail, yet eerily devoid of human activity. The image took several minutes to expose, making it impossible to capture the moving people and objects. But one individual did remain largely motionless during the exposure time, as he was getting his boots polished. His incomplete, shadowy form represents one of the first photographic "portraits."

The year *View of the Boulevard du Temple, Paris* was created, Daguerre enlisted the help of François Arago to help publicize his invention. Arago was both a scientist and a shrewd politician, and he helped promote the "daguerreotype" process to the Académie des Sciences and the French government. When Daguerre's images were finally revealed to the public on August 16, 1839, they caused an immediate sensation. Almost overnight, daguerreotypists set up shop throughout Europe and North America. Framed daguerreotype family portraits began replacing the work of painters, forcing artists to rethink the purpose of painting itself. The "nonrealistic" experiments of Impressionism and later art movements owed their inspiration, in part, to the invention of Niépce and Daguerre.

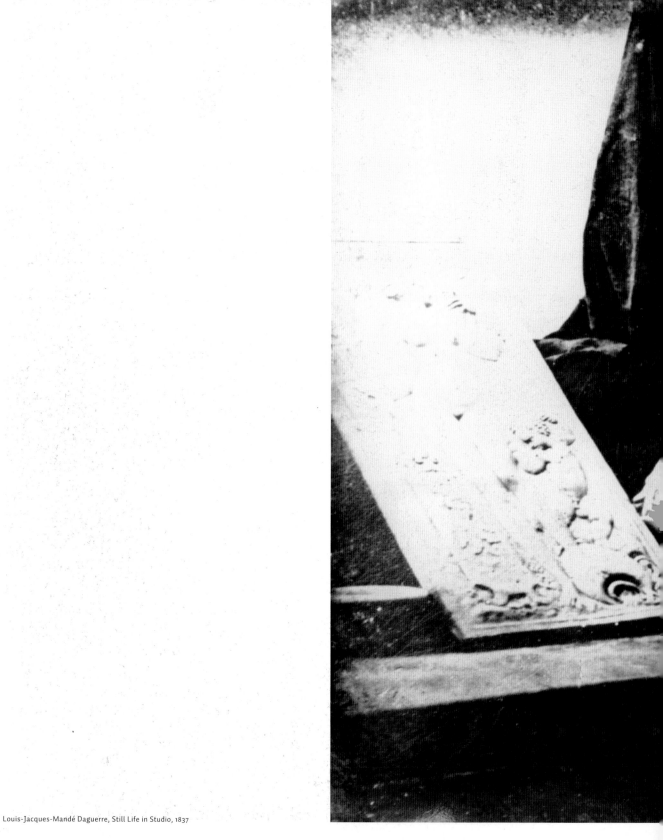

Louis-Jacques-Mandé Daguerre, Still Life in Studio, 1837

1805 Battles of Trafalgar and Austerlitz

1826 First photograph by
Joseph Nicéphore Niépce

1830 July Revolution
in France

1790	1795	1800	1805	1810	1815	1820	1825	1830	1835	1840	

Henry Fox Talbot, The Open Door, April 1844

1853–70 Haussmann's renovation of Paris

1861–65 American Civil War 1870 Start of the Franco-Prussian War

1893 Edvard Munch, *The Scream*

1887–89 Construction of the Eiffel Tower

1895 First Venice Biennale

1845 1850 1855 1860 1865 1870 1875 1880 1885 1890 1895

TALBOT'S OPEN DOOR

When describing such images as The Open Door *(1844), Henry Fox Talbot said that he tried to use his painter's eye to find beauty "where ordinary people see nothing remarkable." Talbot's quiet, calmly composed scenes often belie the revolutionary nature of his photographic innovations.*

In January of 1839, English inventor William Henry Fox Talbot (1800–1877) read a translated report from a meeting of the French Académie des Sciences. He was shocked to learn that fellow inventor Louis Daguerre was claiming credit for a process using a camera obscura to capture permanent images of nature. Talbot's surprise arose from the fact that he had already devised a similar process himself. Over the coming years, Talbot would work tirelessly to promote and refine his own contributions to photography.

Henry Fox Talbot had a keen interest in a variety of scientific topics, including mathematics and physics. In the early 1830s, he began conducting optical experiments with a camera obscura. Talbot later explained that these experiments grew out of his own frustrated efforts at making accurate scientific drawings. "I was amusing myself on the lovely shores of Lake Como in Italy, taking sketches … or, rather, I should say attempting to take them, but with the smallest possible amount of success … I then thought of trying again a method I had tried many years before. This method was, to take a camera obscura and to throw the image of the objects on a piece of paper in its focus—fairy pictures, creations of a moment, and destined to fade away. It was during these thoughts that the idea occurred to me—how charming it would be if it were possible to cause these natural images to imprint themselves durably, and remain fixed upon the paper." By 1834, Talbot had devised such a "fixing" method by soaking paper in sodium chloride and silver nitrate. When placed in a camera obscura and exposed to sunlight, his paper would permanently capture Talbot's "natural image" in a surprising way. The dark areas of the image would appear light, and the light areas dark. Talbot would then wash the treated paper in a solution of

salt, which prevented the image from being destroyed by further exposure to light. He further discovered that this "drawing" could "serve as an object, to produce a second drawing, in which the light and shadows would be reversed." Fox Talbot had invented the photographic negative.

For several years, Talbot abandoned his initial research into "photogenic" processes. But the news of Daguerre's discovery in 1839 forced him to hastily present his earlier findings at the Royal Society in London. Talbot then spent the next two years refining his process, which he patented in 1841 as the calotype process. Two years earlier, Daguerre had taken out a British patent for his own invention. Yet Talbot's calotypes never achieved the striking contrasts of dark and light—the visual clarity—of daguerreotypes. Often the pictures had a faded, grainy appearance, especially in earlier images such as *The Open Door*. This drawback initially made Talbot's process less marketable than Daguerre's. Yet over time, the technical innovations of the calotype—its ability to produce multiple copies of images from a single negative—would help spur the development of modern photography. Fittingly, the English term "photography" was coined by British scientist John Herschel, one of Talbot's friends and collaborators.

1812 Napoleon invades Russia

1837 Louis Daguerre invents
the daguerreotype

1855 Courbet's *Realism* exhibition

1819 Théodore Géricault,
The Raft of the Medusa

| 1815 | 1820 | 1825 | 1830 | 1835 | 1840 | 1845 | 1850 | 1855 | 1860 | 1865 |

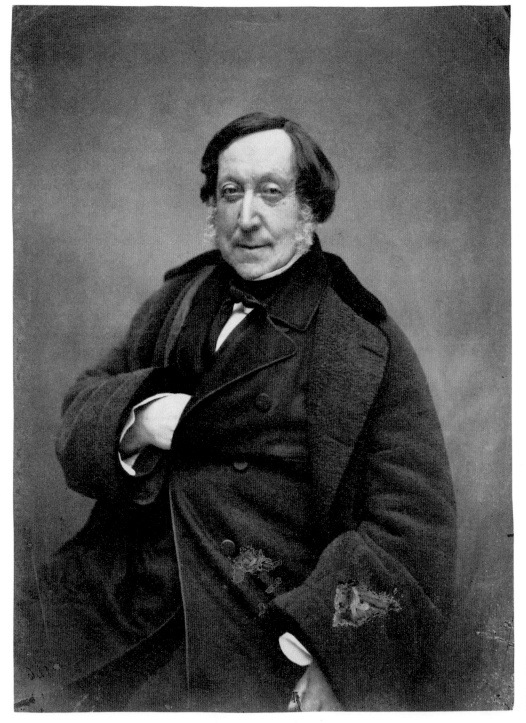

Félix Nadar, Portrait of
Gioacchino Rossini, 1856

right page
Félix Nadar, Aerial Photograph
of Paris, 1858

1904 Entente cordiale between the
United Kingdom and France

1917 October
Revolution
in Russia

1871 Destruction of the Paris Commune **1886** Statue of Liberty erected
in New York Harbor **1900** First line of the Paris Métro opens

1870 1875 1880 1885 1890 1895 1900 1905 1910 1915 1920

PORTRAIT OF GIOACHINO ROSSINI

By 1856, the bright-eyed composer Gioachino Rossini was a cultural lion of Paris. No longer writing famous operas, he lived a life in sumptuous semiretirement—a lover of good food and wine and a friend of numerous artists and writers. New advances in photography enabled Felix Nadar to capture Rossini's casual but magnetic personality with his camera.

Like Louis Daguerre, Felix Nadar (1820–1910) was a show-man. Born Gaspard-Félix Tournachon, he developed a pseudonym that humorously reflected his early career as a caricaturist. "Nadar" is an abbreviation of a phrase meaning "one who stings." Nadar's ebullient personality won him many friends among France's leading cultural figures, such as the artist Honoré Daumier and the actress Sarah Bernhardt. He soon combined his artistic and social talents with an aptitude for photography. By the mid-1850s, Nadar's studio had become famous for its photographic portraits.

Nadar profited from significant technical advances in photography since the days of Daguerre and Fox Talbot. Beginning in 1851, photographers had been using a "wet plate" process, which involved glass plates treated with a quick-drying substance called collodion. This procedure reduced exposure times considerably and produced high-quality negatives. Daguerreotype portraitists required their subjects to sit motionless for several minutes, preventing them from capturing anything like a "natural" expression on the face. But now sitters only had to remain motionless for a few seconds, enabling them to relax in front of the camera. Nadar's clients had the added benefit of posing for an artist with a keen understanding of composition and lighting. His photographic portraits often have the same vitality and character of the best portrait paintings. Not surprisingly, many of Nadar's most famous works depict his own artist friends. His Gioachino Rossini portrait of 1856, for example, is especially effective at capturing the Italian composer's jovial character. We see a man who spent much of his later life enjoying the fruits of his early operatic successes. Like many Nadar images, the sitter seems to be communicating with the viewer, establishing a strong emotional

connection. Such images became the genesis of modern-day political and celebrity culture.

Nadar also explored other ways of using the camera to publicize aspects of city life. In 1858, he produced the world's first aerial photographs, taking snapshots of Paris from a hot-air balloon. These images showed an urban center being transformed by the grand avenues and public squares of Baron Haussmann. Nadar also photographed his city from below, producing remarkable images of Paris's underground sewer system. Using a novel method involving electric lights, Nadar exposed a subterranean, cave-like world of arched tunnels and tracks—a world that supported, yet stood in stark contrast to, the glittering cultural life of Rossini's Paris.

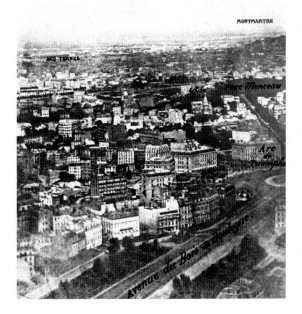

1809 Charles Darwin is born

| 1800 | 1805 | 1810 | 1815 | 1820 | 1825 | 1830 | 1835 | 1840 | 1845 | 1850 |

51 First World's Fair in London

1857 Gustave Flaubert, *Madame Bovary*

1873 Claude Monet, *Impression, Sunrise*

1874 First Impressionist exhibition in Paris

1887–89 Construction of the Eiffel Tower

1894 Tower Bridge in London opened for traffic

1900 Boxer Rebellion in China

1855 1860 1865 1870 1875 1880 1885 1890 1895 1900 1905

THE CRYSTAL PALACE

The Crystal Palace was a perfect subject for early photography. Cameramen delighted in capturing the building's massive steel and glass walls and expansive, maze-like interiors. Such images seemed to embody the spirit of the industrial age. They also inspired new movements in modern architecture.

The Great Exhibition of 1851 was the first truly international showcase for the industrial revolution. Officially known as the Great Exhibition of the Works of Industry of all Nations, it was held in Hyde Park, London. The exhibit presented all the wonders of modern technology and the fruits of British colonialism. For the price of a shilling, one could see microscopes, steel-making machines, public toilets, the latest kitchen appliances, and a mechanical reaper for harvesting crops. Even the world's largest diamond, the Koh-i-noor, made an appearance. Only one year earlier, the diamond had been presented to Queen Victoria as a highly publicized trophy from the First Anglo-Sikh War—part of Britain's decades-long conquest of India in the nineteenth century. Victoria's husband and consort, Prince Albert, was an avid promoter of the exhibition. So it was not surprising to find the Koh-i-noor in Hyde Park during the summer of 1851.

All of these marvels thrilled the millions of visitors who flocked to the exhibit. But the event's most remarkable feature may have been its principal building, the Crystal Palace. Designed by Joseph Paxton, this giant steel-and-glass edifice resembled the greenhouses for which its architect was famous. But the size and scale of the building, the meandering quality of its interior spaces, and the engineering innovations required for its construction would make the palace one of the first seminal works of modern architecture. According to American art historian Vincent Scully, the palace offered something very different from the orderly, sheltering buildings of traditional European cities. Its "skeleton structure of thin iron members," Skully wrote, "was seen by … contemporaries as a delightful maze. It was a place to wander in, endlessly continuous, with only glassy boundaries and with the solids fragmented into complicated webs."

The Crystal Palace was also one of the first buildings to be captured extensively in photographs. This new pictorial medium perfectly revealed the "endless continuity" of the building's interiors. After the fair ended, the palace was removed from Hyde Park and reconstructed (in expanded form) in South London's Sydenham. Most surviving photos show this version of the building. Some even capture the reconstruction process itself, which lasted from 1852 to 1854. Images of the half-finished nave have an expressive, almost musical quality—a symphony of light, shade, and steel. Other reconstruction photos show visitors as well-dressed toy figures exploring an alien world of giant arches and open space. These images would influence the planners of numerous world's fairs and high-tech Olympic villages. They would also foreshadow the steel-and-glass urban landscapes of the twentieth century and beyond.

Philip Henry Delamotte, Transept of the Crystal Palace, Sydenham, 1856

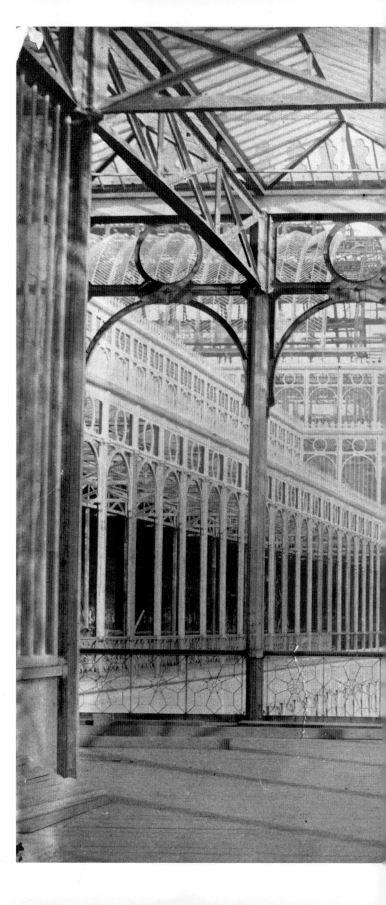

Philip Henry Delamotte, Crystal Palace, London, 1853

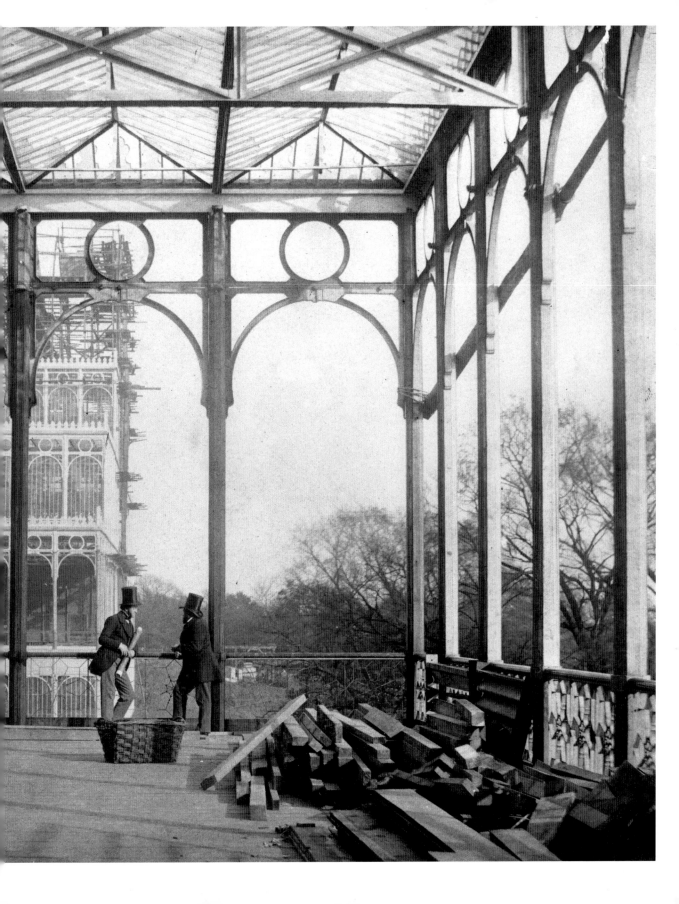

1830 Trail of Tears

1848 The Crimean War

1848–49 Start of the California
Gold Rush

1805	1810	1815	1820	1825	1830	1835	1840	1845	1850	1855

James Robertson, View of the ruined interior of the Great Redan, 1855–56

1861 Abraham Lincoln sworn in
as president of the U.S.

1861–65 American Civil War

1871 Charles Darwin publishes
The Descent of Man

1876 Sioux Uprising in South Dakota

1889 Vincent van Gogh, Starry Night

1897 Tate Gallery is founded in London

1900 Sigmund Freud publishes
The Interpretation of Dreams

1860 1865 1870 1875 1880 1885 1890 1895 1900 1905 1910

THE RUINS OF THE GREAT REDAN

Photographers of the Crimean War exposed the unpleasant realities of a questionable military effort. For the first time in history, photographs would be used as a political tool to criticize government policy. Photojournalism was born.

From its inception, photography has recorded human events in ways that painting and other media have not. The Crimean War (1853–56) provided photographers with an early opportunity to capture military action in progress. The conflict involved a colonial struggle over the crumbling Ottoman Empire, with Russia pitted against a coalition led by Great Britain and France. Most of the fighting was concentrated in the Crimean peninsula, an area that is now part of southern Ukraine.

Though the war ended in Russia's defeat, the conflict was perceived by many in the West as an embarrassment for Britain and its allies. This perception was the result of revolutionary methods of covering the war by the British press. For the first time, the electric telegraph and the war reporter enabled newspapers to provide extensive, daily coverage of the war. Such coverage was often negative, and it exposed numerous examples of mismanagement by the British government and the coalition army. William Howard Russell and other British journalists wrote of troops who were insufficiently supplied and of poor tactical decisions by military leaders. Political scandal followed in the wake of these reports, leading to the resignation of Prime Minister Lord Aberdeen.

British photographers, too, played a key role in exposing the dark side of the Crimean conflict. Roger Fenton (1819–1869) was one of the first such men to arrive in the area. His pictures illustrate the hardscrabble villages and desolate, rocky landscape of the Crimean region—a region where British soldiers often look confused and out of place. James Robertson (1813–1888) began photographing the war in 1855, and his images often go a step further than Fenton's in revealing the conflict's brutality. His depiction of the ruined Great Redan, which had been a key fortress for the Russian army, is a typical example. It shows the messy, haphazard destruction that follows in the wake of military battle.

The pioneering work of Fenton and Robertson inspired photographers in other countries to document their own conflicts. Later war photographers, such as Mathew Brady, would produce increasingly shocking images. Brady had become famous as a daguerreotypist in the United States, producing dignified portraits of U.S. political leaders. But the American Civil War (1861–65) radically affected Brady's art. The quiet civility of his early works was replaced by some of the most devastating wartime scenes. In his 1865 photos of Richmond, Virginia, the capital of the short-lived Confederate States of America, Brady shows an entire city in ruins. The shells of the buildings have a ghostly eeriness—a quality that would be documented again in Berlin, Hiroshima, and the other centers of twentieth-century military destruction.

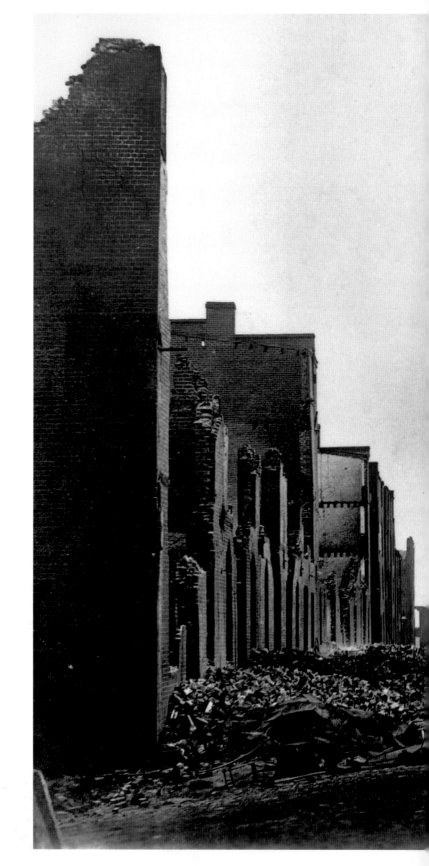

Mathew Brady, Ruins of the Gallego Flour Mills, Richmond, Virginia,
at end of Civil War, 1865

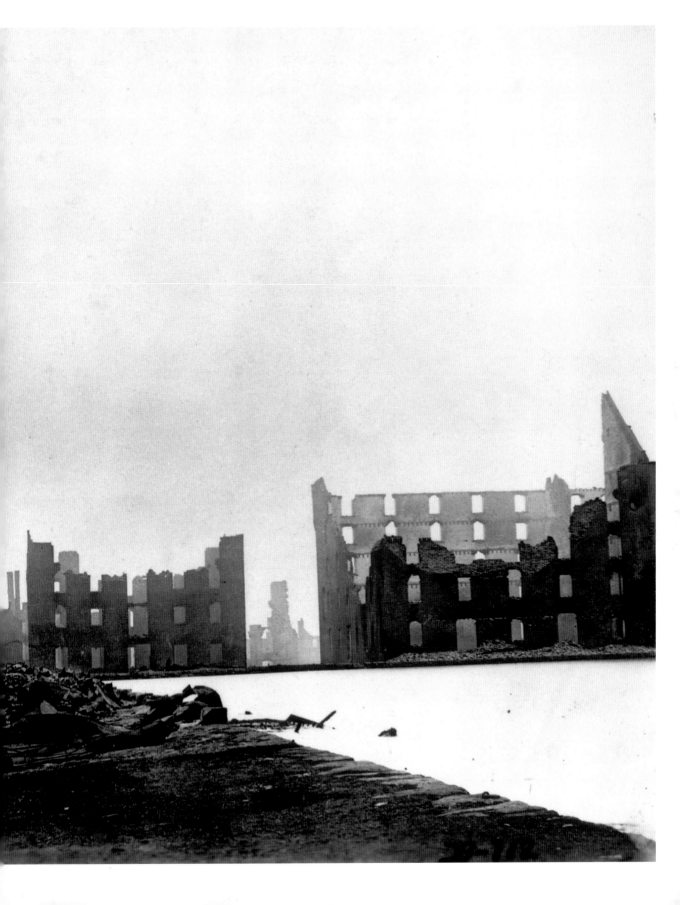

1847 First exhibition of the
French Impressionists

1814 Ludwig van Beethoven, *Fidelio* **1826** Joseph Nicéphore Niépce **1838–42** First Opium War in China **1856–60** Second
invents photography Opium War

1810 1815 1820 1825 1830 1835 1840 1845 1850 1855 1860

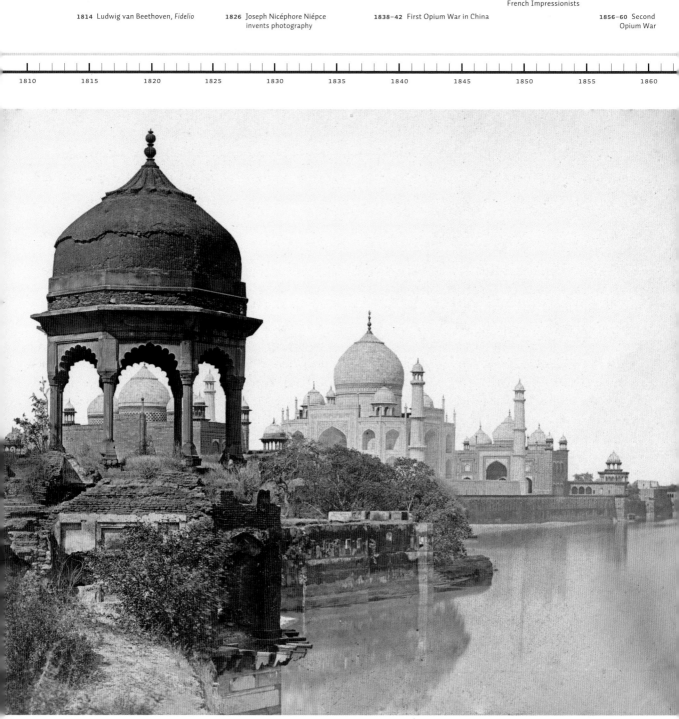

Felice Beato, The Taj Mahal in Agra, seen from the east, ca. 1860

1870–71 Franco-Prussian War

1867 Karl Marx, *Das Kapital*

1891 Construction of Trans-Siberian Railway started

1908 Child Emperor Pu Yi ascends the Chinese throne at the age of two

1914 Beginning of World War I

| 1865 | 1870 | 1875 | 1880 | 1885 | 1890 | 1895 | 1900 | 1905 | 1910 | 1915 |

BEATO'S TAJ MAHAL

Now one of the most recognizable buildings in the world, the Taj Mahal was a revelation to Westerners of the mid-nineteenth century. Felice Beato's architectural portrait depicted the great mausoleum as part of an even grander land-scape of onion domes, minarets, and pinnacles. Such images promoted the romantic nature of international travel.

Few people in the nineteenth century could afford to travel far from their home country, or even their place of birth. In the West, painted and printed images of distant lands had long served as a substitute for real exploration. But soon after the development of photography, a new kind of travel image would bring Westerners closer to foreign cultures than they had ever been before. By the early 1840s, British and French daguerreotypists had photographed the ruins of ancient Greece and Rome. Calotypists of the early 1850s brought back images of ancient temples from Egypt and domed mosques from the Holy Land. Through these pictures, a growing number of people could rediscover the legendary places of the Bible and ancient mythology.

Such images also fueled a desire in Western cities for photos of more remote places. The increasing influence of Britain, France, and other colonial powers in the Asian continent paved the way for photographic expeditions in India and the Far East. The Italian-born British photographer Felice Beato (1832–1909) became particularly famous for documenting cultures across Asia. Beginning his career as an assistant to James Robertson during the Crimean War, Beato traveled farther and farther east to capture some of the most graphic war-related images. He photographed the skeletal remains of rebels in Lucknow during the Indian Rebellion of 1857, and he captured the dead bodies of Chinese soldiers at the end of the Second Opium War in 1860. Ultimately, Beato would reach a Japan newly opened up to the West. There he would portray the geishas, samurai warriors, and street life of the country's Meiji Era.

But Beato's most lasting contribution may be his photographs of Asian architectural monuments. His pictures of the ramparts and palaces of Peking (now Beijing), China are some of the most evocative images of buildings long gone. They provide an invaluable record of China before its twentieth-century modernization. The images also show Beato's flair for creating panoramic scenes. One image portrays the massive city walls of Peking as extending almost indefinitely into the distance, a powerful symbol of the permanence and mystery of an ancient civilization. In his picture of the Taj Mahal, the iconic mausoleum is shown obliquely behind a nearby tower, seeming to rise up out of the mist of the Yamuna River. The romantic nature of the composition is enhanced by the partially ruined state of the buildings in the foreground. A multifaceted, complicated artist, Beato was able to use his photographs to both critique the excesses of colonial ambition and to glamorize the opportunities for exploration that such ambition made possible.

1861–65 American Civil War **1870–71** Franco-Prussian War

1888 Vincent van Gogh,
Sunflowers

1855 1860 1865 1870 1875 1880 1885 1890 1895 1900 1905

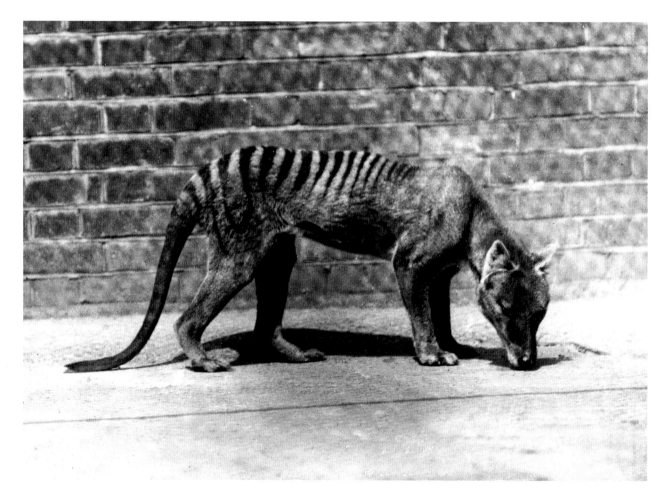

Tasmanian Wolf, 1900

right page
Michigan Carbon Works (pile of buffalo skulls), 1870s

1911 Marie Curie awarded the Nobel
Prize for Chemistry

1939–45 World War II

05 German expressionist group
Die Brücke is founded in Dresden

1927 Charles Lindbergh flies nonstop
from New York to Paris

1945 Atom bombs dropped on
Hiroshima and Nagasaki

1955 *The Family of
Man* exhibition
at MoMA in
New York

1910 1915 1920 1925 1930 1935 1940 1945 1950 1955 1960

THE LAST TASMANIAN TIGER

Photography helped make the wildlife conservation movement possible. Captivating images of exotic species provided a unique connection between animal and human. Especially poignant were photos of the "last known" living examples of a species often showing their subjects in confined isolation—sad reminders of a preindustrial world that had been lost.

The concept of wildlife conservation is a modern one. It may have had its origins in nineteenth-century Romanticism—a period when artists and writers began presenting nature as a noble creation, something to be admired in its own right—but the conservation movement probably began in earnest at the end of the 1800s. Industrial expansion during that time saw dramatic declines of species throughout the world, especially the United States. Huge areas of Midwest prairie were converted into farmland. Animals that had once numbered in the millions (the American buffalo) and billions (the passenger pigeon) were wiped out or nearly so. Many nineteenth-century Americans labeled wild creatures either as pests or as resources for making human products. Railroad companies had the animals culled to open up transportation routes to the West, while the garment industry paid hunters handsomely for the finest pelts and feathers. But as the twentieth century dawned, a growing number of nature enthusiasts began to question such policies. Some of America's most "characteristic" fauna were being lost with startling rapidity, and the remaining endangered species needed to be protected from a similar fate.

Photography was one of the most important tools in this effort. Photographers not only captured the serene beauty of future national parks—the Yellowstone territory in Wyoming and the Yosemite Valley in California—but they also depicted the vagaries of uncontrolled human expansion. Some of the images had a certain shock value, such as the 1870s photo of a mountainous pile of buffalo skulls.

Other photographs bolstered the conservationist effort in subtler ways. By the early 1900s, some of the world's rarest species were languishing in zoos throughout Europe, North America, Australia, and elsewhere. Some of these institutions had the dubious honor of housing the last known examples of a species. In 1936, the last documented Tasmanian tiger (or thylacine) died at the Hobart Zoo in Australia. Photographs of this carnivorous marsupial revealed an animal that seemed to have emerged from a primeval past. Known as "Benjamin" by its handlers, the creature was often depicted with its mouth open frighteningly wide—a function of the species' unusual jaw structure. One open-mouthed picture of Benjamin made it look especially desperate, a lonely figure "shouting out" against a world to which it no longer belonged. Such photos helped change the Tasmanian tiger's image from a "common chicken thief" to a national symbol. In 1917, the thylacine officially took its place on the Tasmanian coat of arms—an ironic tribute to a vanishing animal.

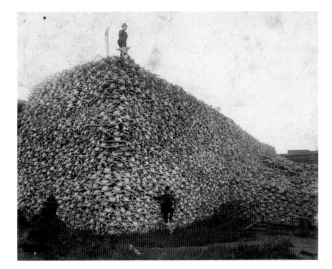

1865 Slavery abolished in the U.S.

1883–85 First skyscrapers in Chicago

1876 Battle of Little Bighorn

1903 Henry Ford founds the Ford Motor Company Detroit

1855	1860	1865	1870	1875	1880	1885	1890	1895	1900	1905

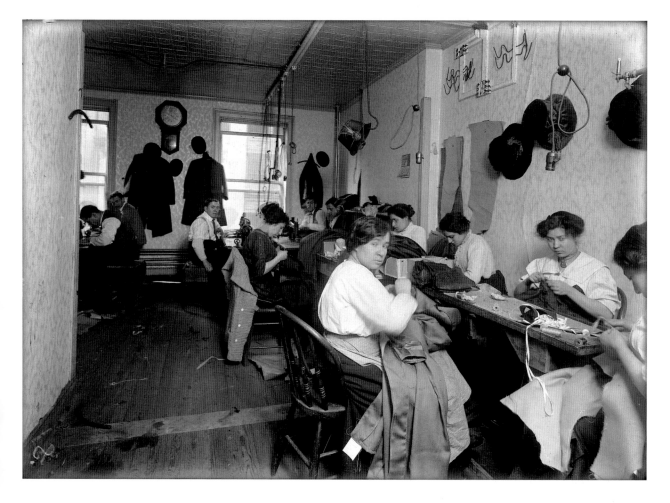

Lewis Hine, A Corner in an Old Time Sweat Shop, New York, 1910

07 Pablo Picasso,
Les Demoiselles d'Avignon

1925 Francis Scott Fitzgerald,
The Great Gatsby

1911 Ernest Rutherford develops
his model of the atom

1939–45 World War II

1927 Charles Lindbergh flies nonstop
from New York to Paris

1948 Universal Declaration of Human
Rights before UN General Assembly

1910 1915 1920 1925 1930 1935 1940 1945 1950 1955 1960

THE SWEAT SHOP

Lewis Hine helped invent the notion of "documentary photography," even though he didn't coin the term. Hine's "photo stories" used both images and captions to describe the tenacity of immigrant workers in early twentieth-century America. Photos such as A Corner in an Old-Time Sweatshop, 1910, *helped improve the image of these new Americans.*

The flood of European immigrants into America from 1880 to 1920 fundamentally changed the demographic make-up of the United States. Not only did Southern and Eastern European populations increase dramatically, but the traditional rural nature of America forever changed. The United States was now primarily an urban nation, and American culture would evolve to promote the needs and address the problems of these growing cities. By the beginning of the twentieth century, the Progressive Era had begun. Artists, philanthropists, writers, and educators began looking for ways to better assimilate the new urban poor, most of whom were factory employees who both lived and worked in deplorable, overcrowded conditions.

Lewis Wickes Hine (1874–1940), a Midwesterner from Oshkosh, Wisconsin, decided to move to New York City and join the ranks of these reformers. A budding artist and writer, Hine took a teaching position at the progressive Ethical Culture School, where he instructed children of immigrant families. In 1904, when he began teaching photography to his students, he also took up a school-sponsored assignment to photograph immigrants at their main port of entry in New York—Ellis Island. This effort was the first in a series of projects that transformed Hine from an instructor into a full-time photojournalist in 1908. From the beginning, Hine's work depicted immigrants and the American poor with a directness that avoided sentimentality. This quality enabled him to explore some of the thornier issues faced by his subjects.

Hine's most famous photos were taken for the National Child Labor Committee (NCLC), a philanthropic group dedicated to ending child labor in the United States. He depicted children working in cotton mills, vegetable canneries, cigar factories, and other labor-intensive industries. The effectiveness of these images lies in the way the children are portrayed. Hines shows them as efficient workers who make the best of their situations. The artist also developed creative ways of captioning the photos and combining them into collections that he later referred to as "photo stories." Ultimately, these photographic creations would play a large role in the passage of laws restricting child labor in 1916.

Hines adapted similar methods when portraying the working life of adult immigrants. Again, he refrained from images of overt exploitation or abuse, and instead focused on his subjects' diligent attentiveness to their work. In *A Corner in an Old-Time Sweatshop*, 1910, the men and women are seen sewing with serious-minded efficacy, despite their cramped surroundings. To some extent, such work helped reverse the common stereotype of the "lazy" immigrant and helped foster the often elusive goal of the "American dream."

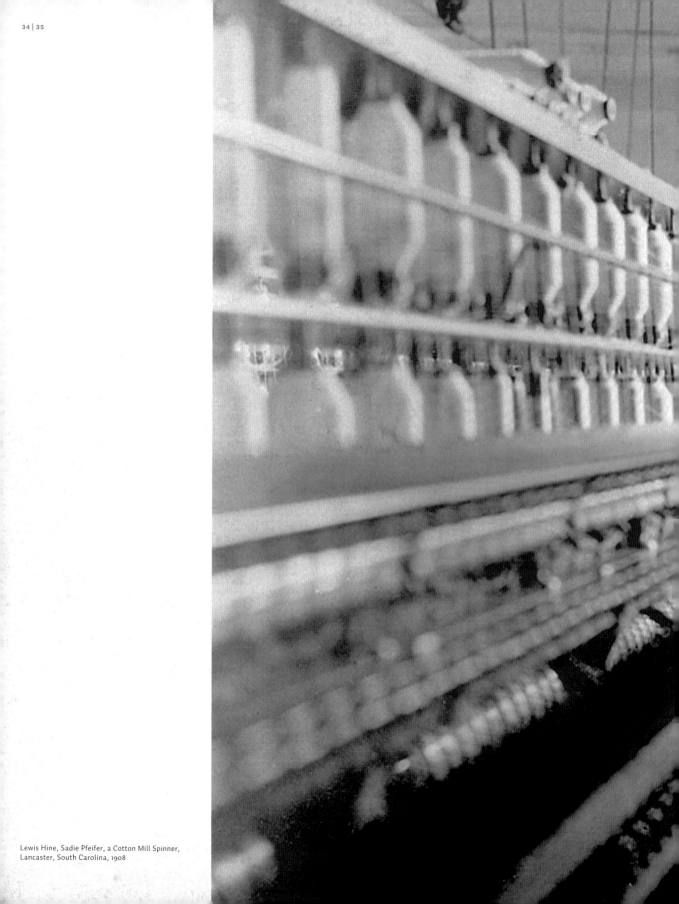

Lewis Hine, Sadie Pfeifer, a Cotton Mill Spinner,
Lancaster, South Carolina, 1908

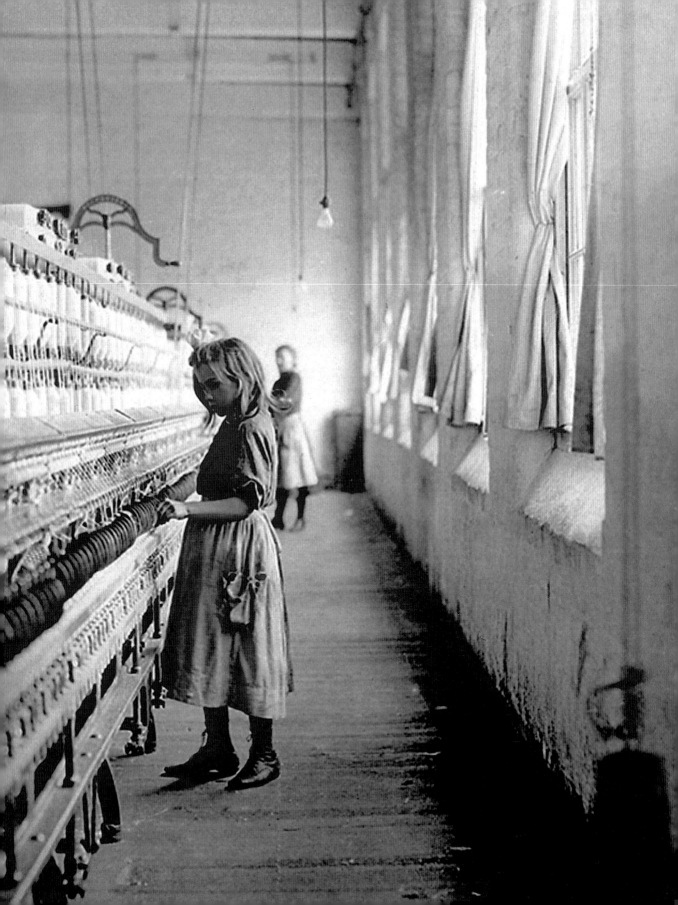

1866 Civil Rights Act

1883 Opening of the Metropolitan
Opera in New York

1891 Construction of Trans-Siberian
Railway begins

1901 Theodore Roosev⸱
sworn in as
president of
the U.S.

| 1855 | 1860 | 1865 | 1870 | 1875 | 1880 | 1885 | 1890 | 1895 | 1900 | 1905 |

1914–18 World War I 1939–45 World War II

1917 October Revolution in Russia 1933 Adolf Hitler comes to power 1945 Atom bombs dropped on
 Hiroshima and Nagasaki
1913 Armory Show in New York shows
 the European avant-garde

1910 1915 1920 1925 1930 1935 1940 1945 1950 1955 1960

EARLY FLIGHT

Alberto Santos-Dumont was one of the most recognizable figures in Paris. An avid inventor and adventurer, he spent years developing and testing the ideal flying machine. His aerial creations were a common site above the city's streets and boulevards. Santos-Dumont also made certain that his "heroic" exploits were captured in dramatic photographs.

Popular history has often awarded Orville and Wilber Wright the title of "inventors of the airplane." And while Orville's 1903 flight in the *Wright Flyer* at Kitty Hawk, North Carolina, was a seminal achievement—the first sustained, powered flight in a heavier-than-air vehicle—the development of human aircraft had a decidedly complicated early history.

In his own day, Alberto Santos-Dumont was probably far better known than the Wright brothers. He came from a wealthy Brazilian family, with a father who ran one of the country's most successful coffee plantations. After completing his studies in Paris in the 1890s, he began experimenting with different ways of traveling by air. Balloon flight was all the rage in Paris, and Santos-Dumont created several of his own balloons and lighter-than-air dirigibles. Each of his experiments needed to be tested, and the young aviator would steer his hydrogen-filled creations above city cafes, apartments, and the Arc de Triomphe. In 1901, his airship *Santos-Dumont #6* won a prize for successfully traveling from the Parc Saint Cloud to the Eiffel Tower and back—a distance of about eleven kilometers (seven miles)—in thirty minutes or less. Photographs of #6 circling the top of the Eiffel Tower became famous. Santos-Dumont's bullet-like aircraft—with its delicate wooden frame and steering mechanism underneath—compliments the graceful, open-framed steel spire of the tower. Images like this would not only influence future aviators, it would also inspire the creations of early twentieth-century artists, who often merged aircraft and skyscrapers in their architectural fantasies.

Santos-Dumont also experimented with heavier-than-air vehicles. In his engine-powered Demoiselle monoplanes of 1908 to 1909, he sat directly below the wing and steered the aircraft—making some of the first flights over the countryside near Paris. Photographs of the Demoiselle often highlight its graceful, curved wings; making it resemble a giant mechanical dragonfly hovering over tree-lined city streets and country roads. Like other images of Santos-Dumont in action, these photos have a theatrical quality that suited the personality of their subject. By contrast, the famous 1903 image of the *Wright Flyer* at Kitty Hawk shows the Wright brothers in quiet isolation. Despite the revolutionary nature of the event it captured, the picture has a level-headed, pragmatic character—a quality reflective of small-town American culture at the beginning of the twentieth century.

Alberto Santos-Dumont rounding the Eiffel Tower in his airship *Santos-Dumont No. 5*, 1901

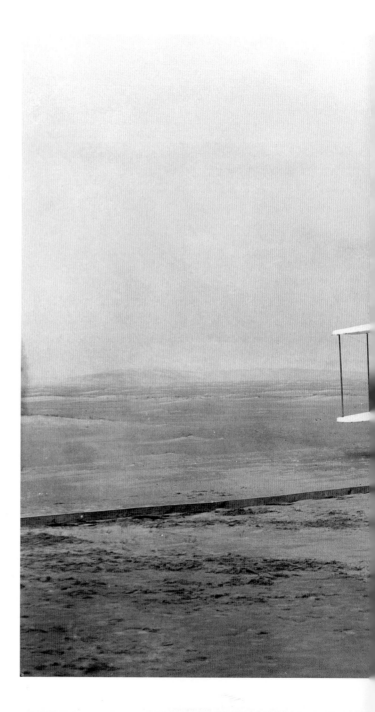

John Daniels, Flight of the *Wright Flyer* in Kitty Hawk, North Carolina, 1903

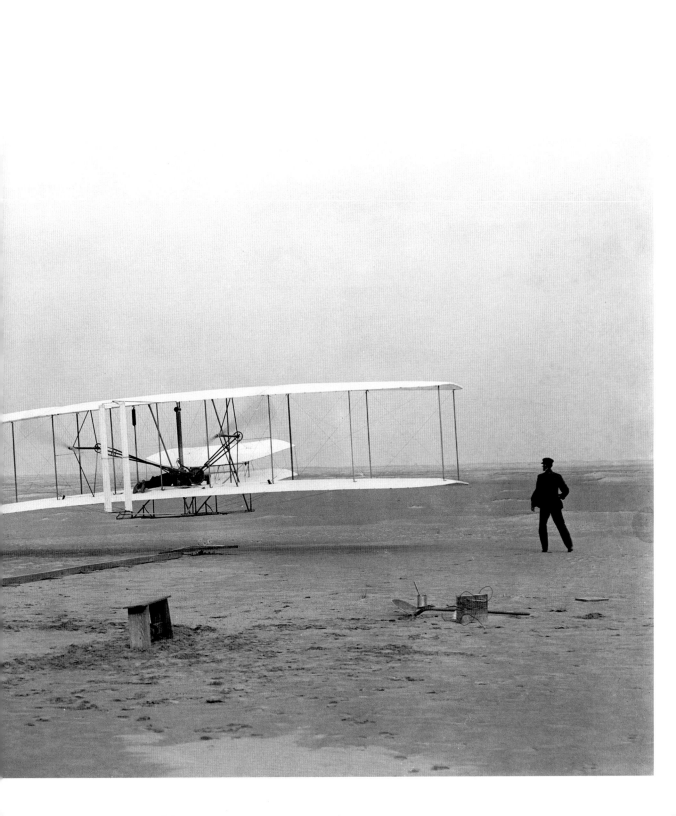

1900 Freud publishes
*The Interpretation
of Dreams*

1903 Henry Ford establis
the Ford Motor
Company in Detroit

1855 1860 1865 1870 1875 1880 1885 1890 1895 1900 1905

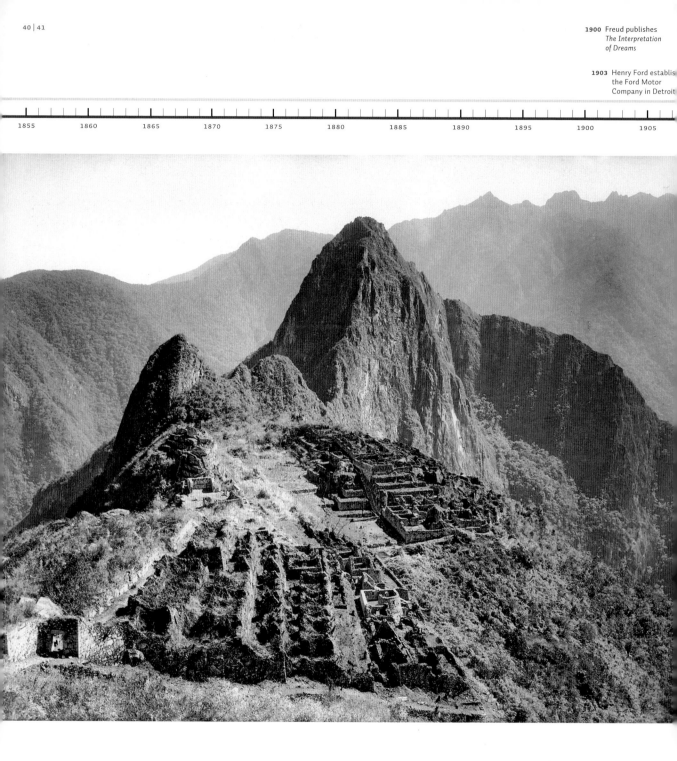

Martín Chambi, Machu Picchu, 1925

1916 Albert Einstein, Theory of Relativity

1919 Treaty of Versailles officially ends World War I

1914 Assassination of Archduke Franz Ferdinand of Austria on June 28; World War I breaks out

1933 Franklin D. Roosevelt sworn in as president of the U.S.

1929 Stock market crash heralds global economic crisis

1939–45 World War II

1950–53 Korean War

1953 Ernest Hemingway wins the Nobel Prize in Literature

1910 1915 1920 1925 1930 1935 1940 1945 1950 1955 1960

MACHU PICCHU

As photography spread around the globe, local artists began to use the camera to both document and enrich the cultures of their regions. The indigenous Peruvian photographer Martin Chambi captured the rural customs and archaeological splendor of his Andean high country. Chambi's images of Machu Picchu are among his most evocative.

By the time Machu Picchu was first photographed by archaeologists in 1911, the age of European exploration was nearing its end. The ancient Inca site, clinging precariously to its jagged peak, seemed to represent one of the last, most remote hidden corners of the world. American professor and amateur archaeologist Hiram Bingham had been led to the site in 1911 by local guides while he was traveling through the Peruvian Altiplano. He returned multiple times to Machu Picchu over the next several years, with partial funding from the American National Geographic Society. The society's popular magazine published many of the first images of Machu Picchu in April 1913, an early coup for a publication that would become a leading promoter of international tourism. *National Geographic*'s readers were thrilled by the Machu Picchu story, a site seemingly out of a Gothic novel—combining as it did majestic beauty and mysterious origins.

Over the years, Machu Picchu would also become a proud symbol of Peruvian independence. Its sophisticated temples and houses featured the perfectly cut stonework that was typical of the Inca. One of the structures, the Intihuatana ("Hitching post of the sun"), was likely used as an astronomical device. Such pre-Columbian wonders inspired a generation of Peruvian artists who wanted to look beyond their Spanish colonial heritage toward deeper origins. Martin Chambi (1891–1973) came from a poor Quechua-speaking family in southeastern Peru. In the 1920s, he established his own studio in Cusco, the heart of the ancient Incan empire. Many of his studio portraits emphasized both the captivating strength and "otherness" of his native subjects. In *The Giant of Paruro* (1929), Chambi captured the 2.1-meter- (7-foot-) tall Juan de la Cruz

Sihuana, a full-blooded native Peruvian, in ragged sandals and patchwork clothing. His attire and calm countenance were shown in sharp detail against a fuzzy Victorian background—the unnerving realities of modern Peru supplanting a faded colonial past.

But Chambi's best-known images were taken out of doors, reveling in the local customs, landscapes, and history of his mountainous nation. The photographer depicts small-town musicians playing the traditional zampoña flute, as well as Indian mothers with spindles in their hands and babies on their backs. He even celebrates his own native origins in a self-portrait with a mule, peasant clothing, and an Andean background. Chambi also created some of the most romantic images of Incan architecture. His expertly composed portraits of Machu Picchu use sunlight and shadow to capture the grandeur and mystery of the ancient mountain site. These images still inspire fascination today, as the meaning and purpose of Machu Picchu remain elusive.

1867 The Alaska Purchase by
the United States

1887–89 Construction of
the Eiffel Tower

1888 First crossing of the Greenland
icecap by Fridtjof Nansen

1900 Sigmund Freud
publishes
*The Interpretation
of Dreams*

1855 1860 1865 1870 1875 1880 1885 1890 1895 1900 1905

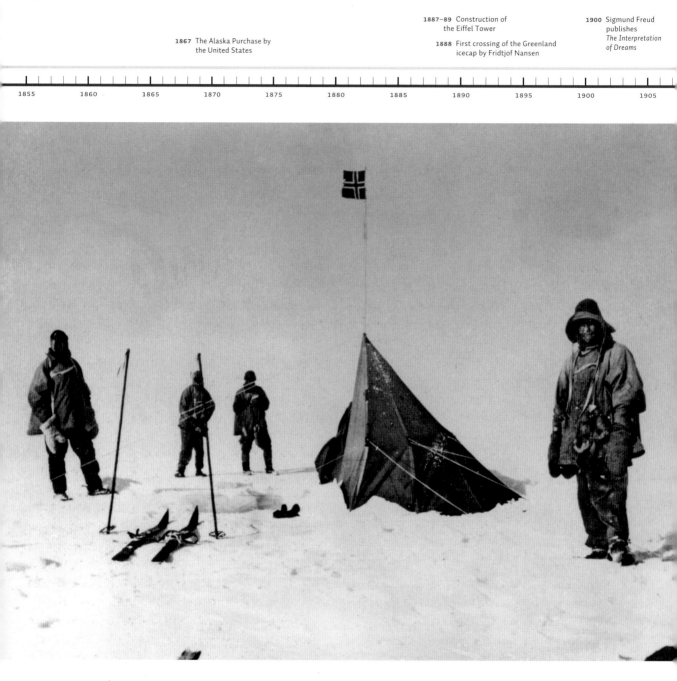

W. R. Bowers, Scott's Expedition sights Roald Amundsen's Tent, 1912

1919 Bauhaus founded by Walter Gropius in Weimar

1931 Completion of the Empire State Building

1912 Jackson Pollock is born

1925 Francis Scott Fitzgerald, *The Great Gatsby*

1946 UNESCO is established

1948 Mahatma Gandhi is assassinated

| 1910 | 1915 | 1920 | 1925 | 1930 | 1935 | 1940 | 1945 | 1950 | 1955 | 1960 |

SCOTT'S ANTARCTIC VOYAGE

Robert Falcon Scott's final expedition to the Antarctic ended in tragedy. But the photographs that survived the journey visually captured the heroism of his effort. Images of fortress-like icebergs and barren tundras often aroused memories of imposing realms from ancient mythology.

The continent of Antarctica was the last to be discovered by people, with the first confirmed sightings only occurring in the early 1800s. So the exploration of that frozen land was also a key part of Western culture's final "heroic" age of discovery. Maritime technology was finally enabling people to cross the treacherous, iceberg-filled waters below the Antarctic Circle. Knowledge of how to travel across the continent was still limited, though, and a small group of remarkable expeditions would slowly acquire this knowledge—often at the cost of their lives.

Like many of the conflicts between leading nations around 1900, the race to explore Antarctica and reach the South Pole became a highly competitive struggle for national prestige. Beginning in the late 1890s, expedition teams from Belgium, Great Britain, Norway, Sweden, Germany, France, and Japan slowly made inroads into the "new" continent. They reached places that would eventually be given names honoring their own cultures—regions like the French "Loubet" Land, the British "Graham" Land, and the German "Kaiser Wilhelm II" Land. But the two most important Antarctic explorers would eventually transcend national boundaries in the winter of 1911 to 1912. In their race to reach the South Pole, the efforts of Roald Amundsen and Robert Falcon Scott would present a struggle between human fortitude and pride and the unforgiving elements of nature.

Both Scott and Amundsen had prepared extensively for their South Pole chase. Scott had led the Discovery expedition of 1901–4. Sponsored by the British Royal Society and Royal Geographical Society, the journey would take Scott and his party farther south than any previous expedition, 857 kilometers (463 nautical miles) away from the Pole.

But the journey also made important scientific discoveries—the finding of dry valleys that lacked ice or snow and the identification of numerous animal and plant species. From 1903 to 1906, Amundsen had traversed Canada's Northwest Passage, where he worked and lived with Netsilik Inuit people. The Norwegian refined his skills with sled dogs there, and he learned to travel more efficiently through ice-bound landscapes.

Amundsen and Scott's dual journey to the South Pole began in 1910, when they began their preparations. Both expedition teams arrived in Antarctica in early 1911, camping only 320 kilometers (200 miles) apart. But it was Amundsen who got the head start on his final poleward journey, setting out on October 19. Scott didn't begin traveling south until November 1. So by the time Scott's party reached the Pole on January 17, 1912, they found Amundsen's Norwegian flag already there. It had been there for more than a month.

The optimism of Scott's five-man team quickly turned to bitter disappointment, and they would soon experience even worse luck. On the journey home, they caught the worst of the Antarctic weather—conditions they would not survive. Yet despite the tragedy, it was Scott's team that would produce most of the remarkable photographs of that time. Images of giant icebergs, taken in the September before the fateful journey, would give people back in Britain a sense of the grandeur of the Antarctic landscape. Scott's group also took poignant photos of the South Pole—images of weary, frustrated men surrounding the flag of a rival nation.

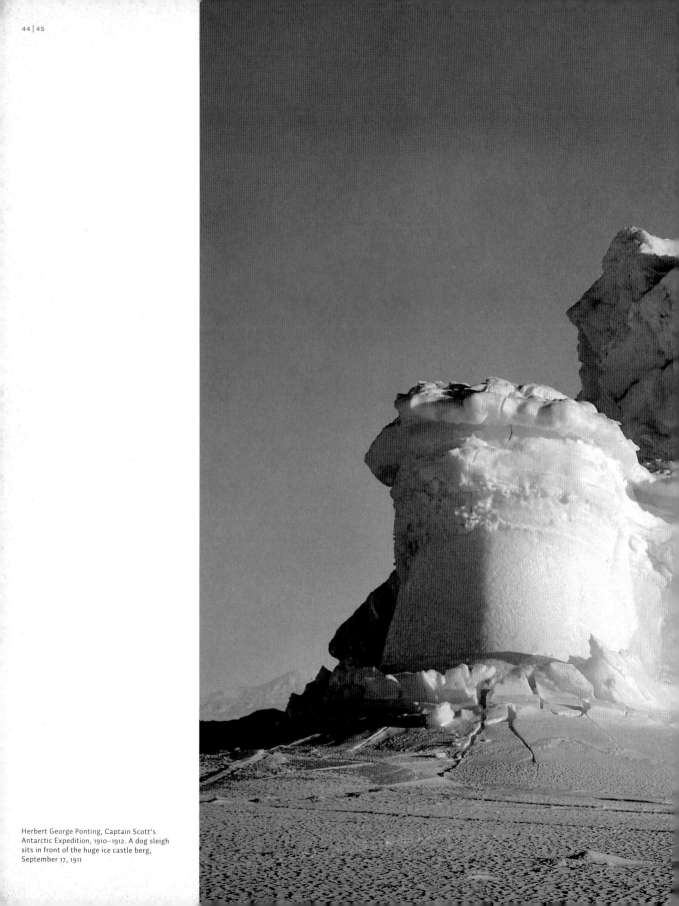

Herbert George Ponting, Captain Scott's
Antarctic Expedition, 1910–1912. A dog sleigh
sits in front of the huge ice castle berg,
September 17, 1911

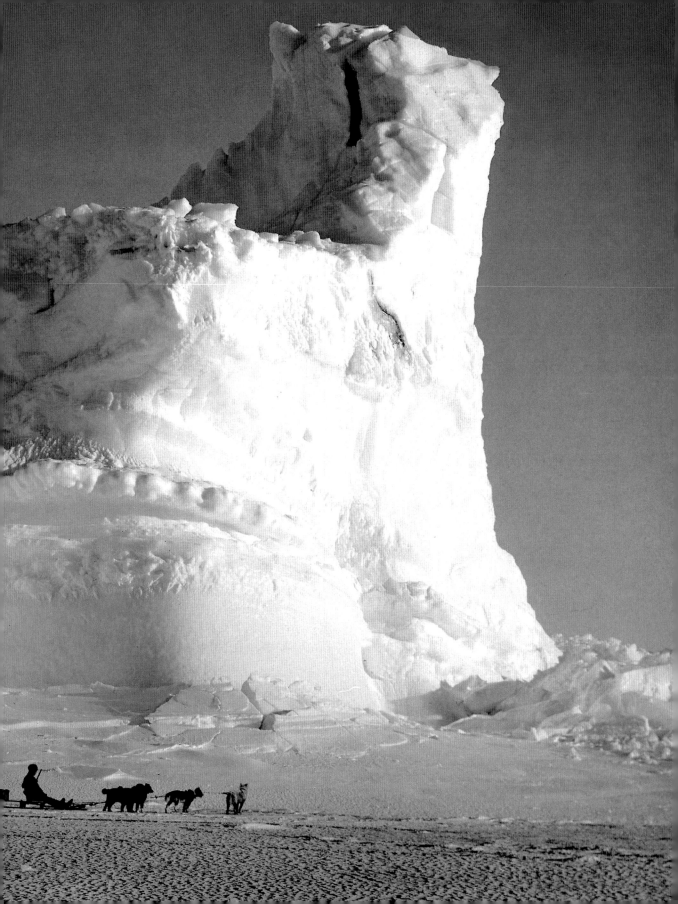

1860 1865 1870 1875 1880 1885 1890 1895 1900 1905 1910

1924 André Breton,
Surrealist Manifesto

1939–45 World War II

1913 Armory Show in New York 1929 Stock market crash heralds 1940 Charlie Chaplin, 1950–53 Korean War
shows the European avant-garde global economic crisis *The Great Dictator*

| 1915 | 1920 | 1925 | 1930 | 1935 | 1940 | 1945 | 1950 | 1955 | 1960 | 1965 |

TRENCH WARFARE IN WORLD WAR I

What started as a noble fight for king and country ended in a disillusioned Europe. World War I brought the full force of industrial warfare into play for the first time. It also involved an unprecedented level of battle photography, and the trench became the most poignant symbol of courage and wastefulness during the Great War.

In 1914, the growing unrest between Europe's powerful nation-states came to a head with the assassination of Austrian Archduke Franz Ferdinand. He had been killed by a Serbian gunman in the volatile Balkan city of Sarajevo. This event had the effect of a lighted match in a tinder-dry forest, leading to the conflagration that was World War I. Europeans quickly took sides, either behind Austria and the German-speaking countries of Central Europe or the Entente powers allied with Serbia—Russia, Great Britain, and France.

As with most major conflicts throughout history, initial hopes by both sides were for a quick war and a glorious victory. But the Great War would feature technology that soon banished all thoughts of easy triumph. The machine gun, the barbed-wire fence, poisonous gas, and the defensive trench made traditional methods of troop warfare obsolete. Yet the continued use of such methods meant that soldiers were more vulnerable than ever before. Attempts to break trench-supported defensive lines led to unprecedented battle casualties.

Reporters and even fellow soldiers took chilling photos of wartime atrocities. In one image from 1914, British soldiers in France, armed with machine guns, begin to advance out of their trench toward the German lines. Above them stands a tangled mesh of barbed-wire fencing, almost resembling burned-out vegetation. But the image's central figure is the dead soldier in the foreground, his body wedged into the trench's depression. Because of press censorship, both self-imposed and government-mandated, such images did not circulate widely during the war. But they became more available at war's end, showing people the true cost of the conflict.

Over time, many soldiers who experienced the worst of the fighting became disillusioned. High casualty rates and the unsatisfactory postwar peace treaties made the conflict seem an unnecessary tragedy. Many image makers reflected this attitude. Charlie Chaplin directed his own film version of trench war absurdities in the dark comedy *Shoulder Arms* (1918). The film created some of the earliest war-related parodies: the overbearing drill sergeant and the bumbling recruit who couldn't march properly or hold a gun. The trench became a surreal set piece, where Chaplin's soldier character was seen shooting at the enemy from below and keeping a score of his successes on a chalkboard. The concept of war as a "shooting gallery" was played for comic effect, but it reflected the new realities of war in a technological age—where enemies were becoming increasingly anonymous and war aims increasingly foolish.

British soldiers in the trenches during World War I. From *Official Series The Great War – With dogged courage we overcome stiff resistance and break the Hun lines from Epehy to Bellicourt*, ca. 1914

Charlie Chaplin as a soldier in *Shoulder Arms*, 1918

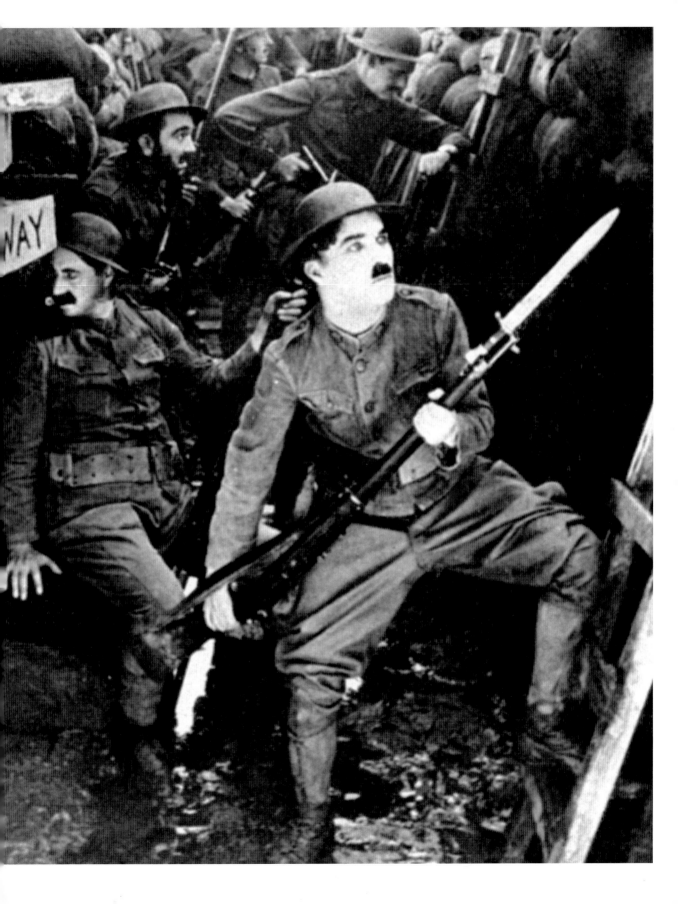

1891 Construction of Trans-Siberian
Railway started

1892 Premiere of Pyotr Tchaikovsky's ballet
The Nutcracker in Saint Petersburg

1888 Vincent van Gogh, *The Night Café*

| 1860 | 1865 | 1870 | 1875 | 1880 | 1885 | 1890 | 1895 | 1900 | 1905 | 1910 |

Uprisings during the revolution in front of the Kremlin in Moscow, October 1917

right page
July 4–17, 1917, in Petrograd: Demonstrators are shot by Cossacks and nobility loyal
to the government, 1917

1 Wassily Kandinsky, *Concerning the Spiritual in Art*

1922 Josef Stalin becomes general secretary of the Soviet Communist Party

1914 Marcel Duchamp's first readymade, *Bottle Rack*

1940 Trotsky murdered in Mexico

1936–39 Spanish Civil War

1949 The Soviet Union commences its first atomic test

1950 Abolition of racial segregation in the U.S.

1915　1920　1925　1930　1935　1940　1945　1950　1955　1960　1965

RUSSIAN REVOLUTION: DEMONSTRATIONS IN MOSCOW

The Russian Revolution was the spark that led to the end of a stubbornly traditional culture. Images of Moscow protests in 1917, set amid onion domes and medieval towers, foreshadowed the radical changes that the country would undergo in the succeeding decades.

The earliest photographs of Moscow were taken in the 1840s, and they show a Kremlin and cityscape still evocative of the Middle Ages. But the modernization of Mother Russia was soon to come. The elimination of serfdom in 1861 would be followed by the development of a contemporary "national" culture. Composers Modest Mussorgsky and Alexander Borodin and writers Leo Tolstoy and Fyodor Dostoyevsky would help define the Russian spirit for an industrializing West. They portrayed a nation of passion and psychological intensity, but one held back by entrenched political and social traditions and hardened by a harsh climate.

Russia also began to produce a small group of intellectuals and political leaders who aimed to overturn those cultural barriers. Growing dissatisfaction with the tsarist monarchy led to the founding of socialist parties in the 1880s and 1890s, as well as Vladimir Lenin's Marxist Bolshevik party in 1903. These groups helped spearhead the revolution of 1905, which saw violent workers' strikes throughout the country. The revolution would force Tsar Nicholas II to create a new legislative assembly, the State Duma, to incorporate leftist political leaders. But Nicholas would give the Duma only limited powers, and political unrest continued to fester.

By February of 1917, Russia's involvement in World War I had led to catastrophic losses of troops—around six million dead—as well as food shortages and crippling inflation at home. The result was another workers' strike in Saint Petersburg, which was now known by a Russian name, Petrograd. Factories, businesses, and universities shut down. When Nicholas II gave orders to suppress the protesters, the military largely mutinied and refused to carry out his order. The Tsar's political allies in the Duma withdrew their support, and Nicholas would be placed under house arrest in March. The new government would consist of several competing factions, with the socialists under Alexander Kerensky initially winning the upper hand. Over the coming months, however, Kerensky's fragile coalition would lose its hold on power, as military losses and economic depravations mounted. In October, Lenin's and Leon Trotsky's Bolsheviks would stage a relatively quiet coup at the Winter Palace. The bloodiest stages of the Russian Revolution—including the assassination of the Tsar and his family—were to come.

Photographs from 1917 gave only scattered glimpses of the revolution's early conflicts. A picture from July of that year showed an unsuccessful Bolshevik uprising in Petrograd, the streets strewn with dead and fleeing bodies. But the famous "storming" of the Winter Palace in October was not a photogenic event, as it involved relatively few people and little violence. Some of the most dramatic imagery depicted strikes in other Russian cities. One 1917 photo taken in Moscow revealed a chaotic mix of crowds and banners, which seemed to spill out of Saint Basil's Cathedral and the towers of the Kremlin. Mother Russia's ancient culture had been jolted by revolutionary fervor.

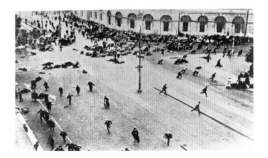

1875 1880 1885 1890 1895 1900 1905 1910 1915 1920 1925

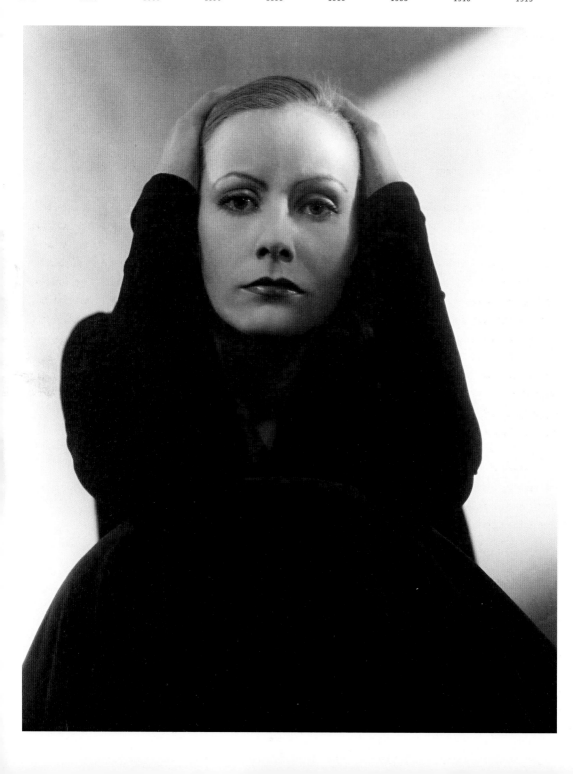

1946 UNESCO founded

4 André Breton,
Surrealist Manifesto

1945 Atom bomb dropped on
Hiroshima and Nagasaki

1969 Woodstock Festival

1952 Samuel Beckett, *Waiting for Godot*

| 1930 | 1935 | 1940 | 1945 | 1950 | 1955 | 1960 | 1965 | 1970 | 1975 | 1980 |

STEICHEN'S GRETA GARBO

Edward Steichen helped bring modern art to America with his gallery 291. He also brought an artistic sensibility to American photography. His portraits of Hollywood celebrities and fashionistas were often stripped down to essential shapes, reflecting modernist and art deco sensibilities.

Though born in Bivange, Luxembourg, Edward Steichen (1879–1973) spent much of his career promoting the development of American culture. He moved with his family to the United States as a toddler in the 1880s, a moment when the country was first distinguishing itself in several artistic fields. Edward became a fine draftsman, painter, and cameraman, and with photographer Alfred Stieglitz he would open up a gallery in 1905. Called "Little Galleries of the Photo-Secession," or simply 291, the gallery would bring the work of many great European modernists to American clients—artists such as Pablo Picasso, Paul Cezanne, Auguste Rodin, and Constantin Brâncuși. The gallery would also become famous for introducing Steichen's own work, especially his photography.

Steichen's early photos used dramatic shading, simple forms, and a soft focus that gave the works a painterly quality. These images have a wistful introspectiveness, and they often portray the artists and writers he championed— Rodin, Henri Matisse, George Bernard Shaw. But Steichen also brought his artistic aesthetic to commercial photography, becoming one of the first modernists to create fashion photos.

After World War I, Steichen's photographic style acquired a harder edge, producing photos with sharp clarity and an emphasis on exploring abstract form. He also began creating more commercial work, doing freelance assignments for pioneering fashion magazines *Vogue* and *Vanity Fair*. Often his best-known images involved Hollywood celebrities. Steichen's interest in film began before the war, when he opined that a "Winslow Homer, himself, may live to see a perfected cinematograph, that has been operated by another Winslow Homer ... with the possible

accompaniment of a phonograph, that will have all the great qualities of the canvases and obviously more ..." Steichen's own still portraits strove to attain those lofty artistic goals. In his image of Chinese American actress Anna May Wong, the subject's head became a disembodied shape—a piece of exotic human porcelain—that appeared to float serenely on an abstract reflective surface. Even more famous was his image of Greta Garbo, which achieved similar reductive beauty. The Swedish actress was shown crouching in a voluptuous black dress, her hands and arms covering the sides of her face. Her position, as well as the image's dramatic sidelighting, transformed Garbo's body into a radiant face surrounded by darkened shapes. Here Steichen truly created a photographic canvas, with the actress transformed into art object.

Edward Steichen, Portrait of Greta Garbo, 1928

1893 Edvard Munch,
The Scream

1901 André Malraux, French
Minister of Culture, is born

1911 Wassily Kandinsky, *Concerning
the Spiritual in Art*

1936 Charlie Chaplin,
Modern Times

| 1890 | 1895 | 1900 | 1905 | 1910 | 1915 | 1920 | 1925 | 1930 | 1935 | 1940 |

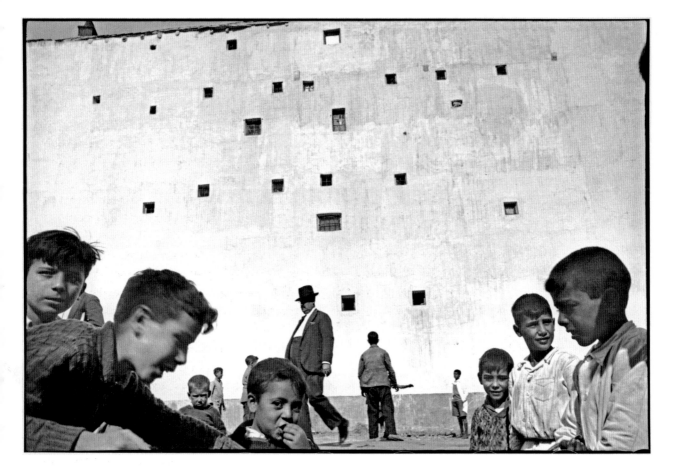

Henri Cartier-Bresson, Spain, Madrid, 1933

1948 Mahatma Gandhi
is assassinated

1969 Neil Armstrong lands
on the moon

9–45 World War II

1965–75 Vietnam War

1989 Fall of the
Berlin Wall

1945 1950 1955 1960 1965 1970 1975 1980 1985 1990 1995

HENRI CARTIER-BRESSON IN MADRID

Cartier-Bresson was a master of the fleeting moment. Blessed with quick-fire reflexes and a flair for composition, he used his highly portable Leica camera to capture people in the midst of life. He also brought a new sense of informality to photographic art, helping paving the way for modern photojournalism.

Like Edward Steichen, Henri Cartier-Bresson (1908–2004) began his career as an artist, studying painting in Paris with Cubist artist André Lhote and society portraitist Jacques-Émile Blanche. He only began taking photographs seriously in the 1930s, when he acquired a new Leica camera with a 50mm lens. This small, German-made camera enabled Cartier-Bresson to take pictures "on the run," and to remain inconspicuous while doing so. Thus the young artist was able to create what he called "instant drawings." Using his training as an artist, he developed a remarkable talent for taking snapshots with perfect composition—images that needed no cropping in the darkroom.

Even Cartier-Bresson's early works displayed a sure sense of form and expression. His images of street life in Madrid from 1933 seemed to express the languid pace of life and the laughter of children playing games. They also made expressive use of the region's traditional whitewashed architecture. In one example, a single façade covers nearly the entire background of the shot. The tiny windows that irregularly pierce its wall create a modernist composition, almost reminiscent of Piet Mondrian's grid paintings. In the foreground, eager children seem to crowd out a weary, middle-aged man strolling past in a suit and hat—the passing of generations in a slow-paced culture.

Throughout his career, Cartier-Bresson would continue to explore the artistic possibilities of crowds and street life. During World War II, he escaped from a German prison camp and began portraying the effects of war on ordinary people. Some of his best works revealed the conflicts that occurred after the fighting had stopped. In 1945, while at the Dessau camp for displaced persons, he captured a woman in the act of denouncing a French Gestapo informer. The effec-

tiveness of the image lies in its complex mix of emotions. The fiercely officious expression on the denouncer's face contrasts starkly with resigned melancholy in the condemned informer. But the reactions of faces in the crowd are much more subtle, ranging from anger to pity to indifference.

After the war, Cartier-Bresson increasingly became a respected art photographer of world events. He covered the struggles for independence in India and Southeast Asia, the rise of Communism in China, and the postwar Soviet Union. He also helped found Magnum Photos in 1947, one of the first agencies run by photographers to promote, protect, and sell their own work. Cartier-Bresson's output began to decline in the 1960s, but he still managed to produce masterful images of social change at street level. His picture of two women in a sixties Paris café perfectly summed up the growing generation gap of the time. A prudish older woman stares disapprovingly at a younger woman's "scandalously" revealing mini dress. Once again, the impression of an instant had become a permanent record of an era.

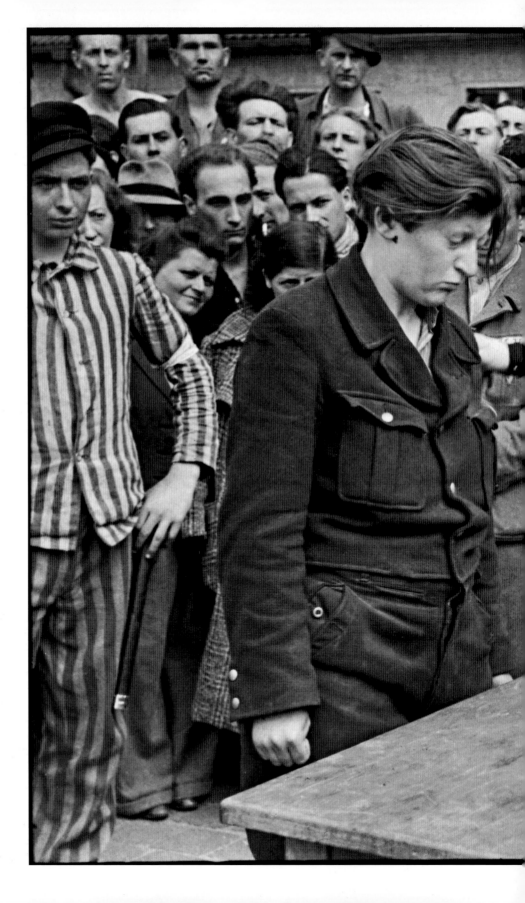

Henri Cartier-Bresson, Dessau,
Germany, 1945

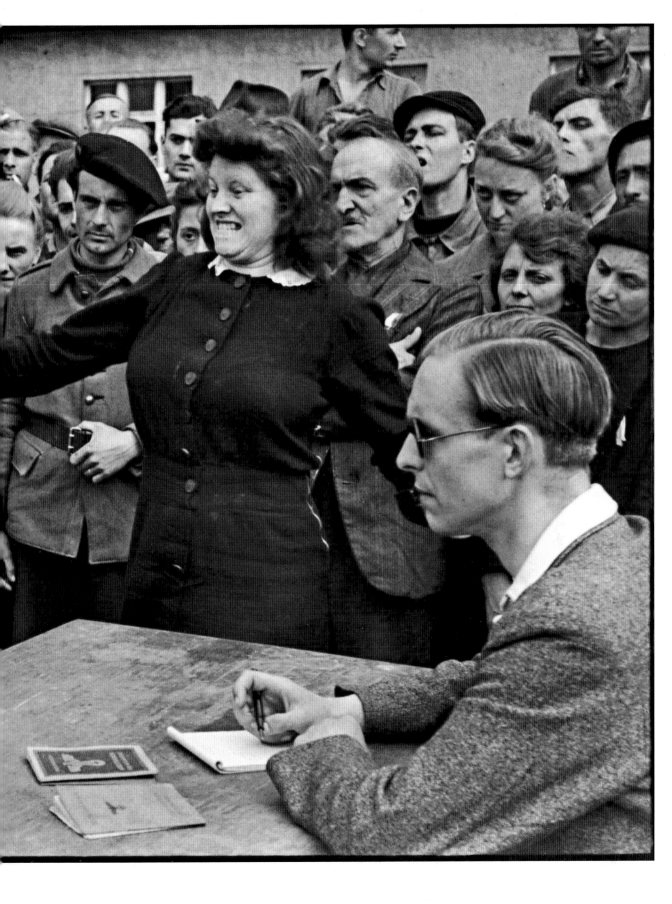

1933 Adolf Hitler comes
to power

1919–33 Prohibition in the U.S.

1939–45 W
War I

1928 Alexander Fleming
discovers penicillin

1890 1895 1900 1905 1910 1915 1920 1925 1930 1935 1940

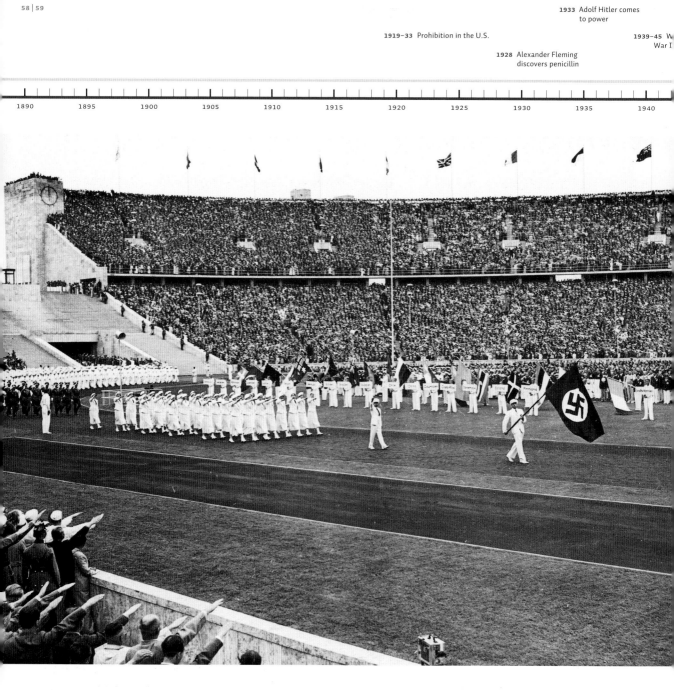

Opening Ceremony of the Olympic Games in Berlin, 1936

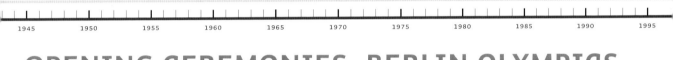

1944 Normandy landings

1961 Adolf Eichmann sentenced to death in Jerusalem

1 Japanese attack Pearl Harbor

1955 First documenta exhibition in Kassel, Germany

1968 Assassination of Martin Luther King, Jr.

1948 UN Declaration of Human Rights

| 1945 | 1950 | 1955 | 1960 | 1965 | 1970 | 1975 | 1980 | 1985 | 1990 | 1995 |

OPENING CEREMONIES, BERLIN OLYMPICS

Adolf Hitler's Germany clearly understood the value of spectacle. Filmmaker Leni Riefenstahl used the 1936 Olympics Games as an extravagant tool for promoting Hitler's regime—and for covering up its less attractive side. Yet other images from the Games uncovered the fallacies of Nazi racial theory.

Art was a central focus of Nazi Germany. Adolf Hitler himself was a frustrated artist, having tried and failed twice as a young man to gain admission to the Academy of Fine Arts in Vienna. Hitler never lost his interest in art, however, and he used the carefully crafted image to influence popular opinion toward Nazi politics and culture. His architect Albert Speer created the Zeppelinfeld stadium in Nuremburg—a building both neoclassical and brutally modern—for some of the Nazi regime's most theatrical rallies. Such efforts may have been inspired by the grandeur of Hitler's beloved Wagnerian operas, and they enlisted the participation of thousands.

The 1934 Nuremburg rally was filmed by an actress-turned-director named Leni Riefenstahl (1902–2003). Her landmark film, *Triumph of the Will*, perfectly captured the elaborately staged performance, using innovative editing techniques, long-focus lenses, and sophisticated pictorial compositions. The final film had a subtle rhythm and visual style that accentuated the rally's enormous, geometrically arranged crowds and marching soldiers. Riefenstahl never joined the Nazi party, but she worked with an iron-fisted determination that Nazi leaders often cultivated in themselves.

The grandest "film set" offered to Riefenstahl and Hitler was the Berlin Olympic Games of 1936. Now the master "showmen" could display their skills of organization and technical wizardry to impress a truly international audience. Riefenstahl's documentary *Olympia*, nearly three and a half hours long, again used innovative techniques to capture its events. The director advanced the art of the tracking shot, employing cameras placed on specially constructed rails throughout the stadium. These cameras captured the energy of the Games' races, while the use of slow motion added a sense of heroism to the competitors' achievements. Yet unlike *Triumph of the Will*, *Olympia* did not reserve its heroic treatment for Germans and other "Aryans." It also lionized black American sprinter Jesse Owens and the Japanese triple jumper Naoto Tajima. Riefenstahl, it turned out, was not as dogmatic as her führer about Nazi racial theory. Other parts of her film, however, did seem to acquiesce to the Nazi ideal. Its introduction featured well-muscled German actors playing the roles of ancient Greek Olympians.

Photos from the Berlin Olympics also captured the excitement and lock-step precision of the Games. In an image from the opening ceremonies, the German Olympic team marched in pristine white outfits past saluting crowds—with the Nazi flag carrier proudly in the lead. Behind them, the newly built Olympic stadium overflowed with a sea of international attendees. Hitler's Games proved the most successful Olympics to date, strengthening the regime's reputation at home and, to a certain extent, in other countries. Hitler had become a master organizer who knew how to bring "prosperity" to his formerly impoverished nation. For a time, the distasteful aspects of Hitler's Germany, its hatred of Jews and other minorities, and its increasing militarism, were suppressed. Leni Riefenstahl won accolades for *Olympia* throughout Europe, and the innovations of the 1936 Games—down to the use of an Olympic torch—would become standard procedure in later ceremonies. The Olympics had become an effective tool for nations that needed a "makeover."

1890 1895 1900 1905 1910 1915 1920 1925 1930 1935 1940

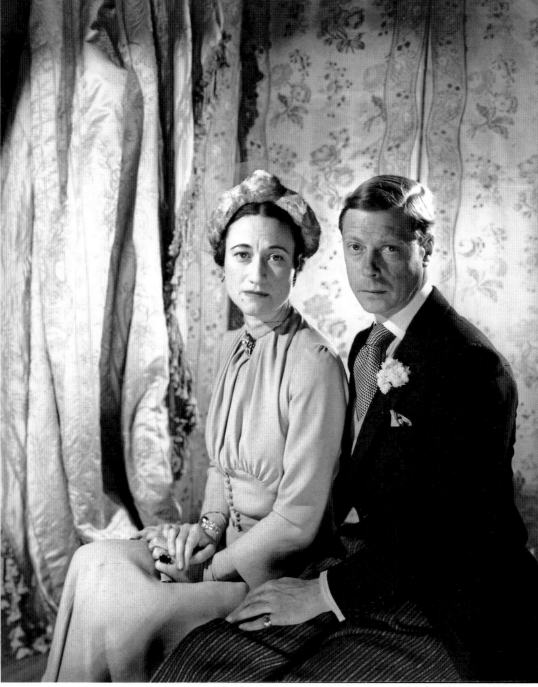

DUKE AND DUCHESS OF WINDSOR

In the wake of the Russian Revolution and the assassination of Tsar Alexander II, many European royal families were looking to establish closer ties with their subjects. Photographers like Cecil Beaton began portraying the British royals more like American celebrities—an especially fitting approach for the Duke of Windsor and his fashionable American bride.

During the long reign of George V (1910–36), the British king presented himself as a sober, hard-working public servant and family man. These Victorian "middle-class" values were an important asset during a reign of tumultuous activity. The power of European royal families was waning, especially after the assassination of Tsar Nicholas II in 1918, and the British empire was breaking apart. Unprecedented social changes were also taking place, especially in the 1920s. Traditional values were being "attacked" from every corner, with the growth of a youth culture, the acceptance of young women freed from restrictive clothing, and the blossoming of abstract and sexually explicit art and literature. Such changes overwhelmed many of George V's conservative subjects, enhancing his own popularity as a restrained, dignified monarch who seemed to represent the best qualities of the British past.

But George's heir was better suited to the culture of the twentieth century than to the Victorian age. The Prince of Wales, or Prince David as he was often called, became the first British royal to achieve modern celebrity status. He traveled widely around the empire and was the subject of newsreels and countless photographs. His many affairs, his love of sport, and his penchant for fine living made him a royal bon vivant. By 1934, one of these affairs had evolved into a long-term relationship. Wallace Simpson was a twice-married American socialite, her then husband being the British shipping executive Ernest Aldrich Simpson. Wallace and David's relationship scandalized the royal family and key members of Parliament. The British press, however, initially kept the affair secret from the public, in deference to royal authority.

When George V died in early 1936, David became King Edward VIII. But he refused to cut Wallace Simpson off, despite pressure from Prime Minister Stanley Baldwin. Simpson filed for divorce in October of that year, and the British press ended their self-imposed silence in early December. Overwhelming opposition from the public, as well as the Church of England's refusal to marry the couple, soon created a constitutional crisis. King Edward VIII was forced to abdicate on December 11, famously asserting that he found "it impossible to carry the heavy burden of responsibility and to discharge my duties as king as I would wish to do without the help and support of the woman I love."

The former king and his new wife would receive the titles of Duke and Duchess of Windsor, and they would be conveniently exiled to France. Their visit to Hitler's Germany in 1937 further distanced the couple from the British government. After the war, the Windsors remained prominent—if somewhat pathetic—figures in New York and Paris society. Cecil Beaton (1904–1980) was an esteemed part of that world, and he photographed the couple in 1937. His portrait captured the Windsors' cultured refinement, but it couldn't avoid the suggestion of repressed melancholy.

Cecil Beaton, Portrait of Wallis, Duchess of Windsor and Edward, Duke of Windsor, 1937

1902 Alfred Stieglitz founds the
Photo-Secession in New York

1924 André Breton,
Surrealist Manifesto

1937 Picasso's
Guernica

1890 1895 1900 1905 1910 1915 1920 1925 1930 1935 1940

1949 Democratic Republic of Germany
(DDR) officially established

1969 Neil Armstrong lands
on the moon

1945 Beginning of Cold War

1955 First documenta exhibition
in Kassel, Germany

1973 First oil crisis

1990 Reunification
of Germany

0–44 Vichy Regime in France

1945 1950 1955 1960 1965 1970 1975 1980 1985 1990 1995

PABLO PICASSO BY LEE MILLER

Since the era of Nadar, countless artists and writers have been "sketched" by the camera. The effort to capture the "genius behind the face" has occupied many photographers. Lee Miller, once a muse for other artists, produced some of the finest photographic portrayals of Pablo Picasso, T.S. Eliot, and the giants of twentieth-century culture.

Lee Miller 1907–1977) was blessed with striking good looks and an artistic sensibility. She started her career in New York City as a high-end fashion model for *Vogue* magazine, and she was photographed by Edward Steichen. But in 1929, she left New York to immerse herself in the modernist mecca of Paris. She soon became both an apprentice and a muse for American Surrealist Man Ray (Emmanuel Radnitzky, 1890–1976). Man Ray was among a number of artists exploring the aesthetic possibilities of photography. He created pictures that he called "rayographs," which involved a technique first pioneered by William Henry Fox Talbot in the 1830s. Man Ray would place objects on treated photo paper and expose them to light. The resulting image would show the object with light and dark tones reversed. Like other Surrealists, Man Ray created images that juxtaposed objects in unusual ways. Some of his best-known photographs involve Lee Miller. But Lee was also becoming an accomplished photographer in her own right, quickly developing a distinct photographic style.

Recent scholarship has found that a number of photos attributed to Man Ray were likely taken by Miller. But by the early 1930s, Lee had escaped from her tutor's shadow. Her early works experimented with surrealist shapes and textures, transforming the surface of desert stones into rippling skin and capturing a spreading mass of asphalt tar on a city pavement. She also began creating incisive portraits of her many artist friends. Miller's pictures have a delicate, airy quality, which can sometimes playfully offset an image's serious or frightening content. Her portrait of Picasso balances the aggressive intensity of the artist's gaze with the relaxed, white-washed setting of a Mediterranean courtyard. Other Miller portraits capture their subjects with

disarming informality—a lazy Dylan Thomas leaning back in his chair, a shirtless Isamu Naguchi surrounded by his sensually organic sculptures, and a prim T.S. Eliot in his three-piece suit and leather chair.

World War II gave Miller a chance to broaden her artistic range. Like Henri Cartier-Bresson, she created iconic images of the war's forgotten men and women. She depicted a Red Cross nurse wiping her brow after a "long shift," doctors using a bronchoscope on a soldier to check for lung damage, and a horrifically beaten SS prison guard shortly after the 1945 liberation of Buchenwald concentration camp. Other wartime photos would recapture her Surrealist origins, like the 1941 portrait of two young British women in an air-raid shelter—their Dada-esque masks in striking contrast to their conservative woolen outfits. Miller even portrayed her own efforts to "conquer" Fascism, as when she depicted herself bathing in Hitler's apartment bathtub in Munich—a humorously erotic image that also included her dirty boots at the base of the tub.

Many of Miller's wartime images were commissioned by *Vogue* magazine, and she would continue working for *Vogue* as a freelancer in the 1950s—mixing fashion photography with more personal photo stories about her life on Farley Farm in southern England. Yet alcoholism and depression reduced her productivity late in life, and her fame as a photographer was only rekindled after her death.

Lee Miller, Picasso at the Hôtel Vaste Horizon, Mougins, France, 1937

| 1890 | 1895 | 1900 | 1905 | 1910 | 1915 | 1920 | 1925 | 1930 | 1935 | 1940 |

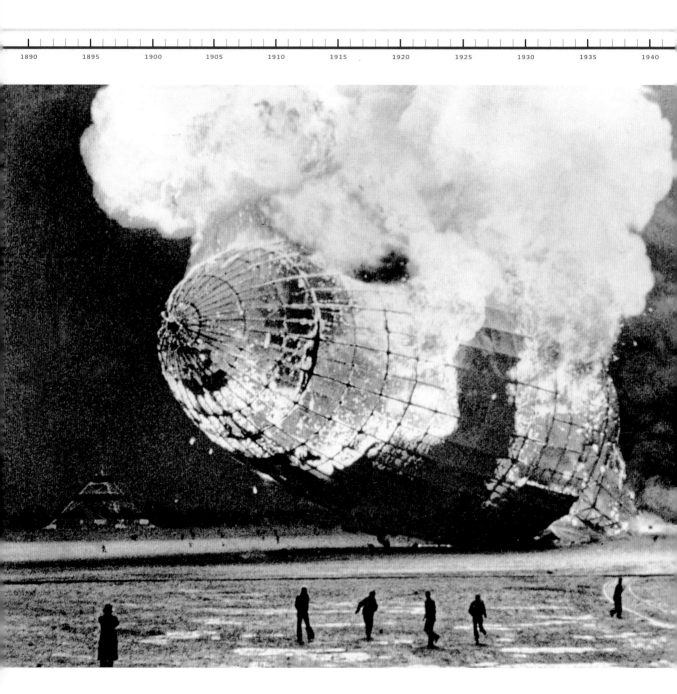

Zeppelin disaster, Lakehurst, N. J. Blazing wreck of the Hindenburg after explosion,
May 6, 1937

1955 *The Family of Man* exhibition in the
Museum of Modern Art, New York

1945 Atom bombs dropped on
Hiroshima and Nagasaki

1960 Clement Greenberg,
Modernist Painting

1968 Student revolts
Martin Luther King, Jr.
is assassinated

1979–89 War in Afghanistan

1990 Final year of the
Cold War era

1962 Cuban Missile Crisis

| 1945 | 1950 | 1955 | 1960 | 1965 | 1970 | 1975 | 1980 | 1985 | 1990 | 1995 |

HINDENBURG DISASTER

On May 6, 1937, film crews were ready to capture the triumphant landing of the LZ 129 Hindenburg airship at Lakehurst Naval Air Station in New Jersey. What ensued was one of the first instances of "live" disaster coverage. Images of the mighty balloon collapsing in flames showed the destructive side of modern technology.

"It's practically standing still now. They've dropped ropes out of the nose of the ship, and they've been taken a hold of down on the field by a number of men. It's starting to rain again; it's—the rain had slacked up a little bit. The back motors of the ship are just holding it just, just enough to keep it from—It burst into flames! It burst into flames, and it's falling, it's crashing! Watch it! Watch it, folks! Get out of the way! Get out of the way! Get this, Charlie! Get this, Charlie! It's fire—and it's crashing! It's crashing terrible! Oh, my, get out of the way, please! It's burning and bursting into flames, and the—and it's falling on the mooring-mast and all the folks agree that this is terrible, this is the worst of the worst catastrophes in the world.... oh, four- or five-hundred feet into the sky and it ... it's a terrific crash, ladies and gentlemen. It's smoke, and it's flames now ... and the frame is crashing to the ground, not quite to the mooring-mast. Oh, the humanity and all the passengers screaming around here."

These words were transcribed from Herbert Morrison's radio broadcast of the *Hindenburg* crash, and they remain among journalism's most famous. The *Hindenburg* was one of the first disasters to be broadcast live, and Morrison's desperate words were "illustrated" by devastating imagery. The crash began when the ship's swelling frame was suddenly lit up by two successive explosions in the rear. Footage showed the outer layer of the ship peel off and disintegrate, revealing the inner structure of the vessel lit up in flames. When the huge dirigible hit the ground, it landed with its front end stuck upward—like a sinking ship at sea. As the nose of the ship fell downward, the last bits of skin melted away and the entire vessel was set ablaze.

In all, the entire process lasted just over half a minute. But the aftereffects of the disaster would be dramatic and permanent. The Hindenburg had been considered the finest product of a long line of Zeppelin airships going back to 1900. By the 1920s, the German-based Zeppelin company offered the safest and most comfortable form of international transportation in the world. One of these ships, the *Graf Zeppelin*, became an important part of popular culture, its image displayed on "air-mail" postage stamps of different countries.

The *Hindenburg* itself had taken five years to build, beginning in 1931, and it made several successful transatlantic voyages in 1936. But the tragic—and widely viewed—demise of the vessel in 1937 would soon signal the end of Zeppelin flight. By the end of the thirties, nearly all of the giant airships were taken out of commission. A new "safest way to travel" would evolve with the airline industry. But imagery of air tragedies, from accidental plane crashes to the horrors of 9/11, continue to affect people and government policies in profound ways.

1905 German expressionist group
Die Brücke is founded in Dresden

1930 Grant Wood, *American Gothic*

1928 Alexander Fleming discovers
penicillin

| 1890 | 1895 | 1900 | 1905 | 1910 | 1915 | 1920 | 1925 | 1930 | 1935 | 1940 |

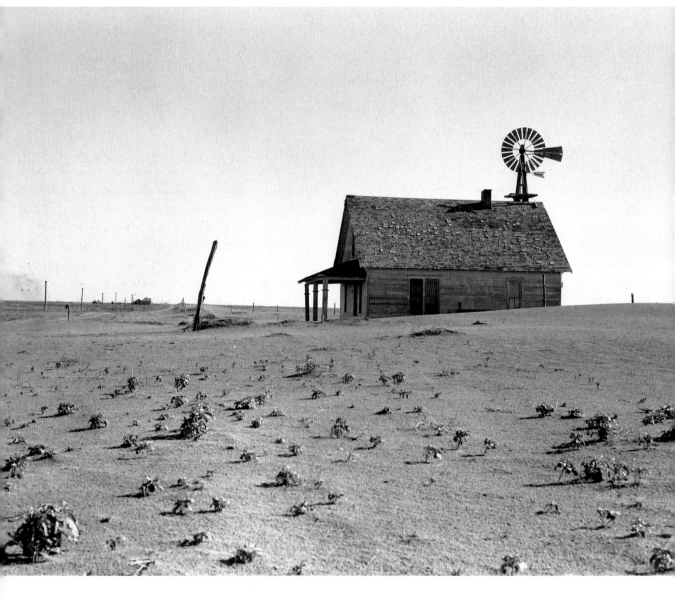

Dorothea Lange, Dust Bowl Farm, Coldwater District, north of Dalhart, Texas, June 1938

1949 North Atlantic Treaty Organization (NATO) is founded

1983 Discovery of the AIDS virus, HIV

1946 UNESCO is established **1965–75** Vietnam War **1973** Watergate scandal **1995** Founding of the World Trade Organization (WTO)

1945 1950 1955 1960 1965 1970 1975 1980 1985 1990 1995

DUST BOWL FARM

During the Great Depression, the United States federal government hired artists to capture the effects of poverty on American life. It was one of the largest government-sponsored art projects in history, and it spawned the careers of Dorothea Lange and other great American photographers.

Like many professional photographers, Dorothea Lange (1895–1965) began her career by setting up a portrait studio. Working in San Francisco during the 1920s, she photographed a number of successful artists from the American West, including printmaker Roi Partridge. But she later wrote of her dissatisfaction with this part of her career. "I enjoyed every portrait I made in an individual way," she said, "but it wasn't really what I wanted to do. I wanted to work on a broader basis. I realized I was photographing only people who paid me for it. That bothered me."

Lange would soon be freed from her reliance on individual patrons. As the country became mired in the Great Depression, Lange began portraying people who couldn't afford her studio portraits. A trip to New Mexico in 1931 produced images of hardy determination among the Navajo Indians. She also began portraying the breadlines and indigent workers on the streets of San Francisco. Such images would bring her to the attention of the federal government, which was beginning to establish programs that promoted employment and fostered a typically American art. The Resettlement Administration (RA) and the U.S. Farm Security Administration (FSA) both hired her to document poverty in rural areas nationwide. Lange was given great freedom to choose her subjects, and she traveled extensively throughout the West Coast, the desert lands of the Southwest, the cotton farms of the Southeast, and the Dust Bowl farms of the Southern Plains.

Lange's most heavily reproduced images were taken during this period. Her iconic *Migrant Mother* (1936) depicted an unemployed migrant family at a pea-picker's camp in Nipomo, California. The pea crop had been decimated by cold weather, and the young family had been "living on

frozen vegetables from the surrounding fields, and the birds that the children killed." Lange's portrait of the thirty-two-year-old mother shows a face both determined and fearful, her beautiful features prematurely aged by poverty and heavy outdoor labor. The children stand next to her, their faces buried in her shoulders. Lange's image had an almost sacred quality, an impoverished Madonna with two weeping cherubs. Other photos from Lange's FSA period showed the effects of the Dust Bowl on the rural landscape. One image from 1938 depicts a farm house and windmill in the Coldwater District of Texas. Lange's asymmetrical composition isolates the rural buildings in a desert of dried-up farmland—imbuing it with a strong sense of melancholy. Such images evoke the works of Andrew Wyeth, Edward Hopper, and other American portrayers of alienation.

Shortly after the United States entered World War II, Lange bravely documented a controversial wartime policy. She photographed the relocation of Japanese Americans to internment camps in the West. Her damning images portray crowded lines of families waiting to be shipped from their homes, Japanese American children reciting the U.S. Pledge of Allegiance, and elderly Japanese grandparents sleeping on cots in cramped barrack bedrooms. Because these works openly criticized the U.S. government during wartime, they were suppressed for many years.

After the war, Lange began photographing other impoverished regions of the globe—Ireland, India, Vietnam, etc. In 1972, seven years after her death, the Whitney Museum in New York organized the first exhibition of her Japanese American internment photos—cementing Lange's place among her country's great photographic documentarians.

1929 Stock market crash heralds
global economic crisis

1917 October Revolution in Russia

1940 German
occupat
of Franc

1932 Aldous Huxley,
Brave New World

1890 1895 1900 1905 1910 1915 1920 1925 1930 1935 1940

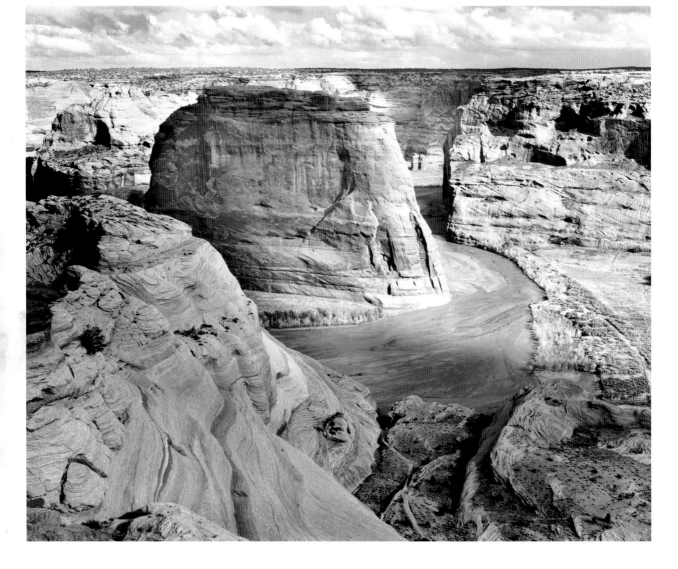

Ansel Adams, Canyon de Chelly, 1942

right page
Timothy O'Sullivan, Ancient ruins in the Cañon de Chelle, New Mexico, 1873

1959 First happening by Allan Kaprow
in New York

1982 Michael Jackson
releases *Thriller*

1954–62 Algerian War

1963 Martin Luther King, Jr.
"I Have a Dream" speech

1975 Pol Pot comes to power

1994 Nelson Mandela
becomes first
black South African
president

| 1945 | 1950 | 1955 | 1960 | 1965 | 1970 | 1975 | 1980 | 1985 | 1990 | 1995 |

CANYON DE CHELLY

Ansel Adams remains the most beloved of all American photographers. His images of American national parks often capture the organic nature of landscapes, suggesting the movement of glacial forces that created them. He also used innovative exposure and production techniques to give his pictures a remarkable clarity.

The idea of the national park began in the American West, with the writings of Scottish-born naturalist John Muir and the explorations of Ferdinand Hayden. Reflecting on the rugged beauty of California's Yosemite Valley, Muir wrote "No temple made with hands can compare with Yosemite … the grandest of all special temples of nature." Muir's ability with words spread his enthusiasm for nature throughout America, and it led to the founding of the Sierra Club and modern environmentalism. But just as significant was the work of Hayden, who was both an explorer and expert politician. Hayden's survey team extensively documented the Yellowstone region in Montana. Its photographer, William Henry Jackson (1843–1942), took dramatic photos of the Yellowstone's geysers, mountains, and river valleys. These images helped persuade the United States Congress to set aside the region as the world's first national park. Other nineteenth-century photographers, such as Timothy O'Sullivan (1840–1882), captured details of America's remote landscapes. O'Sullivan's "Geographical Explorations" involved photographing the Canyon de Chelly area in New Mexico. His image of the ancient Anasazi ruins called the "White House" is particularly evocative, showing the fortress-like cave city peering out from under a massive canyon wall—a wall "painted" with curtain-like vertical patterns of manganese and iron oxide. O'Sullivan had revealed both the geological and the aesthetic wonders of the area.

Ansel Adams (1902–1984) became the twentieth-century's best-known photographic chronicler of the national parks. Like O'Sullivan, he traveled to Canyon de Chelly and the landscapes of the desert Southwest. But Adams' images have a unique luster that makes them among the most widely reproduced photos today. This aesthetic feature was achieved through the artist's innovative Zone System, a technique he developed with collaborator Fred Archer. In the Zone System, the photographer exposes and develops an image so that each region of the photograph will have optimal contrasts of light and shade. This technique was especially effective in the large-scale landscape shots for which Adams is most famous. One of his finest images of the Canyon de Chelly shows the massive canyon landscape from a high perspective. The "flowing patterns" on the eroded canyon walls lead the eye on a winding path through the park. Adams reveals the region as a living place created by the organic processes of erosion. Collectively, the work of Jackson, O'Sullivan, and Adams played a major role in making the national park an integral part of American popular culture.

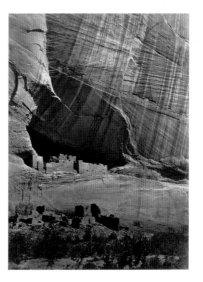

1900	1905	1910	1915	1920	1925	1930	1935	1940	1945	1950

Massive landing and deployment of U.S. troops day after victorious D-Day action on Omaha Beach, June 9, 1944

1987–93 First Palestinian Intifada

2002 U.S. opens
detention
camp in
Guantánamo

Racial segregation
abolished in the U.S.

1965 Vietnam War begins

1979 The Soviet Union
invades Afghanistan

1988 Freeze, exhibition of Young
British Artists in London

1962 Andy Warhol,
Campbell's Soup Cans

1955 1960 1965 1970 1975 1980 1985 1990 1995 2000 2005

NORMANDY LANDINGS

In early June of 1944, the massive landings on the Normandy coast became a turning point of World War II. Photographs of the landings show an operation of unprecedented size and technological sophistication—a twentieth-century armada of battleships, airships, and tanks.

"The men around me lay motionless. Only the dead on the waterline rolled with the waves. An LCT braved the fire and medics with red crosses painted on their helmets poured from it. I didn't think and didn't decide it. I just stood up and ran for the boat.... As I reached the deck I felt a shock, and suddenly was covered in feathers.... I saw that the superstructure had been blown away and that the feathers were the stuffing from the kapok jackets of the men who had been blown up. The skipper was crying. His assistant had been blown up all over him and he was a mess."

These words of Robert Capa (1913–1954) describe his harrowing, first-hand account of the landings at Omaha Beach on D-Day—June 6, 1944. Capa was born Endre Ernö Friedmann in Budapest, Hungary. He had escaped Nazi Germany in 1933 and made his way to the United States, where he eventually found work with the leading photography magazine *Life*. Capa's ability to capture the "action shots" of war was unmatched. So when the United States entered World War II, he traveled to the front lines of many battles. His most famous images capture the blurry figures of D-Day soldiers bravely trudging through the waters toward Omaha Beach. Capa had advanced with the second wave of amphibious troops. Tragically, of the more than one hundred snapshots that Capa took on that day, only 8 survived. The others were destroyed accidentally in the dark-room by one of Capa's young assistants.

The landing at Omaha was part of a coordinated series of maneuvers on D-Day. Allied forces targeted five locations along an eighty-kilometer (fifty-mile) stretch of Normandy beach, between the towns of Caen and Valognes. Code-named "Operation Neptune," the action began with air-borne landings by British and American forces, which were meant to establish inland defensive positions behind the beaches—enabling beachheads to be established by later waves of amphibious troops. The airborne landings were largely successful, though the paratroopers suffered heavy casualties on June 6. Among the five beaches that were assaulted, Omaha was the only one defended by a nearly full division of German infantry. The terrible fighting that Capa witnessed there would result in more than 6,000 deaths.

By July 9, the entire beachhead had been established. Now photographers began to capture stunning images of the full-scale Normandy invasion. One of these photos revealed nearly all of the latest military technology of the era. A seemingly endless array of battleships surround the beach, unloading convoys of trucks filled with troops. Military airships hover overhead, protecting the soldiers from the German Luftwaffe. Photos like this made the Allied forces seem invincible, and over the coming months France and the rest of Europe would be freed from Nazi control. The unprecedented scale of World War II would also transform the political and social landscape of the West.

1907 Picasso, *Les Demoiselles d'Avignon,*
first work of Cubism

1902 Alfred Stieglitz's *Camera Work*
is founded

1914–18 World War I

1916–22 Dada move-
ment

1930–31 Empire State Building in
New York by William van Alen

1924 Thomas Mann, *The Magic Mountain*

1945 Atom bombs droppe
Hiroshima and Naga

1939–45 World War II

1941 Japanese attack
Pearl Harbor

| 1900 | 1905 | 1910 | 1915 | 1920 | 1925 | 1930 | 1935 | 1940 | 1945 | 1950 |

Alfred Eisenstaedt, V-J Day in Times Square,
August 14, 1945

1965 Vietnam War begins

1955	1960	1965	1970	1975	1980	1985	1990	1995	2000	2005

V-J DAY IN TIMES SQUARE

Alfred Eisenstaedt had become famous in the 1920s for his portraits of Marlene Dietrich and decadent Berlin society. But the celebrated photographer of Life *magazine would later capture mainstream America with similar energy—best seen in his iconic image of reunion on V-J Day in New York City.*

Alfred Eisenstaedt (1898–1995) lived a life that covered nearly the entire twentieth century. For much of that century, he used his camera to portray the glamour and the restlessness of a world in transition. Like Henri Cartier-Bresson, Eisenstaedt had a talent for using the newly developed Leica camera—capturing his subjects with an arresting nonchalance. Hollywood celebrities, world leaders, and ordinary men and women were all depicted in the same casual manner.

Born in an area of Prussia that is now Poland, Eisenstaedt began his career in the 1920s in jazz-age Berlin. The German capital was one of Europe's most liberal, experimental cities, and Eisenstaedt started freelancing for the city's prominent *Berliner Tageblatt (BT)* newspaper. Some of his most famous work from the period depicts the glamorous world of German filmdom and the UFA studio. Eisenstaedt captured Marlene Dietrich in her famous top hat and tails in 1929. With cigarette in hand and a provocative smirk, the androgynous Dietrich reflected many of the more "scandalous" aspects of Berlin subculture—including its sexual frankness and its references to gay society. A year earlier, Eisenstaedt had captured Dietrich with two other women who were pushing the cultural envelope: Chinese American actress Anna May Wong and budding German filmmaker Leni Riefenstahl.

But the freewheeling era of the 1920s would not last, and Eisenstaedt witnessed dramatic changes in Germany during the Great Depression. The rise of Adolf Hitler posed serious threats to the photographer's career and safety. In Eisenstaedt's 1933 portrait of Joseph Goebbels, the Nazi propaganda minister seemed to be sneering at his Jewish portraitist. By 1935, Eisenstaedt had safely immigrated to the United States. He would spend much of the rest of his long career with *Life* magazine, capturing offbeat shots of America's rich and famous, from Marilyn Monroe to Bill Clinton. But Eisenstaedt's most enduring photos remain his depictions of ordinary soldiers leaving for combat in World War II—as well as those coming home after the war. His iconic *V-J Day in Times Square* captures the joyous energy of reunion. The couple's dancelike pose evokes the sound of the swing music that helped boost wartime morale for Americans at home and abroad. Though the picture was taken to celebrate the U.S. victory over Japan, Eisenstaedt may also have expressed his own joy at the demise of a Nazi government that had hijacked his native country.

1938 Nuclear fission discovered by Otto Hahn
and Fritz Strassmann

1911 Ernest Rutherford develops
his model of the atom

1939–45 World 1945 Atom bombs droppe
War II Hiroshima and Nag

1941 Japanese attack Pearl Harbor

1937–45 Second Sino-Japanese War
between China and Japan

| | | | | | | | | | | |
|1900|1905|1910|1915|1920|1925|1930|1935|1940|1945|1950|

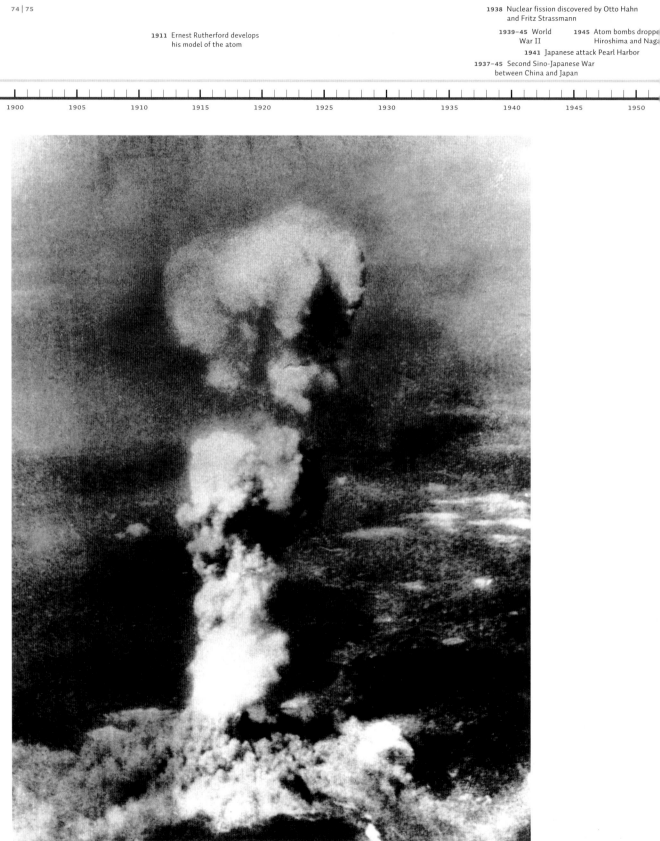

1954 First commercial nuclear power
plant in Obninsk near Moscow

8 Declaration of Independence of
the State of Israel, May 14

1972 U.S. uses napalm as a tool
of war in Vietnam

HIROSHIMA DESTROYED

Like Mathew Brady's ghostly pictures of Richmond after the Civil War, photos of Hiroshima capture a place where no life seems possible. Images such as these, as well as pictures of the giant Hiroshima mushroom cloud, remain the extreme depictions of wartime devastation.

Photographers have been capturing the destruction of war since the mid-1800s. James Robertson's Crimean forts, Mathew Brady's Civil War ruins, and the soldier-photographed death trenches of World War I all forced viewers to weigh the benefits of war against the terrible costs. But of all the conflicts during the age of photography, World War II seemed to be the most justified. Tyrannical fascist governments had oppressed their own populations, murdered millions of Jews and other minorities, and had sought to expand their territories at the expense of other sovereign nations. The victory of the Allied powers laid the groundwork for a more democratic Europe. Yet many of the actions at war's end still raise uncomfortable questions. The firebombing of Dresden, a city of Baroque architectural splendor and little military value, destroyed a priceless center of German culture and killed over 25,000 people. Local photographer Walter Hahn (1889–1969) captured the city shortly after its decimation. An angelic sculpted figure overlooks jagged pieces of ruined walls and exposed foundations.

But the most controversial military decisions of World War II were the bombings of Hiroshima and Nagasaki. The atomic bomb had been developed with utmost secrecy in the New Mexico desert. The lead scientist of this "Manhattan Project," Robert Oppenheimer, later referred to the moment when he first realized the weapon's destructive power, saying "We knew the world would not be the same. A few people laughed, a few people cried. Most people were silent. I remembered the line from the Hindu scripture, the *Bhagavad-Gita*; Vishnu is trying to persuade the Prince that he should do his duty and, to impress him, takes on his multi-armed form and says, 'Now I am become

Death, the destroyer of worlds.' I suppose we all thought that, one way or another."

Death came to Hiroshima on August 6, 1945. Lieutenant Colonel Paul Tibbets, Jr. piloted the Enola Gay, the B-29 bomber that dropped the weapon. Tibbets later tried to describe that day when he said, "A bright light filled the plane. We turned back to look at Hiroshima. The city was hidden by that awful cloud ... boiling up, mushrooming." Tibbets' mushroom cloud was captured in photographs taken over Hiroshima. Such pictures remain among the most effective visual warnings against future nuclear war.

Other devastating images from Hiroshima were aerial photos of the bomb's destructive consequences. The city had been reduced from a bustling metropolis to a giant, empty grid pattern. Only stumps of trees and pieces of walls remained. These images seem to burn and sizzle with radioactivity—suggesting the real-life radiation that was responsible for many of the approximately 200,000 Hiroshima-related casualties.

George R. Caron, Mushroom cloud above Hiroshima, August 6, 1945

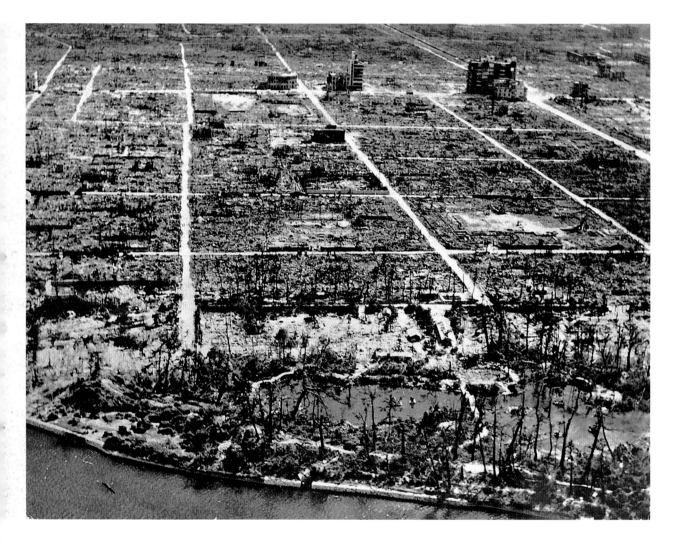

Hiroshima destroyed, 1945

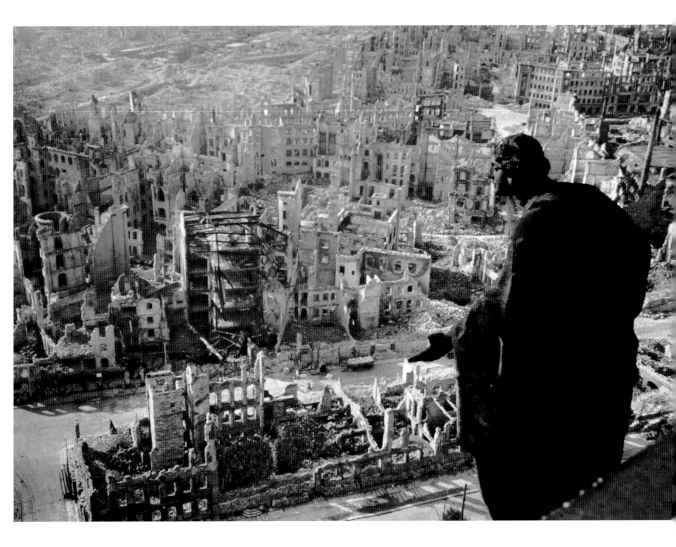

Walter Hahn, Dresden destroyed, February 1945

1947–48 First Kash
War

1947 India gains
independence
from the
British Empire

1943 Michael Curtiz, *Casablanca*

1930 Salt March

| 1900 | 1905 | 1910 | 1915 | 1920 | 1925 | 1930 | 1935 | 1940 | 1945 | 1950 |

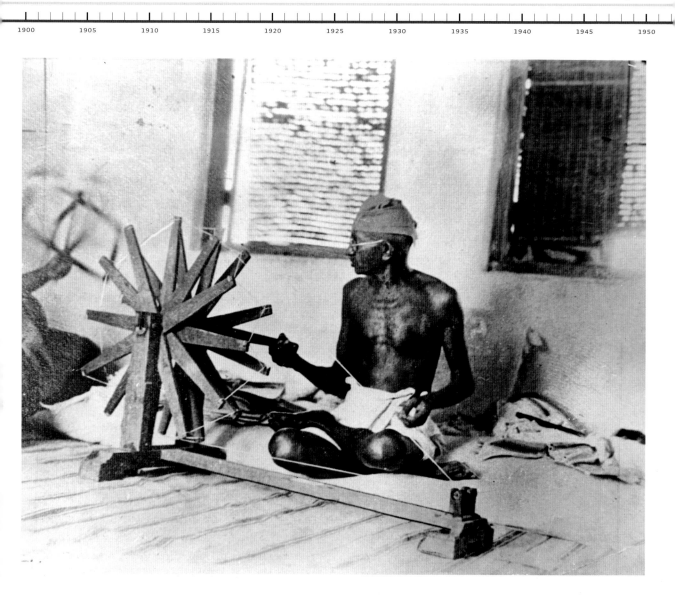

Margaret Bourke-White, Gandhi and the Spinning Wheel, 1946

1962 Sino-Indian War

8 Mahatma Gandhi
is assassinated

1969 Apollo Moon landing

1993 Mumbai bombings

1973 Yom Kippur War

1957 Ghana is first African colony to gain
independence after World War II

| | | | | | | | | | | |
|1955|1960|1965|1970|1975|1980|1985|1990|1995|2000|2005|

GANDHI

Mohandas Karamchand Gandhi led his country's struggle for independence through his actions and his very appearance. Photographs of Gandhi in traditional Indian dress in 1930s London, or of Gandhi working at the ancient spinning wheel, reminded people of the enduring nature of Indian society and the inequities of the British occupation.

The leader of India's independence movement was not always the stoic figure portrayed in film and popular legend. Gandhi had a prickly wit, and he was once quoted as saying "I believe in equality for everyone, except reporters and photographers." Yet Gandhi also enjoyed and appreciated the spotlight. He was one of his country's most widely photographed people, and he made certain to project an image that reflected the values of his culture—values of nonviolence and self-sufficiency.

Gandhi came from a relatively privileged background in the western coastal city of Porbandar. From an early age he absorbed the principles of Jainism, which emphasize non-violence, tolerance, and spiritual liberation. After traveling to England to get his law degree at Cambridge, he moved to South Africa in 1893, where he would spend more than twenty years fighting for legal equality of Indians in that British colony. Gandhi would also conduct his first large-scale experiment with nonviolent protest, directed against the Immigrants Regulation Act of 1913 in Transvaal. The act invalidated traditional Indian marriages and maintained an unfair annual tax on Indian residents. Gandhi's protests led to dozens of casualties at the hands of South African authorities, as well as the arrest of Gandhi himself. Yet news of the violence became an international story, and the British government eventually repealed the more onerous aspects of the 1913 act. Gandhi had learned to use both the press and his own nonviolent techniques to force political change.

Upon returning to India, Gandhi began using similar methods to protest British rule in his home country. After World War I, violence between British troops and Indian dissidents escalated, especially after the massacre at

Amritsar in 1919—an unprovoked attack on Indians by British soldiers. Gandhi criticized the violence on both sides and soon became India's most prominent voice for independence. As a leader of the Indian National Congress, he promoted local production of salt, fabrics, and other goods to replace British imports. Gandhi also promoted the Indian cause through his own appearance. He gave up wearing Western clothes in favor of his country's traditional robe, or *dhoti*, which he humbly wove himself. Some of the most striking images of Gandhi were taken in England during his 1931 negotiations with the British government. Gandhi's presence on the drab London streets, with bright white robe and sandals, angered many British politicians. Winston Churchill called him a "seditious" leader, and was appalled to see him "striding half-naked up the steps of the Vice-regal palace." Over time, however, Gandhi began winning the support of Western writers, artists, and intellectuals.

In the 1940s, shortly before Gandhi's death, American photographer Margaret Bourke-White captured images of the old pacifist at his spinning wheel. Like many who were sympathetic to his cause, Bourke-White appreciated Gandhi's use of the spinning wheel as a "symbol of economic and spiritual power." Gandhi's mastery of the visual gesture would help create an independent India in 1947. Subsequent leaders who strove for peaceful revolution, including Martin Luther King, Jr., would be inspired by Gandhi's example.

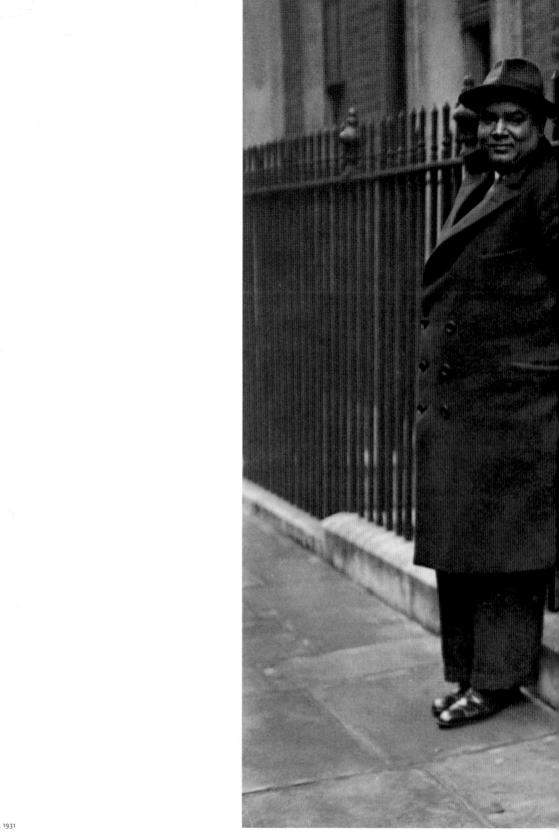

Mahatma Gandhi in London, 1931

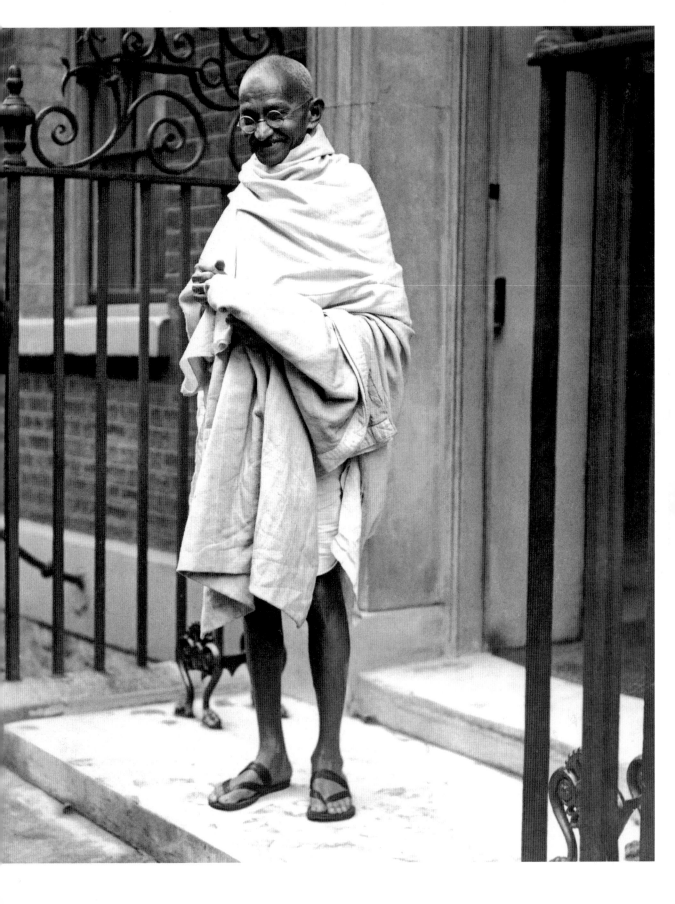

1929 Opening of the Museum of
Modern Art in New York

1948 UN Declara
of Human
Rights

1922 First British Mount Everest
Expedition

| 1900 | 1905 | 1910 | 1915 | 1920 | 1925 | 1930 | 1935 | 1940 | 1945 | 1950 |

Tenzing Norgay atop Mount Everest, 1953

1955 *The Family of Man* exhibition
at MoMA in New York

1968 Assassination of
Martin Luther King, Jr.

1 J. D. Salinger,
Catcher in the Rye

1961 John F. Kennedy sworn in
as president of the U.S.

1976 First G7 summit

1991 World Wide Web (WWW)
cleared for general use

1989 Massacre in Tiananmen Square
in China

1955	1960	1965	1970	1975	1980	1985	1990	1995	2000	2005

TENZING NORGAY ATOP MOUNT EVEREST

On May 29, 1953, Sir Edmund Hillary and Tenzing Norgay reached the top of the world—the 8,848-meter (29,029-foot) summit of Mount Everest. Hillary captured the moment by photographing Tenzing with flags and ice ax in his hands, a solitary figure representing human courage and tenacity.

Today, the Mount Everest region is a mecca for adventure tourism. Hundreds of people each year reach the summit, often at a cost of thousands of dollars. Many more pay smaller fees to explore the region along specially construct-ed walkways. In high tourist season, these pathways below the mountain known locally as Qomolangma, or "Holy Mother," can become clogged with Western customers. Yet Everest's "death zone," which lies above 8,000 meters (26,200 feet), has never been entirely tamed by modern commercialism. Several deaths are reported there every year, and more fatalities likely go unconfirmed. The Holy Mother still presents the same risks that it did to Tenzing Norgay and Edmund Hillary in 1953.

Attempts to climb the Himalaya's highest peak began in the 1920s. British mountaineers George Mallory and Andrew Irvine may have reached the summit in 1924, but neither climber survived the journey and no official confir-mation of the team's success has been determined. By the early fifties, however, improvements in climbing technology and oxygen equipment, as well as greater knowledge of the mountain's topography, made reaching the summit increasingly likely. Sherpa Tenzing Norgay had reached the southeast ridge of Everest in 1952 with a Swiss-led expedi-tion. A year later, Norgay would make his way back up the mountain with New Zealand climber and former Air Force navigator Edmund Hillary.

Norgay and Hillary were part of a larger British ex-pedition led by Colonel John Hunt. The expeditions' other two-man climbing team, Tom Bourdillon and Charles Evans, made the first attempt at the summit. They climbed to only a few hundred feet of their goal, but serious oxygen depri-vation forced them to turn back. Yet the information they

provided to Hillary and Norgay about their route greatly assisted the second team. On May 28, the Sherpa and the Kiwi began their ascent, reaching the top of the world at 11:30 a.m. the next day. Hillary had brought a camera with him, and when they reached the summit he asked Norgay to pose with his ice ax held high. On the ax's handle were an array of flags—those of the United Kingdom, the United Nations, Nepal, and India—that signified the international importance of the team's achievement. Hillary's image was not recorded that day, nor was the national flag of New Zealand. Yet the conquering of Everest would earn Hillary a knighthood and make him a living folk hero. His portrait, which had been absent on Everest's summit, would soon appear on the New Zealand five-dollar bill, the first of that country's notes to honor a living person.

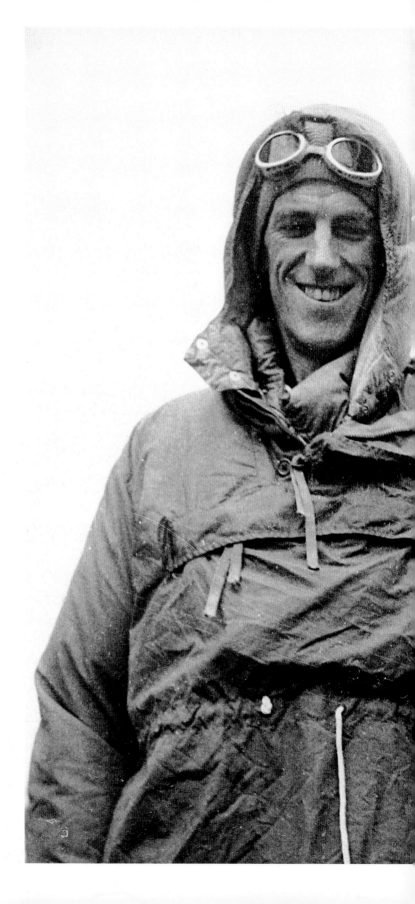

Edmund Hillary and Tenzing Norgay after reaching the top
of Mount Everest

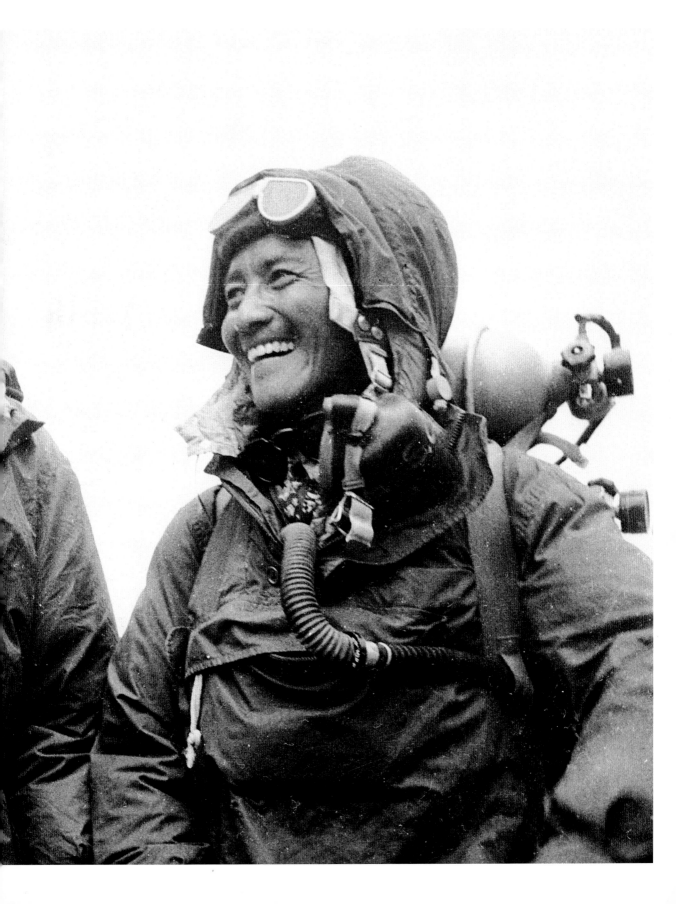

1911 Ernest Rutherford develops
his model of the atom

1927 Charles Lindbergh flies nonstop
from New York to Paris

1939–45 World War II

1930 Luis Buñuel, *L'Age d'Or*

1905 1910 1915 1920 1925 1930 1935 1940 1945 1950 1955

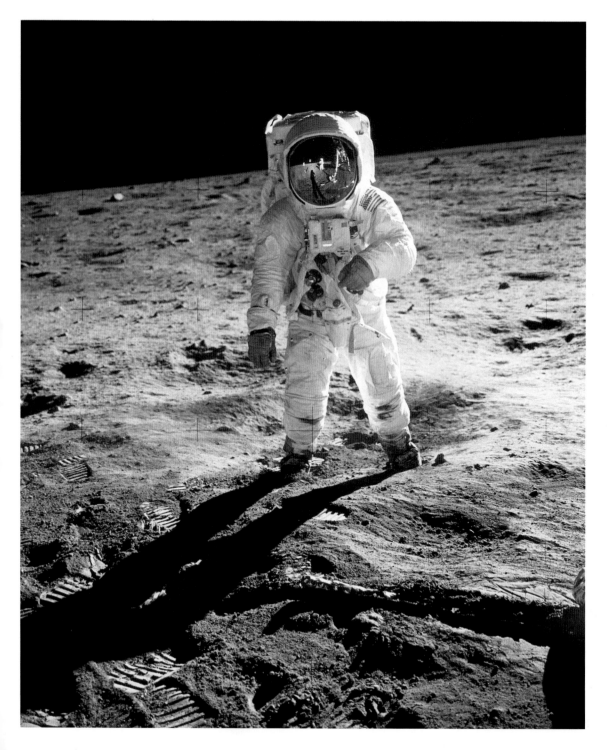

1986 First modular space station *Mir*
 Challenger space shuttle disaster

1962 Cuban Missile Crisis 1981 First flight by the *Columbia* 1998 Construction of International
 space shuttle Space Station (ISS) begins

7 Soviet Union launches 1969 Woodstock Festival
 the first *Sputnik*

| 1960 | 1965 | 1970 | 1975 | 1980 | 1985 | 1990 | 1995 | 2000 | 2005 | 2010 |

COLD WARRIORS IN SPACE

*The "Space Race" was a complex mix of individual heroism, scientific discovery, and Cold War machinations.
The Soviet Union achieved many of its earliest victories. In 1961, cosmonaut Yuri Gagarin completed the first manned
voyage in space. Once again, photographs captured the achievement as it occurred.*

World War II may have ended the Nazi's unique brand of fascism, but it also created a tense East-West division in Europe that would last for more than forty years. American journalist Walter Lippmann wrote a series of essays in 1947 that popularized the term "Cold War." At the time, Lippmann and others were skeptical about the prospects of ending Soviet hegemony in Eastern Europe. "It will be evident," he wrote, "to the reader who has followed the argument to this point that my criticism of the policy of containment, or the so-called Truman Doctrine, does not spring from any hope or belief that the Soviet pressure to expand can be 'charmed or talked out of existence.'" Indeed, both Western and Eastern nations ended up employing a remarkably wide range of diplomatic, economic and military tools to "wage" the war.

One of the chief Cold War weapons was scientific technology, and the space race created a perfect playing field for Soviet/American competition. By the fifties, both nations understood the political value of establishing footholds in space, even if the military value of such an adventure was less clear. The early successes of Soviet space travel included the launch of the unmanned *Sputnik* in 1957 and the flight of Yuri Gagarin in 1961. Both achievements had a profound effect on the West. Close-up images of Gagarin in his space suit, with all the classified details of his spacecraft hidden, embarrassed American leaders. These photos also acted as propaganda for the Soviet regime back home. Gagarin soon became one of the most photographed heroes of Russia, his attractive image being shown among the splendors of the Kremlin Palace and on tours of Europe.

Back in the United States, President John F. Kennedy responded to the Gagarin flight by announcing America's goal of sending a man to the moon "before the decade is out." The U.S. National Aeronautics and Space Administration (NASA), founded in 1958, now had the unequivocal support of the government and would expand its operations. In 1962, NASA astronaut John Glenn would become the first American to orbit the earth. The Gemini missions of the mid-sixties would see the first successful space walks and long-term space flights. Then, in 1968, the Apollo 8 mission would send the first men into orbit around the moon. One of Apollo's astronauts, Bill Anders, took the famous image of Earth from space, a picture that came to symbolize the "blue planet's" beauty and fragility. A year later, Apollo 11 would realize Kennedy's goal of a manned moon landing. With a massive worldwide audience watching, Neil Armstrong and Buzz Aldrin bounded across the dusty lunar surface—playfully making golf swings and somberly raising the American flag. Among the photographs taken on the "Sea of Tranquility" that day, the most famous one shows Aldrin posing for Armstrong's camera—his moonlike visor reflecting the images of Armstrong and the lunar lander in front of him.

Apollo 11 astronaut Buzz Aldrin standing on moon, with astronaut Neil Armstrong and lunar module reflected in helmet visor, during historic 1st walk on lunar surface, July 20, 1969

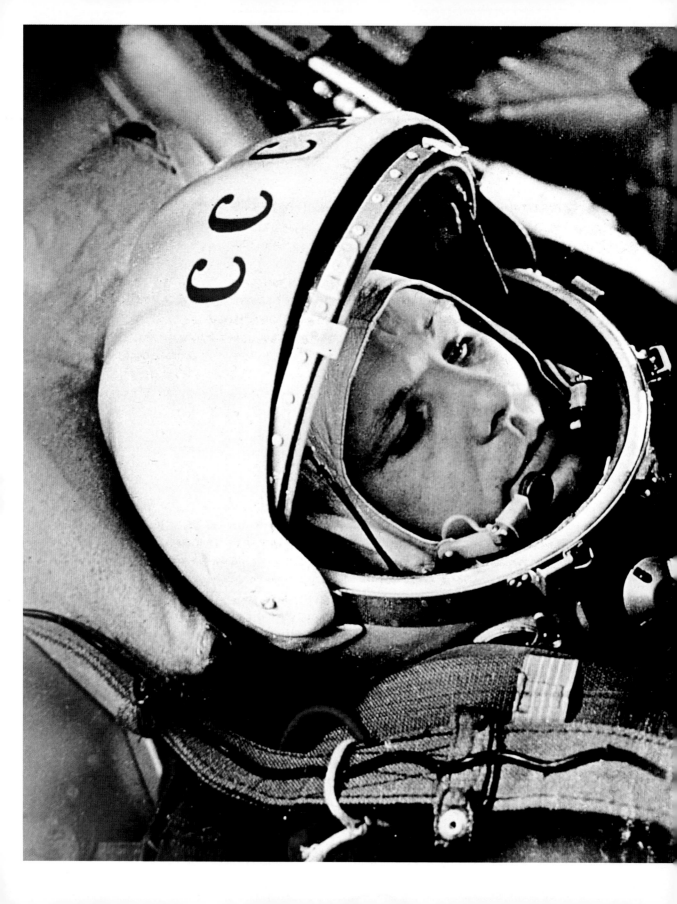

Russian cosmonaut Yuri Gagarin, the first man in space, who completed a circuit of the Earth in the spaceship satellite *Vostock*, 1961

1911 Wassily Kandinsky, **1919–33** Prohibition in the U.S. **1941** Japanese attack **1950** Korean War
Impression III Pearl Harbor

1905 1910 1915 1920 1925 1930 1935 1940 1945 1950 1955

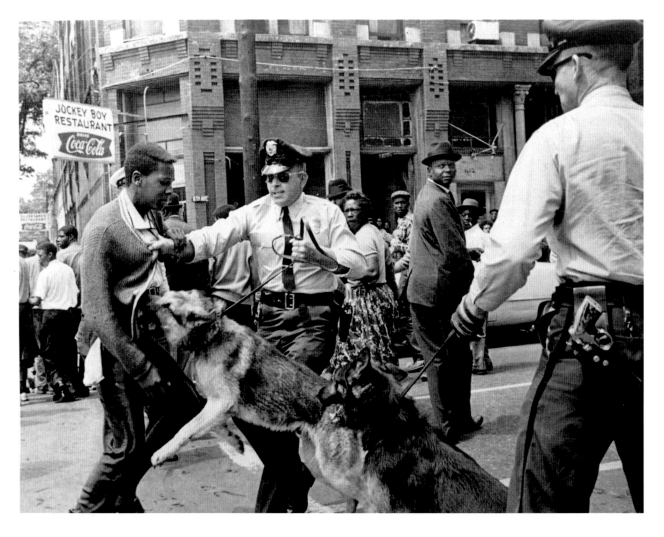

Demonstrator attacked by police dog in Birmingham, Alabama, 1963

1960 Clement Greenberg,
 Modernist Painting

5–68 Civil rights 1965–75 Vietnam War 1973 First oil crisis
 movement in the U.S.

 1963 Martin Luther King
 "I Have a Dream" speech

| 1960 | 1965 | 1970 | 1975 | 1980 | 1985 | 1990 | 1995 | 2000 | 2005 | 2010 |

CIVIL RIGHTS MOVEMENT

Photographers played a key role during the struggle for civil rights in the United States. Images of police attacking unarmed black protesters in the American South shocked Northern whites. They also helped invigorate the efforts of Martin Luther King, Jr. and other black leaders.

The practice of slavery in America has had long-lasting repercussions. Slavery officially ended after the Civil War in the 1860s, and the U.S. Constitution's fourteenth amendment gave citizenship rights to black Americans. But these military and legal achievements didn't fix the deep-rooted animosity between the races—an animosity nearly as strong in the North as it was in the South. Beginning in the late 1870s, racist laws set up restrictions against black suffrage in the South. Many African Americans remained in economic slavery as dependent sharecroppers on white-owned farms. Other "Jim Crow" laws further separated the races, reserving the best schools, restaurants, hotels, and washrooms for whites. Even in the North, where job opportunities were greater and more diverse, black migrants found themselves shuttled into urban ghettos.

Of course, the very concept of segregation was based on the power of the image. Visual differences between black and white were often enhanced in racist cartoons and films, presenting black characters as wide-eyed simpletons. Such stereotypes became culturally ingrained over generations. But by the end of World War II, the long-struggling civil rights movement began to gain steam. The exemplary service of black soldiers during the war led to the integration of the U.S. military in 1948. Now, black leaders could focus on integrating other parts of American society. New and photogenic spokesmen for civil rights understood how to use the media to advance their cause. On the vanguard of this movement was Martin Luther King, Jr., pastor and co-founder of the Southern Christian Leadership Conference (SCLC).

King was an impressive orator and a magnetic visual presence, both at the pulpit and on the street. He and the SCLC would organize a series of nonviolent protests in Southern cities. One of the most dramatic actions took place in early 1963 in Birmingham, Alabama, a center of the Jim Crow South. The campaign began with boycotts of certain white-owned businesses. It then grew to include more provocative engagements, including sit-ins at libraries and other public places. Finally, in early May, hundreds of black schoolchildren joined the sit-ins in what became known as the "Children's Crusade." These actions were directed at Birmingham's chief of police, Eugene "Bull" Connor, an ardent and often brutal supporter of segregation.

At first, Connor's forces had simply jailed the protesters when they refused to disperse. But by May 3, the city's jail had no more room for new arrivals. So on that day, his police began using violent means to clear the downtown business district. They sprayed the protesters with high-powered hoses, knocking many of the children to the ground, and then confronted them with German shepherd police dogs. Photojournalists on the scene took vivid images of the chaos. Bill Hudson (1932–2010), a photographer for the Associated Press, captured two white policemen with dogs attacking a high school student named Walter Gadsden. One of the dogs is shown leaping for Gadsden's stomach, while its officer prevents the teen from escaping. Black onlookers are shown witnessing the scene with a mixture of surprise and revulsion. Images like this would appear in newspapers across the country, forcing the federal government to take action and facilitating the work of Martin Luther King, Jr. Many people at the time criticized the use of children in the Birmingham campaign, but the widely publicized sacrifices of those youth helped inspire the groundbreaking U.S. Civil Rights Act of 1964.

1914–18 World War I **1929** Wall Street crash in New York **1945** End of World War II **1952** Elvis Presley rises to fame

1910 1915 1920 1925 1930 1935 1940 1945 1950 1955 1960

Policemen holding back excited Rolling Stones fans in New York where the band is on tour, June 1964

1962 Andy Warhol, *Campbell's Soup Cans*

0 The Beatles form

1976 Apple Computers founded

1988 *Freeze*, exhibition of Young British Artists in London

1970 British rock band Queen form

1982 Michael Jackson releases *Thriller*

1965 1970 1975 1980 1985 1990 1995 2000 2005 2010 2015

FANS OF THE ROLLING STONES

The fifties and sixties witnessed an explosion of youth culture. Rock music in particular released the pent-up energy of young baby boomers in America and elsewhere. Fans of the Beatles and the Rolling Stones seemed to lose all inhibition in their presence. Images of these fans storming police barricades almost resemble the political riots of past revolutions.

The idea of teen culture likely originated in the 1920s, when American youth began throwing off the clothing, music, and Victorian customs of their parents. The flappers of the early Jazz Age were replaced by the bobby-soxers of the thirties and forties, swooning and often screaming in delight at the voice of Frank Sinatra or the clarinet of Artie Shaw. But the independence—the cultural "otherness"—of American youth dramatically intensified after World War II. As the fifties progressed, the middle-aged Americans that had experienced depression and war became increasingly conservative. The massive generation of children that would follow them, known in the United States as the baby boomers, grew up in vastly different circumstances of postwar prosperity and comfort. Cultural differences between the boomers and their parents would be fostered by advertisers and the media, leading to the popularization of a new term: "generation gap."

That gap would manifest itself most clearly in rock and roll, a music made possible by the modern electric guitar, developed in the forties and fifties. Rock was emotionally raw and often sexually explicit, a perfect combination for a growing teen movement. But rock and roll's popularity was also closely associated with image. Elvis's swaying hips and Jerry Lee Lewis's wild, acrobatic performance style became arousing symbols of the new culture, reproduced through fan magazines, television, and countless album covers. Rock had "turned up the volume" for America's youth, and that youth responded with a surge of pent-up energy.

By the early sixties, rock had also taken hold in Europe, especially in cities like Liverpool, Hamburg, and London. British bands like the Beatles and the Rolling Stones came from middle-class origins, but they developed their sound through the music of black America—the rhythm and blues of Muddy Waters and Howlin' Wolf. Appropriately, the Stones' very name came from a Muddy Waters hit. As the popularity of these bands took off in the UK, British record producers knew they needed to showcase their talent in the United States. In February 1964, the Beatles began the "British Invasion" in America—with a number one single in "I Want to Hold Your Hand" and a raucous concert appearance on the Ed Sullivan Show. The Rolling Stones would follow them in the summer of that year, creating pandemonium of their own at live concerts—highlighted by Mick Jagger's provocative, full-lipped gaze. The impact of these bands is best known from video clips of Ed Sullivan, the T.A.M.I. Show, and other performance venues. But still photos also capture the spirit of the time. One image depicts riotous Stones fans in New York City during the band's first concert tour in June 1964. The youthful, modestly dressed crowd—mostly girls—have been transformed into a surging mob, frantically trying to get past a police barricade and get as close as possible to their new heroes.

1950 Abolition of racial segregation
in the U.S.

1939–45 World War II

1937 Picasso's *Guernica*

1955 Beginning of
Pop Art

1965–75 Vietnam War

1986 Jeff Koons, *Rabbit*

1 John F. Kennedy sworn in
as president of the U.S.

1980 Ronald Reagan elected U.S. president

1998 Michel Houellebecq,
The Elementary Particles

1969 Woodstock Festival

1965 1970 1975 1980 1985 1990 1995 2000 2005 2010 2015

THE SILVER FACTORY

The Factory was Andy Warhol's "assembly line" of art. Here he produced his famous silkscreen portraits with industrial efficiency. The studio was also a den of experimentation, "lit" by the silver tinfoil that covered its ceilings and walls. Some of the best photos of the Silver Factory depict the surreal sets of Warhol's groundbreaking films.

Pop artists developed an entire visual language around the growing mass media. Their art used the media image as a source of inspiration. The ubiquitous print advertisement was lampooned by Richard Hamilton's collages; the comic strip was ironically reinterpreted by Roy Lichtenstein; and the hamburger and other icons of consumerism were recreated in plaster by Claes Oldenburg. But the most savvy, and the most exhaustive, assault on Western commercialism was undertaken by Andy Warhol.

Warhol set up his studio in 1962 in what was then a low-rent district on East 47th street in Manhattan. Here he would create his own commercial "factory" for art, producing many of his great "portraits" of Hollywood celebrities and Campbell's soup cans. The flattened, industrial appearance of his art reflected America's increasing dependence on the mass-produced image. Even the silkscreen printing technique that he used to produce the art was partially mechanized. Warhol's factory soon began creating silkscreen portraits for an ever-widening fashionable clientele. The studio also attracted a group of like-minded artists to promote Warhol's vision.

By the late sixties, Warhol's love of celebrity prompted him to direct his own films. These cinematic experiments expanded the aesthetic possibilities of the medium. They often focused on the subtle ways that film can capture movement and time. In *Sleep* (1963), poet John Giorno is shown slumbering for several hours. Other films incorporated New York's gay subculture and parodied traditional forms of American entertainment. In *Camp* (1965), Warhol used the variety show format—complete with a master of ceremonies—to showcase drag performers and the appearance of fellow underground filmmaker, Jack Smith.

Warhol's Factory was also one of the most heavily photographed art studios of all time. *Village Voice* staff photographer Fred McDarrah (1926–2007) captured the studio's filmmaking process. His images of the *Camp* set show off the Silver Factory's famous tinfoil walls and ceilings, as well as Warhol's eclectic mix of art objects—a disembodied pair of legs hanging from the ceiling and the artist's silkscreen cows plastered on the back wall. This surreal backdrop, as well as the casual attitude of the actors, offered a hip visual parody of the slick, highly produced studio photographs from Hollywood's "golden" age.

Filming of the movie *Camp*, directed by Andy Warhol, at Warhol's studio, the Factory, New York, October 30, 1965

1925–26 Walter Gropius, Bauhaus, Dessau

1949 Premiere of Arthur Miller's play
Death of a Salesman

1917 October Revolution in Russia

| 1910 | 1915 | 1920 | 1925 | 1930 | 1935 | 1940 | 1945 | 1950 | 1955 | 1960 |

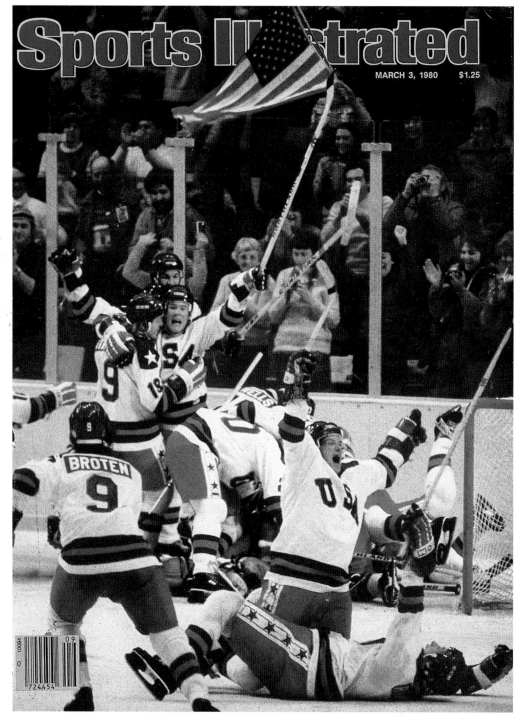

Sports Illustrated

MARCH 3, 1980 $1.25

2005 Founding of YouTube

1963 Assassination of John F. Kennedy 1974 Muhammad Ali regains world 1987 Black Monday (October 19) 1999 Columbine High 2010 Mass panic
 heavyweight boxing title sees markets crash worldwide School massacre at the
 Love Parade
 in Duisburg,
 Germany

1965 1970 1975 1980 1985 1990 1995 2000 2005 2010 2015

BRAZIL VS. USSR

International sport in the twentieth century became more than a showcase for the world's best athletes. It also became a battleground for cultural supremacy between East and West, and for reshaping relations between blacks and whites.

Success on the athletic field has often been used as a proxy for the political and cultural ascendancy of a nation. As early as the late 1800s, track and field contests between Great Britain and the United States—as well as Test cricket matches between Britain and Australia—had aroused patriotic fervor. But as the twentieth century progressed, improved international transportation and the growing mass media created a worldwide sporting culture. By the 1930s, the Olympic Games had become a showcase for promoting the values of Nazi Germany and capitalist America. Sport had also become an outlet for minority populations in the West to overcome deeply entrenched negative stereotypes. Images of sprinter Jesse Owens and baseball outfielder Jackie Robinson played a role in advancing the civil rights movement in the United States.

But beginning in the 1950s, the Cold War gave a new urgency to international sport. Just as the space race had helped define the technological state of affairs between East and West, athletic competitions offered ways to wage Cold War battles that fell short of military violence. For many Americans, the Soviet Olympic gymnasts and figure skaters were often the most visible representatives of their regime. Television cameras often portrayed the Russian athletes as frigid and expressionless, reinforcing the Western perception that Soviet leaders reduced their citizens to obedient automatons. Yet for both sides, the success of their own athletes could represent cultural and political progress. The rise of the Soviet national ice hockey team in the fifties, for example, was seen by Russians as a triumph of hard work and the "team-oriented" values of communism. In 1980, that same Soviet team would be characterized in the West as a vanquished bully, after they

were upset by the young U.S. Olympic squad. For many Americans, this victory symbolized the triumph of free-spirited college kids over a professional, state-sponsored juggernaut. Soon, however, the links between sport and politics would become toxic. Later in 1980, President Jimmy Carter would boycott the 1980 Summer Olympics in Moscow to protest the Soviet invasion of Afghanistan. This decision would lead to a retaliatory Soviet boycott in 1984, and to increasing skepticism about corruption within the Olympic movement.

But images of sport often transcend its negative associations. The "thrill of victory" can be captured with refreshing innocence, as in the image of toothless U.S. hockey players celebrating their victory in 1980. It can also reveal new possibilities for cooperation between people. The image of Brazilian star Pele heading a ball against the Soviet football team—from a friendly 1965 international match in Rio de Janeiro—suggests the potential for a world that has overcome racist attitudes and the often petty political struggles between nations.

March 3, 1980 Sports Illustrated cover, hockey: 1980 Winter Olympics, Team USA victorious with flag after winning game vs. USSR, Lake Placid, NY, February 22, 1980

following double page
Football match, Brazil vs. Russia, Rio de Janeiro, November 21, 1965

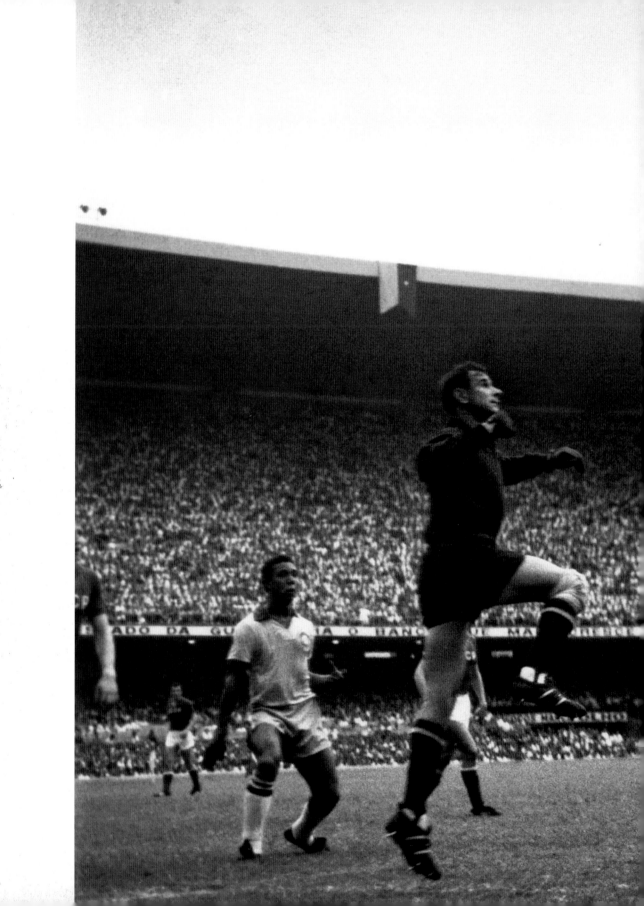

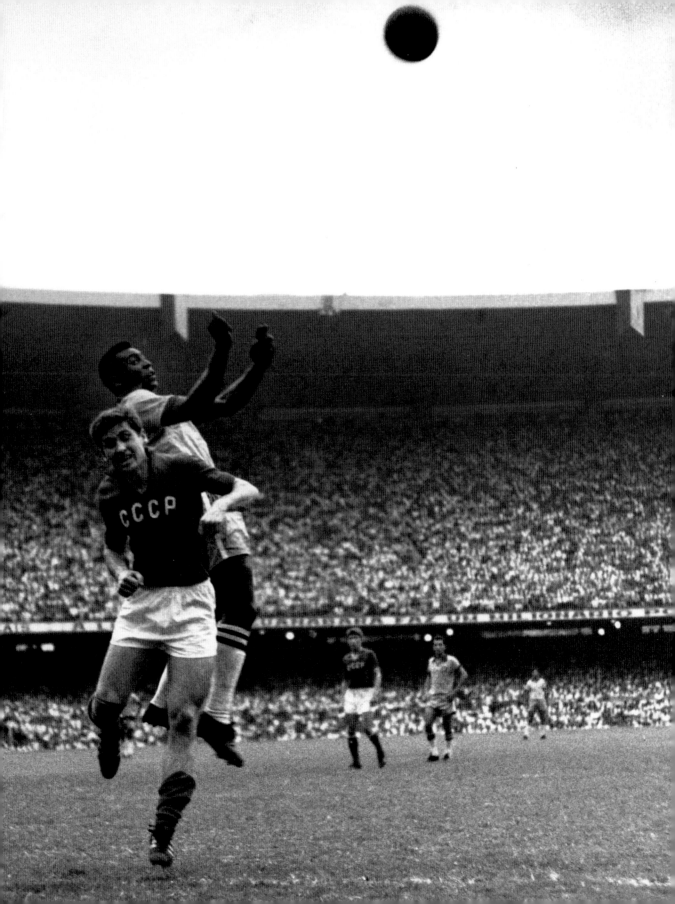

1910	1915	1920	1925	1930	1935	1940	1945	1950	1955	1960

1989 Fall of the Berlin Wall

1968 Student revolts

2001 Terrorist attacks on World Trade Center (9/11)

1994 End of apartheid in South Africa

1993 Nelson Mandela and F. W. de Klerk awarded Nobel Peace Prize

2009 Barack Obama becomes first African American U.S. president

| 1965 | 1970 | 1975 | 1980 | 1985 | 1990 | 1995 | 2000 | 2005 | 2010 | 2015 |

NELSON MANDELA AT ROBBEN ISLAND

For twenty-seven years, Nelson Mandela was arguably the most famous prisoner in the world. Jailed in 1962, Mandela was a mostly invisible source of inspiration for reformers in apartheid South Africa. Thus his official "reappearance" in 1990, after being released from prison, became one of the most celebrated images of the twentieth century.

In assessing his own character, Nelson Mandela once said, "I am fundamentally an optimist. Whether that comes from nature or nurture, I cannot say. Part of being optimistic is keeping one's head pointed toward the sun, one's feet moving forward. There were many dark moments when my faith in humanity was sorely tested, but I would not and could not give myself up to despair." Whether buoyed through positive thinking or other means, Mandela's life has been one of impressive endurance. Few could survive both a twenty-seven-year prison sentence—in some of the world's most repressive jails—and a five-year term as president of a newly constructed nation.

Nelson Rolihlahla Mandela was born in 1918 into a royal family of the Xhosa-speaking Thembu people. His great-grandfather, Ngubengcuka, ruled as Thembu king in the early 1800s. Like Gandhi before him, the young Mandela used his skills as a lawyer to fight for the political rights of South Africa's minorities. These activities increased after the National Party came to power in 1948 and began creating the legal framework for apartheid. After being tried and acquitted for treason in the 1950s, Mandela began resorting to more militant techniques. In 1961, he headed the newly formed "Umkhonto we Sizwe" (or "MK") branch of his party, the African National Congress (ANC). The violent methods espoused by this branch led to Mandela's arrest and eventual conviction to life imprisonment in 1964.

Mandela would spend the next eighteen years at Robben Island, a prison off the coast of Cape Town, where he was assigned to hard labor. Few pictures of Mandela exist from those years. One authentic snapshot was probably smuggled out of the island in the mid-sixties. It shows a weary Mandela in ill-fitting clothes mending a shirt.

The image reveals the anonymity that most prisoners face. Mandela had become a person stripped of his clothes, family, and reputation.

Yet the ANC leader's silent presence at Robben Island helped enhance his stature outside the prison's walls. Mandela became, in absentia, the leading representative of the struggle for black freedom in South Africa. By the eighties, South Africa's government and economy were weakening, and Mandela was moved from Robben Island to mainland prisons, first Pollsmoor and then Victor Verster. But Mandela was also beginning to meet openly with the National Party. Finally, in 1989, the pro-apartheid South African president P. W. Botha was forced to step down from office, and his successor F. W. de Klerk began the negotiation processes that ended apartheid and released Mandela from prison. February 11, 1990 saw the end of Mandela's long separation from his people, as he was shown leaving prison with a defiantly raised fist. The many years of captivity had not destroyed the health or spirit of the seventy-one-year-old leader. These joyous images would help launch Mandela's successful election as South Africa's first truly democratic president.

Nelson Mandela mending clothes at Robben Island, 1966

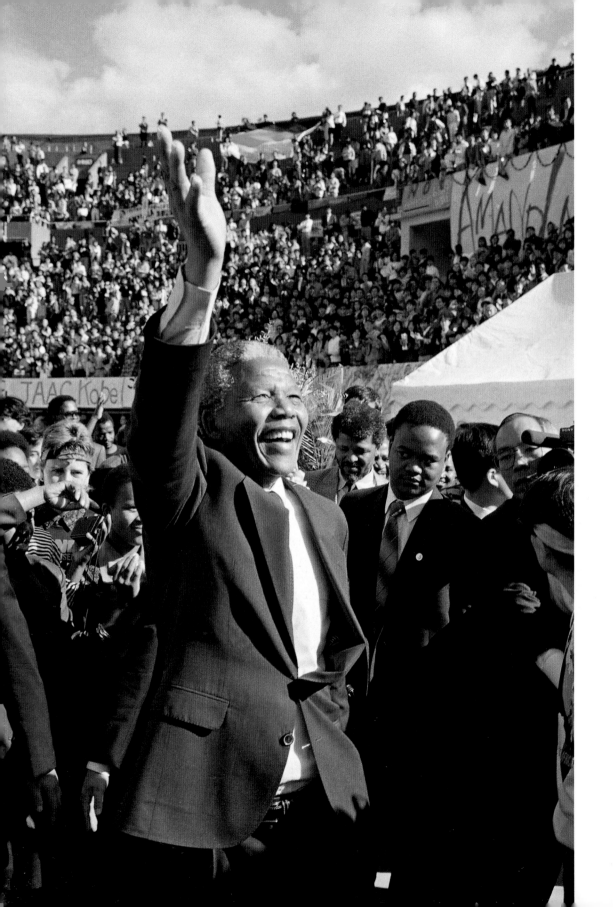

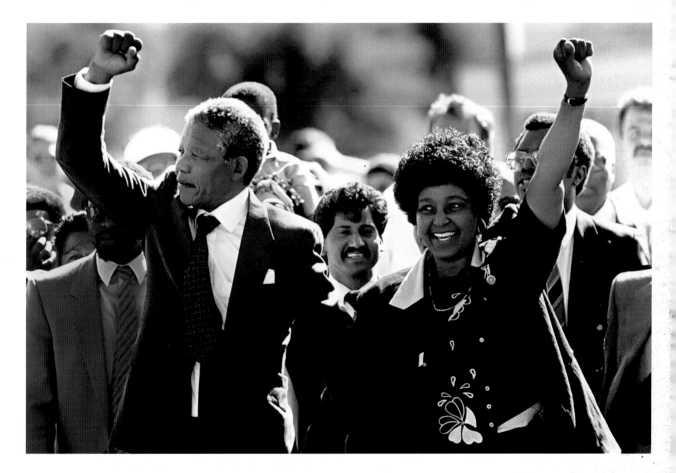

left page
Nelson Mandela at Osaka's Ogishima Park in Western Japan, October 28, 1990

above
Nelson Mandela's release from prison, Cape Town, South Africa, February 11, 1990

104 | 105

1928 Andy Warhol is born

1955–68 Civil rights movement
in the U.S.

1949 North Atlantic Treaty Organization
(NATO) is founded

| 1915 | 1920 | 1925 | 1930 | 1935 | 1940 | 1945 | 1950 | 1955 | 1960 | 1965 |

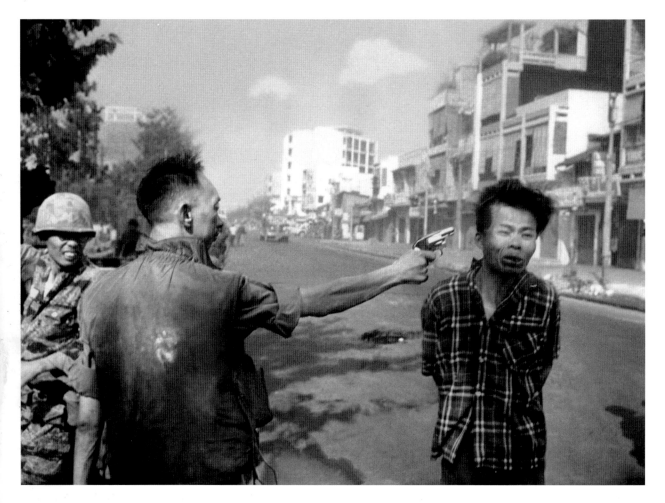

Eddie Adams, Execution in Saigon, 1968

5–75 Vietnam War 1980 John Lennon shot 1989 Massacre in Tiananmen Square 2004 Reports leak of torture at
 in China Abu Ghraib prison
1968 Assassination of 2001 Terrorist attacks on World 2011 Osama bin Laden is killed in
 Martin Luther King Trade Center (9/11) Abbottabad, Pakistan

1970 1975 1980 1985 1990 1995 2000 2005 2010 2015 2020

EXECUTION IN SAIGON

As British photographers had done in the Crimea more than a century earlier, American photojournalists in Vietnam captured the realities of war with unprecedented directness. Their images helped dramatically reshape public opinion about the war, and of America's place in the post-World War II world.

President John F. Kennedy's 1961 inaugural address had charged Americans to "ask what you can do for your country." Kennedy's call for government service had been an appealing one for many young Americans. It helped promote enthusiasm toward the fight for civil rights and the goals of scientific and space exploration. But by the end of the decade, tragic events had shattered such optimism. President Kennedy was assassinated in 1963, and was followed in 1968 by the killings of civil rights leader Martin Luther King, Jr., and JFK's brother and 1968 presidential candidate Robert Kennedy. The violence at home was complimented by military adventures abroad, as American leaders sought to stem the growth of communism in Asia through the Vietnam War. But the folly of this effort would soon be revealed in dramatic images and war reporting.

Even before the sixties, the U.S. military had experienced Cold War failures in Asia. The bloody Korean War (1950–53) had failed to prevent the establishment of North Korea—an East Asian Soviet satellite. Communism had also spread to China under the leadership of Mao Zedong. But these setbacks did not prevent U.S. leaders from tracking communist uprisings in a remote corner of French Indochina. By 1955, after a drawn-out war with French forces, the Communist state of North Vietnam declared independence. To the south, a Western-backed government controlled the Republic of Vietnam, or South Vietnam. The French military had tried and failed to quash the army of North Vietnam, and the Kennedy Administration quietly began to intervene in the early sixties. America's military role in Vietnam would grow decidedly over the decade. By 1968, the United States had approximately half a million personnel in the country. Yet despite the slow progress of the war, the U.S. govern-

ment and general public believed that the conflict would be won. The diminutive North Vietnamese army, they argued, couldn't stand up against American troops and their allies.

But the 1968 Tet Offensive changed public opinion drastically. On January 31, during the Tet holiday (the Vietnamese New Year), a force of more than 80,000 troops attacked dozens of cities, taking the U.S. army by surprise. The offensive was soon turned back, but the strength of the attacks frightened many Americans. North Vietnam was suddenly seen as a more formidable presence, and opposition to the war increased. Imagery from that time also proved decisive in shaping the public backlash. Photographers and television crews were being given unprecedented access to the front lines, and they used this freedom to capture images of startling ferocity. One day after the Tet offensive began, photojournalist Eddie Adams (1933–2004) captured a South Vietnamese police chief shooting a suspected North Vietnamese officer in the head. The savage picture repelled Americans back home, many of whom now felt the war should be left to the Vietnamese themselves. Adams' would later receive the Pulitzer Prize for his work.

The growing quagmire of Vietnam would lead to the withdrawal of President Lyndon Johnson from the 1968 presidential race. Ultimately, the U.S. military would be forced to leave Vietnam and accede to a North Vietnamese victory. Some of the final images from the war were the most dramatic. In 1975, the last remaining U.S. troops were whisked away from Saigon in helicopters—with South Vietnamese citizens desperately trying to climb on board to avoid their fate at the hands of advancing North Vietnamese troops. America, it seemed, had failed the people it had tried to protect.

1939–45 World War II | 1949 People's Republic of China is founded by Mao Zedong | 1959 China annexes Tibet

1915 1920 1925 1930 1935 1940 1945 1950 1955 1960 1965

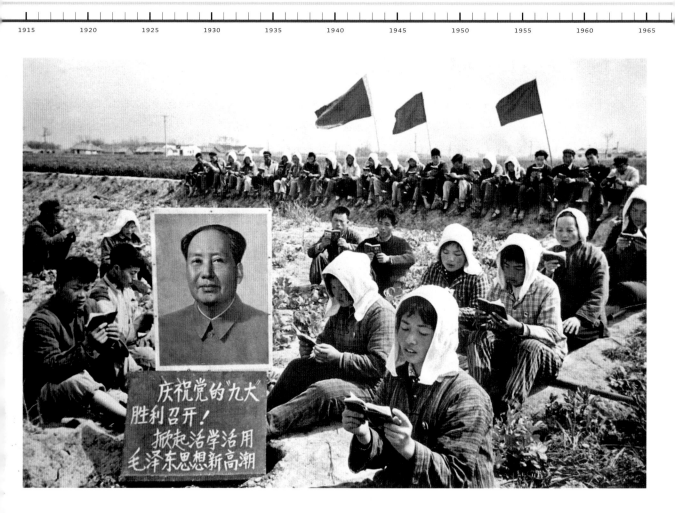

Cultural Revolution in China, Chinese official news agency Picture, 1969

1986 *Challenger* space shuttle disaster

1973 Watergate scandal

1988 Freeze, exhibition of Young
British Artists in London

2008 Summer Olympics in
Beijing, China

1969 Woodstock Festival

1983 Discovery of the AIDS virus, HIV

2011 Chinese Artist Ai Weiwei
is arrested

| 1970 | 1975 | 1980 | 1985 | 1990 | 1995 | 2000 | 2005 | 2010 | 2015 | 2020 |

THE CULTURAL REVOLUTION

The Chinese Cultural Revolution was based in part around the "cult" of the image. Photos of Mao Zedong became holy icons in China. Images of peasants cheerfully following Mao's directives seemed the ideal propaganda for a nation on the front lines of the Cold War.

The Communist Party of China (CPC) was founded in 1921. One of its earliest members, Mao Zedong, would wage a long and violent struggle toward making China a Communist state. His forces were involved in the Chinese Civil War, which began in the late twenties and would weaken the newly formed Republic of China. Subsequent invasions by the Japanese failed to unify the communist and nationalist Chinese factions, and the end of World War II saw the newly liberated Chinese government in a vulnerable position. Mao's superior organizational skills and harsh military tactics forced the nationalists out. China was now a Maoist People's Republic.

Mao quickly consolidated his leadership by killing or sending to labor camps millions of small-business owners and rural landholders. Private ownership of farms and industries passed to government hands through collectivization, and political dissent was violently suppressed. Soviet-style five-year plans rapidly industrialized a formerly rural nation. Yet these gains were compromised by the great famine of the late fifties and early sixties, which wiped out tens of millions. In short, Mao had become a Chinese version of Joseph Stalin, a leader willing to sacrifice his own people for often questionable goals.

Mao also resembled Stalin in the way he used imagery to promote his regime, especially during the Cultural Revolution (1966–76). The overt purpose of this plan was to spread the values of Maoist "culture" to a greater variety of Chinese citizens. Mao's "Little Red Book," a collection of "inspirational" quotes from the Republic's founding father, was published in 1966 and widely distributed. Also distributed was the now iconic photograph of Mao, which became a ubiquitous decoration in Chinese homes. Other propaganda photos showed how the government wanted their "revolution" to be carried out. One image from 1969 shows a Mao portrait "overseeing" a group of rural peasants, who cheerfully read the Little Red Book. A quotation under the portrait reads, "Celebrating the Party's victorious opening of the ninth Congress! Let's stir up the studying and application of Mao talk to a new climax."

Ironically, the year 1969 would mark the beginning of China's move toward greater economic and cultural openness with the West. Negotiations for a visit between U.S. and Chinese government leaders were initiated that year, leading to President Richard Nixon's historic visit to Beijing in 1972. The fate of the Cultural Revolution—and Mao's legacy—was already doomed.

1930	1935	1940	1945	1950	1955	1960	1965	1970	1975	1980

Young boy pointing a toy gun at a caricature of Jimmy Carter at a demonstration during the days of the Iranian Revolution, 1979

980–88 Iran-Iraq-War

9 Saddam Hussein becomes president of Iraq

1990–91 Persian Gulf War

2001 Terrorist attacks on World Trade Center (9/11)

2006 Saddam Hussein condemned to death

| 1985 | 1990 | 1995 | 2000 | 2005 | 2010 | 2015 | 2020 | 2025 | 2030 | 2035 |

IRANIAN REVOLUTION

Thirty years after Gandhi's nonviolent victory over the British in India, a new "holy man" waged his own battle with the West. Like Gandhi, the Ayatollah Khomeini employed a carefully built personal image to help transform Iran. But Khomeini was not above using violent measures to achieve his aims, both during the Iranian revolution and after.

Western powers have long had a turbulent relationship with Iran. During the nineteenth century, the British and Russians fought for influence there, largely over the control of trade routes into and out of the Persian Gulf. But in the twentieth century, the country's growing oil industry dramatically increased Western involvement in Iran. After World War II, nationalist prime minister Mohammed Mossadegh placed Iran's oil reserves under government control and exiled the pro-Western Shah Mohammed Reza Pahlavi. But Mossadegh was ousted in a coup led by the American Central Intelligence Agency and by British intelligence. With the Shah now in power again as a Western puppet, Iran's nationalists and conservative clerics began to foment unrest. Out of this climate arose Ruhollah Khomeini, a clerical leader who sought to end Western meddling in his country and to strengthen Iran's Muslim heritage.

As an Ayatollah, Khomeini had extensive training in political science as well as theology, and he was respected for his political opinions. Khomeini first achieved prominence in the early sixties, when he denounced the Shah's plans to promote capitalist interests in Iran and to give women the right to vote. Fearing Khomeini's growing influence, the Shah's government forced him into exile in Iraq for many years. There he became the leading opponent of the Pahlavis, and he developed his own ideas for running Iran as a theocracy under Islamic Sharia law.

Throughout the seventies, the Shah's inept handling of Iran's economy led to high inflation and widespread unemployment. His close ties to the West; his secular, extravagant lifestyle; and his often brutal suppression of political dissent further destabilized his rule. By January 1979, the Shah had lost the support of his government and was forced to leave the country. In Pahlavi's wake, Ayatollah Khomeini could now return to Iran in victory. Millions lined his route from the Tehran airport to the city center. Khomeini soon put his political ideas into practice, establishing Iran as an Islamic state with himself as *faqih*, or supreme leader.

In photos taken during his triumphant return, Khomeini is seen as an odd mixture of holy man and severe politician. A sea of hands reaches out toward him, as if hoping to be "healed" by his presence. Yet Khomeini greets them with severe restraint, a stern father figure who has come restore the "values" of a wayward nation. These images would signal the end of Iran's traditional relationship with the West. Khomeini would oversee a hostage crisis that broke diplomatic ties with the United States, and he would lead Iran in a bloody war against Iraq. Yet the Ayatollah never truly lost the support of his people, and the theocratic state he established has long survived his death. Today, Khomeini's mausoleum is a major place of pilgrimage in Iran.

110 | 111

1938 Nuclear fission discovered by Otto Hahn and Fritz Strassmann

1954 First commercial nuclear power plant in Obninsk near Moscow

1969 Woodstock Festival

1965 Beginning of the Vietnam War

1973 First oil crisis

1930 1935 1940 1945 1950 1955 1960 1965 1970 1975 1980

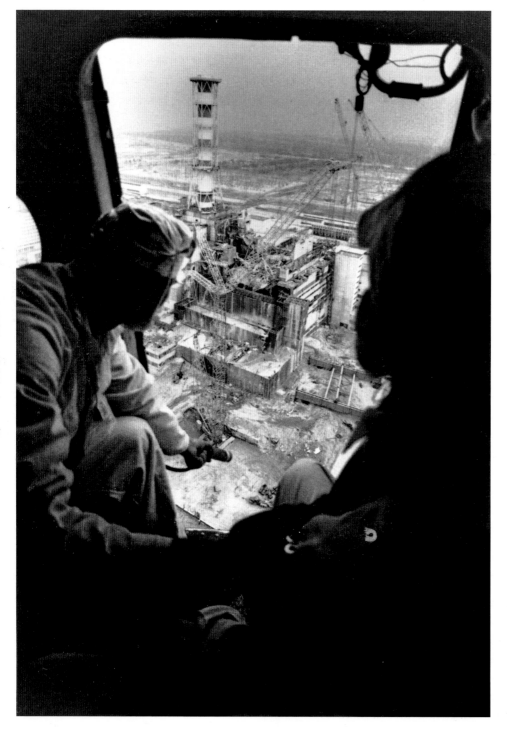

Nuclear Disaster in Chernobyl, Ukraine, April/May 1986

CHERNOBYL

The Chernobyl nuclear disaster of 1986, which slowly claimed the lives of thousands in the Ukraine, Belarus, and Russia, exposed the weakness of a secretive government. The Soviet Union would dissolve only five years after the disaster. But images from Chernobyl continue to raise questions about the viability of nuclear power.

By the 1980s, the Soviet Union had been in a slow, steady decline. Political oppression, a stagnant economy, and the lack of mobility for most Soviet citizens had stunted the country's growth. In 1985, the new party leader, Mikhail Gorbachev, would initiate reforms designed to salvage a failing state. Gorbachev's famous speech in February 1986 introduced the concepts of *glasnost*, or greater "openness" with its own people, and *perestroika*, or the "restructuring" of the Soviet government and economy. The urgency of these plans would become painfully clear in April of that year at a nuclear power plant in the Ukrainian Soviet Socialist Republic.

The V. I. Lenin nuclear power station had been built eighteen kilometers (eleven miles) northwest of Chernobyl in the seventies and early eighties. It contained two pairs of RBMK-1000 reactors, which could produce 1,000 megawatts of power. In April 1986, operators at the plant shut down the reactors' emergency cooling systems for a maintenance test, assessing whether the reactor cores could be cooled efficiently during a power loss. Lack of proper communication and faulty testing procedures caused explosions that destroyed the core of reactor four, and plumes of radioactive smoke were emitted into the atmosphere. Winds carried the toxic haze across large areas of the Ukraine, Russia, and Belarus.

News of the accident was not released by the Kremlin until more than two days after the explosion. Moscow might have suppressed the news even longer had not fallout from the disaster raised radioactivity levels at the Forsmark nuclear power plant in Sweden, 1,100 kilometers (680 miles) away. Twelve hours after Forsmark alerted worldwide authorities of the danger, the Soviet government was forced to admit the Chernobyl embarrassment. The city of Prypiat, a town of about 50,000 that had been created specifically to house Chernobyl employees, was finally evacuated. A new worker's city called Slavutych was hastily constructed to replace the contaminated older town. But many of the residents who moved there—as well as the military personnel enlisted to clean up the Chernobyl site—would die of thyroid cancer and other exposure-related illnesses. The true death count, however, will likely never be known.

As with many industrial disasters, aerial photographs of Chernobyl after the explosion dramatically captured the plant's blackened concrete walls and collapsed roof structures. In one such image, we witness the scene from a helicopter alongside brave engineers in action, armed with a Geiger counter to measure radiation levels. But some of the most evocative photos of Chernobyl were taken years later, in 1990, and don't show the power plant at all. Instead, they focus on the disaster's human legacy. A series of images capture the ghost town of Prypiat. An abandoned amusement park in the town, with its skeleton-like merry-go-round and bumper cars, powerfully evokes memories of death and decay—as well as government deception.

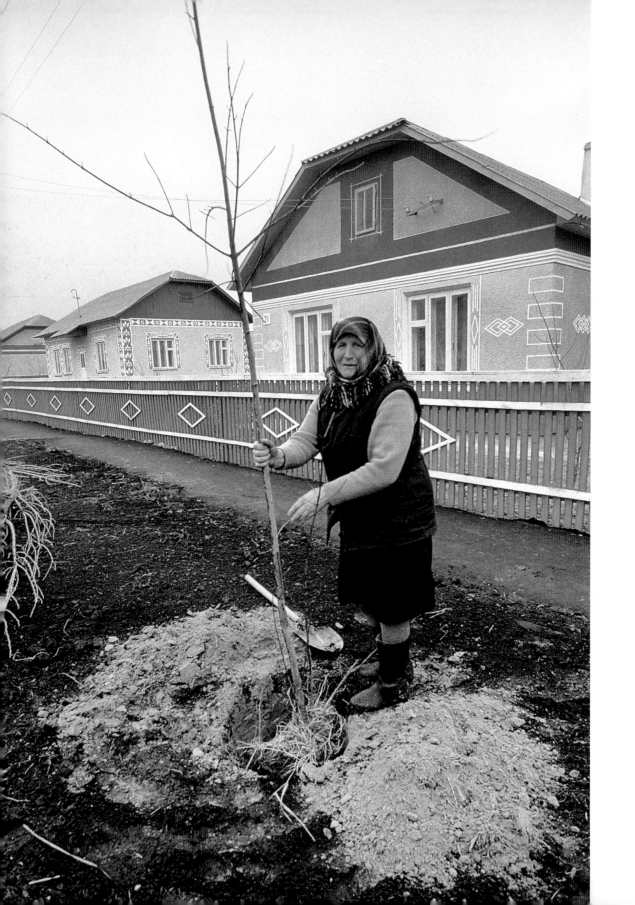

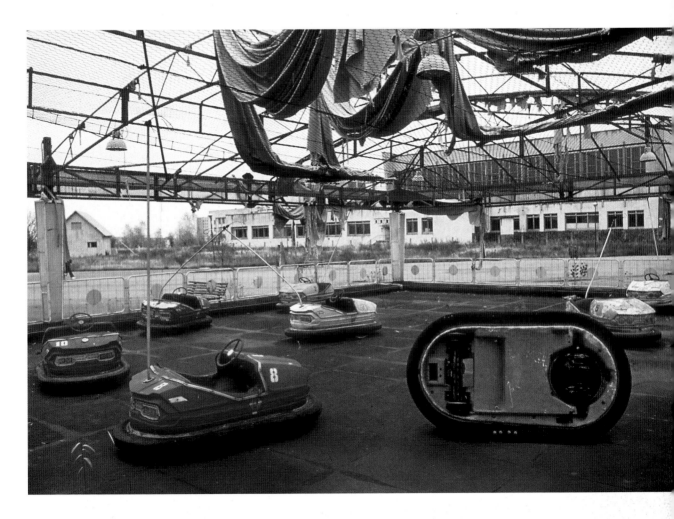

left page
Woman planting a tree at her new home after the Chernobyl explosion,
September 1, 1986

above
Decaying amusement park rides stand in mute testimony in city abandoned
after the Chernobyl nuclear plant accident, November 1990

1930	1935	1940	1945	1950	1955	1960	1965	1970	1975	1980

Exxon Valdez Oil Spill, Alaska, March 1989

2001 Terrorist attacks on World Trade
Center (9/11)

32 Lebanon War **1995** Christo and Jeanne-Claude **2010** Disastrous oil leak in
 wrap the Reichstag, Berlin the Gulf of Mexico

 1986 Chernobyl disaster

| 1985 | 1990 | 1995 | 2000 | 2005 | 2010 | 2015 | 2020 | 2025 | 2030 | 2035 |

EXXON VALDEZ OIL SPILL

Few environmental disasters are as tragically "photogenic" as the oil spill. Aerial images of the spreading crude can resemble an ominous cloak, a devilish reminder of industrial carelessness. The 1989 Exxon Valdez disaster, which occurred on Alaska's pristine southern coast, was one of the first spills to be extensively documented.

Prince William Sound winds through a region of fjords, forests, and biological abundance. The surrounding Chugach National Forest and Kenai National Wildlife Refuge provide homes for bear, moose, mountain goats, wolves, killer whales, harbor seals, and countless migratory birds. Decades before Alaska's official statehood, the United States federal government took an interest in the area. In 1907, President Theodore Roosevelt created the original Chugach National Forest. During the 1970s, the oil crisis again focused federal attention on the sound, when the government stepped up its effort to harvest American sources of petroleum.

The 1,300-kilometer- (800-mile-) long trans-Alaska pipeline, completed in 1977, would terminate at the port of Valdez. Prince William Sound had become a shipping center. The population of Valdez increased more than six-fold from 1974 to 1976, and many local residents suddenly became wealthy. Yet with a growing fleet of oil tankers now traveling in and out the area regularly, Prince William's narrow, ecologically delicate waters became increasingly vulnerable. On March 24, 1989, the oil tanker Exxon Valdez ran aground on Bligh Reef, a traditional fishing area in the sound that lies off Bligh Island. The accident ruptured the ship's oil tanks, and over the next several days millions of gallons of oil spilled into the gulf and spread over hundreds of miles of Alaska coastline. Until the 2010 Deepwater Horizon oil spill in the Gulf of Mexico, this disaster was the largest spill ever recorded in the United States.

But damage calculations from the spill could not match the emotional impact of photographs. Aerial shots of the beached tanker captured the spreading veil of petroleum— which turned the sound's formerly pristine water surface

into dull shades or gray and brown. Other images featured oil-soaked harbor seals, bald eagles, and red-necked grebes. Overall, the tragedy caused the death of 250,000 sea birds and thousands of local mammals. These creatures perished not only from direct contact with the oil, but also from eating contaminated salmon and other prey species.

With its corporate image severely threatened, Exxon financed the $2.1 billion cleanup of the area over the next four years. Yet the magnitude of the spill, and the narrow, enclosed nature of the sound, meant that much of the oil spread quickly onto land. It would soon find its way into the soil, under rocks, and in many places where the original cleanup crews didn't go. Much toxic oil remains in the area, continuing to threaten wildlife. And though the overall health of the sound's ecosystem has improved, the world-wide reliance on oil continues, putting Alaska, the Gulf of Mexico, and other oil-rich areas of the world under ecological threat.

A pigeon guillemot sits covered with oil from an offshore spill on the shore of Prince William Sound, Alaska

1948–49 Berlin Airlift · · · · · · · 1962 Cuban Missile Crisis · · · · · · · 1977 Walter De Ma
 The Lightning
1945 Beginning of Cold War · · · · · · 1955–68 Civil rights movement near Quemad
 in the U.S. New Mexico

1930	1935	1940	1945	1950	1955	1960	1965	1970	1975	1980

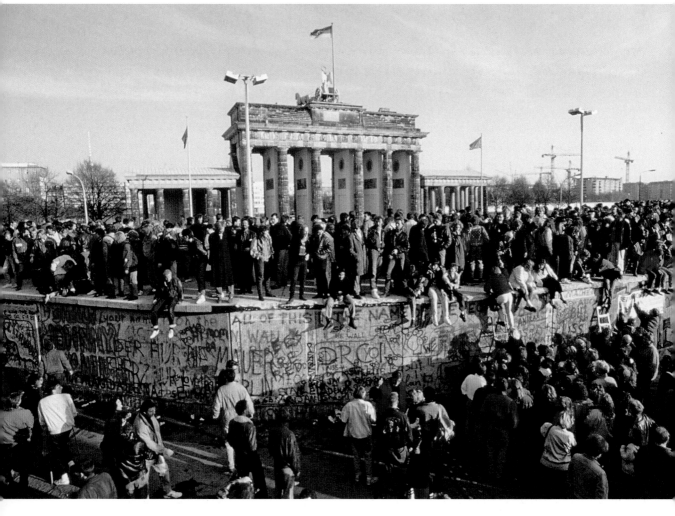

Crowds at the Brandenburg Gate bear witness to the fall of the Berlin Wall,
November 10, 1989

1996 First cloned mammal: Dolly the Sheep

81 First space shuttle,
Columbia

1995–99 Herzog & de Meuron,
Tate Modern, Bankside, London

2006 Florian Henckel von Donnersmarck,
The Lives of Others

1985 1990 1995 2000 2005 2010 2015 2020 2025 2030 2035

FALL OF THE BERLIN WALL

A physical embodiment of the Cold War, the Berlin Wall came to a virtual end on November 9, 1989. The sight of hundreds of East and West Berliners meeting on top of the wall signaled the beginning of a new Germany. Soon, other postwar divisions between East and West would be healed or redefined.

With the creation of an East and West Germany after World War II, an Innerdeutsche Grenze, or Inner German Border, was established. This border came to mark the most significant section of the "Iron Curtain." Yet control of the border was only achieved gradually. For several years after the war, the fences and check posts of the Innerdeutsche Grenze were primitively constructed, lightly guarded, and easy to cross. This enabled East German residents, who feared the growing autocratic power of Stalinist Russia, to immigrate to the West in large numbers. But in 1952, the East German government—under orders from Moscow— began to strengthen and militarize its borders. Soon the area was lined with barbed wire fences, watchtowers, and armed guards. For much of the fifties, the safest route to freedom for East Germans was through the city of Berlin, where the capitalist enclave of West Berlin provided a tiny escape hatch into Western Europe. But by 1961, even this route was closed with the construction of the formidable Berlin Wall.

The wall became a truly "concrete" reminder of the painful relationship between Cold War rivals. Attempted crossings of the wall by East Germans often ended in tragedy. For many Westerners, however, the barrier also became a tourist destination. Eager foreign students would cross the wall through Checkpoint Charlie, "exchange" their money for East German currency, and experience the "exotic" communist world for a day or a weekend. But by the 1980s, gradual economic and social deterioration in the Soviet Bloc led to greater independence among East European nations. In the summer of 1989, the borders between Hungary and Austria were loosened, allowing for mobility across that portion of the Iron Curtain. In October,

East German leader Erich Honecker resigned, leading to the opening of the Berlin wall on November 9th.

At 10:45 p.m. the guards opened the checkpoints, and people were allowed for the first time to cross without showing identification. Huge crowds of ecstatic East Berliners streamed through the gates, many ending up on top of the wall for a long-awaited reunion with the West. Photographers captured the elation of the city-wide party, which would last all night long and into the next day. Images of the throngs on top of the wall often included the Brandenburg Gate, which still had East German and Soviet flags next to it. But the great nineteenth-century Neoclassical monument had again become a symbol of unity for all Germans. Over the coming months, parts of the wall would be torn down by hundreds of locals, tourists, and souvenir seekers—many of whom had traveled from other parts of Europe to get a "piece of history." The events of 1989 would lead inexorably to Germany's reunification in 1990. Today, Checkpoint Charlie has been moved to the Allied Museum as part of an open-air exhibit. It remains a magnet for most tourists who visit Berlin.

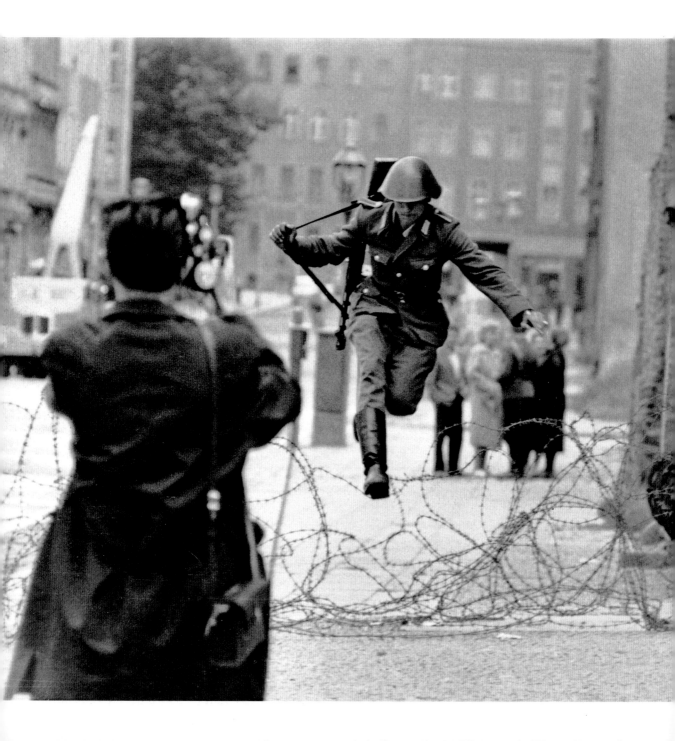

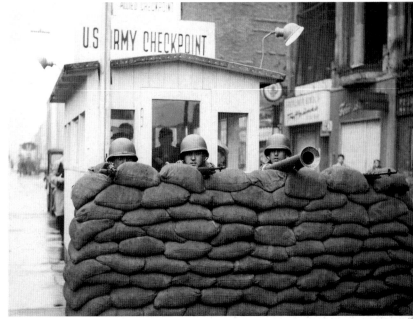

left page
Peter Leibing, Jump into Freedom, 1961
© Peter Leibing, Hamburg

above
U.S. Soldiers sheltered behind sandbags at Checkpoint Charlie, December 4, 1961

1952 Elvis Presley hits the headlines

1945 End of World War II

1973 Watergate scandal

1963 Assassination of John F. Kennedy

1930 1935 1940 1945 1950 1955 1960 1965 1970 1975 1980

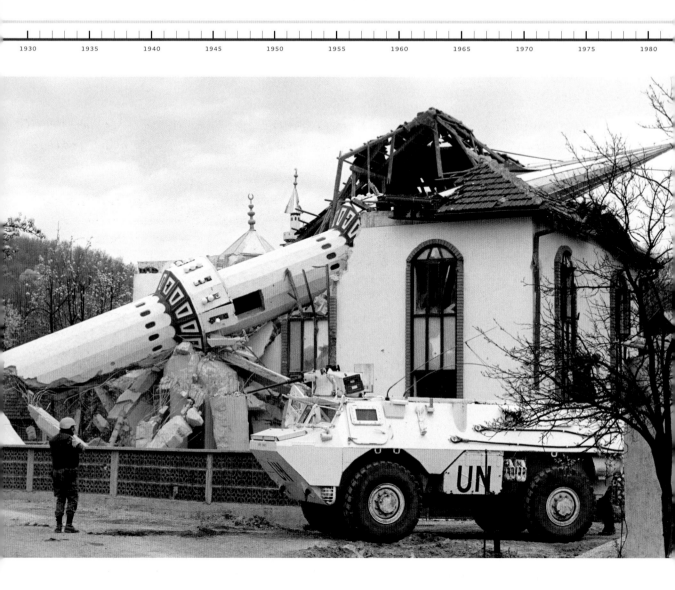

French troops of the United Nations patrol in front of the destroyed mosque of Ahinici,
northwest of Sarajevo, April 27, 1993

BOSNIAN WAR

The Bosnian War combined ancient ethnic conflicts with late twentieth-century weaponry and guerrilla tactics. Much of the worst damage was aimed at places of cultural heritage. Photos of gutted mosques, bombed medieval walls, and ruined Ottoman bridges revealed the fragmentation of a culturally diverse land.

The complicated history of the Balkans stems from its location at the crossroads of ancient empires. The Venetians and Austrians helped shape the Catholic culture of the Croats and Slovenes, the Ottomans established Islam in Bosnia, and the Serbians held on to an Orthodox Christian tradition that they inherited from the ancient Byzantine Empire. After World War I, all of these diverse peoples ended up thrown together in a cultural blender known as Yugoslavia. But their sharp differences in religion and custom, combined with a relatively backward economy, made peaceful coexistence difficult.

World War II saw the Croats collaborate with Nazi Germany and Fascist Italy. An "Independent State of Croatia" was created, in which Croats severely persecuted their Serbian neighbors. After the defeat of the Axis powers, the broken Yugoslav nation was reorganized into a Soviet-style federation of republics, which remained relatively stable under the strong leadership of Marshal Josip Tito. Among the nations of the Soviet bloc, Yugoslavia gained an unusual level of independence from Moscow. But ethnic tensions in Yugoslavia never went away entirely. When Tito died in 1980, Yugoslavia's economy was weak, and the long-standing distrust between Serbs, Croats, and Bosniaks (Bosnian Muslims) bubbled up to the surface.

By 1991, attempts to keep Yugoslavia together as a loosely tied confederation had failed. In June of that year, Slovenia and Croatia declared their independence. This set off a series of bloody wars, primarily the Croatian War of Independence (1991–95) and the Bosnian War (1992–95). The Croatian War was in some ways a continuation of the struggles between Croats and Serbs during World War II. Both sides committed atrocities against the other, but some of the most memorable wartime images involved attacks against historic Croatian cities. The medieval town of Dubrovnik, one of the most beautiful on the Adriatic coast, was shelled by Serbian forces. News reporters filmed the city's ancient walls under fire, a scene that resembled centuries-old illustrations of siege warfare.

The Bosnian War produced even more devastating imagery. Bosnia-Herzegovina was the most heterogeneous of all Yugoslav states. Bosniak, Serb, and Croat populations were spread throughout the region, often living side by side. When the state declared its independence in 1992, minority Serb communities began a war against the Croats and Bosniaks. Soon all three groups were fighting one another, often attempting to kill or expel rival communities in certain areas—a practice that helped popularize the term "ethnic cleansing." As with the Croatian struggle, Bosnian War activities involved targeting places of cultural heritage. The famous sixteenth-century bridge at Mostar, one of the finest achievements of Ottoman civil architecture, was destroyed by Croat forces in November 1993. Crumbling Bosnian mosques were depicted in news photos, one of which featured a broken minaret piercing through the mosque roof, like a guided missile. These images not only shocked people in the West, they also galvanized extremist elements in the Muslim world—possibly playing a role in 9/11 and other subsequent terrorist acts. In the new millennium, however, the Mostar bridge has been rebuilt, and the former republics of Yugoslavia are making slow, painful steps toward healing the wounds inflicted during the 1990s.

1963 Roy Lichtenstein, *Whaam!*

1959 First happening by Allan Kaprow
in New York

1973 First oil crisis

1930 1935 1940 1945 1950 1955 1960 1965 1970 1975 1980

Colored scanning electron micrograph (SEM) of red blood cells clumped together
with fibrin to form a blood clot

BLOOD CLOT

Scientists have created new ways of seeing and capturing nature that expand the definition of photography. The scanning electron microscope, for example, uses electrons rather than light to produce images of the microscopic world. These fantastically detailed "micrographs" give people a new connection to their own bodies.

Technical advances in photography have often coincided with other improvements in scientific knowledge. During the 1830s, when Louis Daguerre and Henry Fox Talbot were conducting experiments in "sun writing," Charles Darwin was traveling to the Galapagos Islands and formulating his explosive theory of natural selection. Fox Talbot himself was a scientist, and his earliest "photographs" depict the minute details of plant leaves.

As photography became more sophisticated in the nineteenth century, scientists began combining the camera and the microscope. In 1893, German scientist August Köhler created a method of viewing microscopic images that was free from glare or other visual distortion. His method, called Köhler illumination, also yielded higher quality photos of these images. Such photographs came to be known as photomicrographs, or micrographs. Later refinements to microscopy would produce even more remarkable images. The electron microscope, developed in the 1930s, did not use natural light to view an image. Instead, it employed a beam of charged atomic particles called electrons to "illuminate" the microscopic world. Because electrons have shorter wavelengths than visible light, they can resolve cells and other features far more clearly than light can. Thus, scientists could now "see the invisible" with unprecedented detail and depth.

Scientists could also use the electron microscope to produce stunningly detailed micrographs, either by using cameras or by scanning the images onto a computer screen. Electron micrographs reveal the cellular world as a strange landscape, as unusual as the most exotic travel photos. Medical researchers can use these images to better understand the progression of disease and to better develop disease treatments. But the pictures are also employed to educate people about the human body. Sometimes the truths revealed by micrographs are a bit unnerving. Images of microscopic mites and other skin-borne animals are shown in all their frightening detail—multi-legged creatures that resemble the monsters of science fiction. Other electron micrographs illustrate details about how the body works. British photographer and scientist Steve Gschmeissner, who produced numerous prize-winning micrographs in the 2000s, captured several stunning images of blood clots. In his surreal creations, the red blood cells resemble a mass of bright-red cinnamon candies caught in a mesh of spaghetti-like fibrin protein. Gschmeissner has also captured micrographs of the immune system's white blood cells, with their puffy, globular bodies looking like sea urchins or children's squeeze toys.

1930 1935 1940 1945 1950 1955 1960 1965 1970 1975 1980

Andreas Gursky, Ocean V, 2010

82 Michael Jackson
releases *Thriller*

1995 Founding of the World Trade
Organization (WTO)

2003 Human genome decoded

2010 Picasso's *Nu au plateau de sculpteur*
fetches $106.48m at Christie's

| | | | | | | | | | | |
1985 1990 1995 2000 2005 2010 2015 2020 2025 2030 2035

ANDREAS GURSKY AND DIGITAL PHOTOGRAPHIC ART

Andreas Gursky creates art that challenges the notion of photographic veracity. Using sophisticated manipulation techniques and witty exaggeration, Gursky plays with themes of modern commercialism and the ubiquitous tourist trade. He also gives photography a new place in the field of modern art.

The development of digital photography in the 1970s and 1980s began a technological revolution, affecting scientists, artists, journalists, and ordinary camera users. The skills of framing the "perfect shot" in a viewfinder or developing film in a photo lab became unnecessary for many weekend snappers. Now images could be downloaded on a computer and easily cropped or retouched with photo-editing software. One no longer had to possess the eye of an Henri Cartier-Bresson or Robert Capa to create his or her own photographic masterworks.

Postmodern artists also found ways of using computer editing to create new and striking images. The German artist Andreas Gursky, for example, developed a contemporary take on the traditional photocollage. Gursky captures multiple images of a particular scene and combines them seamlessly on the computer, creating what appears to be a single image of a vast panorama. His 1990 image of Salerno, Italy, for example, presents multiple perspectives of the landscape—from the city's huge port to its extended coastline and surrounding mountains.

Gursky's "manufactured" photographic language often explores the role of commercialism in the postmodern West. His humorously "wide-angle" views of the Chicago Board of Trade, from 1999, depict insect-like futures traders collecting around the trading floor. Another image, 99 *Cent II Diptychon* (2001), features a cheery supermarket interior with endless rows of packaged goods. Other images focus on the alienating aspects of modern technology. In *Monaco* (2007), a Formula One car racing event overwhelms the sunny Monegasque coastline, transforming it into a generic urban landscape. Still others examine the connections between technology and nature. In *Copan* (2002), apart-ment buildings from São Paulo, Brazil appear to move in an undulating rhythm, while *Bahrain I* (2005) makes a giant desert racetrack resemble a twisted snake.

Gursky's recent *Ocean* series (2010) explores the artistic possibilities of even grander landscapes—the images of Earth taken from satellite cameras. The world's seas are framed as vast, amorphous shapes. Each image seems to evoke abstract expressionist art, with the deep-blue ocean color taking up most of the photographic "canvas." Only the edges of continents sneak into the pictures' sides and corners. Though these works depict huge spaces, Gursky imbues them with a certain delicacy. In some ways, they resemble the first images of Earth taken from space in the 1960s, images that suggest the tenuousness of Earth-borne life.

1971–73 The North Tower of the WTC
is the world's tallest building

1945 Beginning of the Cold War **1955** *The Family of Man* exhibition
at MoMA in New York **1966–73** Construction of the World
Trade Center in New York **1979–89** Soviet
Afghan w

1930 1935 1940 1945 1950 1955 1960 1965 1970 1975 1980

1990 Reunification of Germany

1989 George Bush sworn in as
president of the U.S.

2003 U.S. invasion of Iraq

2011 Osama bin Laden is killed
in Abbottabad, Pakistan

1996 First cloned mammal:
Dolly the Sheep

1985 1990 1995 2000 2005 2010 2015 2020 2025 2030 2035

9/11

On a sunny late-summer morning in 2001, the city of New York was subsumed in an ominous cloud. The terrorist attacks of September 11 were planned for their visual effect. The horrific, surreal images of the event galvanized people in the United States and spawned two separate wars. Yet 9/11's long-term effects on American life may have been limited.

The attacks of 9/11 occurred on the most ordinary of working days. They began at 8:46 a.m. Eastern Standard Time, as many people around the country were on their way to work. When the first plane hit the North Tower of the World Trade Center, television and radio reports struggled to describe the image they were broadcasting. The first reports claimed the aircraft was a small, private plane, leading many viewers to see the event as a tragic accident. But the mood dramatically changed when the second plane struck the South Tower at 9:03 a.m. It was clear that the United States was under attack. By the time many Americans on the East Coast and in the Midwest had reached their offices, the full extent of the tragedy had been revealed. The heart of America's defense industry, the Pentagon, had been sliced open by a third plane. Meanwhile, the twin towers of the World Trade center—the most prominent buildings in Manhattan and a symbol of international commerce—collapsed one after the other in apocalyptic clouds of smoke and debris.

The clouds soon spread over the city, advancing through the streets of Lower Manhattan as rapidly as tidal waves. Television images showed reporters and other New Yorkers fleeing from the advancing "storm." Aerial shots of the city soon broadcast the entire island of Manhattan covered in smoke. Particularly dramatic were images of the Statue of Liberty overlooking a scene of almost Biblical terror.

Yet during and immediately after the attacks, many Americans rejected thoughts of an apocalypse in favor of bold action. The hijackers who took control of United Airlines Flight 93, probably to destroy the U.S. Capitol building in Washington D.C., were nearly overtaken by unarmed passengers and forced to crash the plane in a field near Shanksville, Pennsylvania. Other heroic acts were carried out by the New York City firefighters and police officers who risked their lives to rescue people trapped in the World Trade Center. Subsequent responses to 9/11, including wars in Afghanistan and Iraq, had mixed results.

The relationship between Islam and the West is still unstable. But events in 2011 suggested the ultimate failure of 9/11's al-Qaeda plotters and their terrorist methods. The killing of Osama bin Laden and Anwar al-Awlaki revealed an increasing vulnerability within the al-Qaeda network. Moreover, the Arab Spring demonstrations in North Africa and the Middle East offered a peaceful, more democratic method for political change in the Muslim world.

United Airlines Flight 175 shortly before crashing into the South Tower of the World Trade Center, September 11, 2001

following double page
Smoke billows over Manhattan after the September 11, 2001 attack

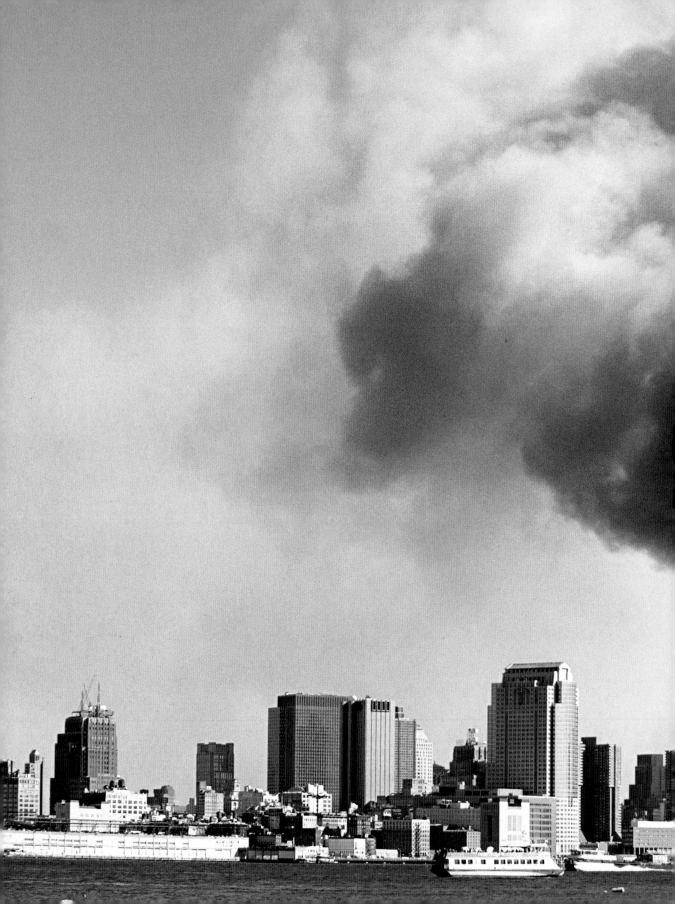

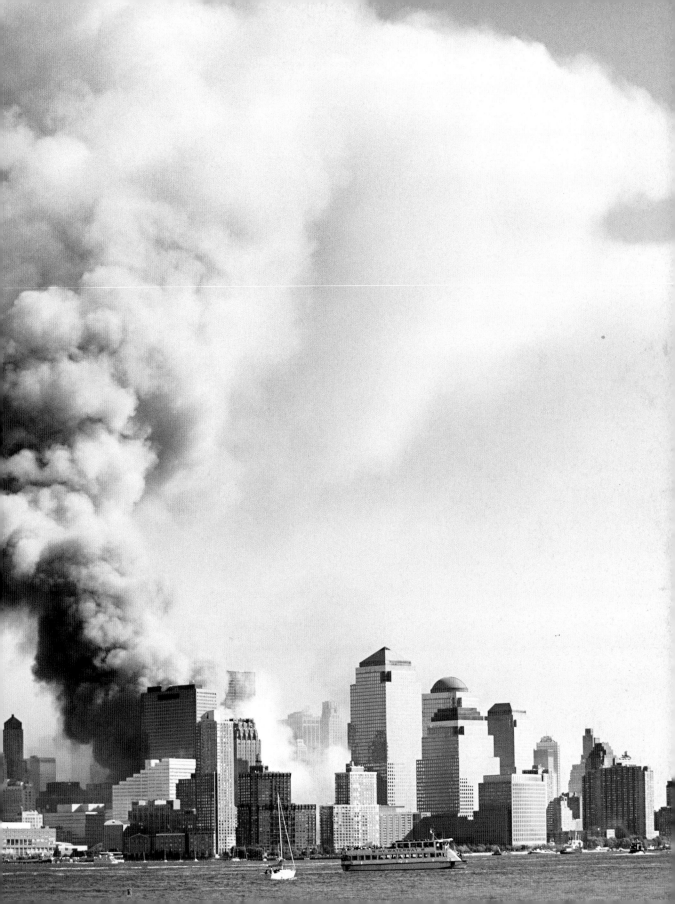

1950 Josef Albers, First painting of
the series *Homage to the Square*

1961 Yuri Gagarin is the first
man in space

1975 End of Vietnam War

1969 Neil Armstrong lands
on the moon

1930	1935	1940	1945	1950	1955	1960	1965	1970	1975	1980

Surface of Mars, 2005

2001 Terrorist attacks on World
Trade Center (9/11)

2 Lebanon War

1995 Christo and Jeanne-Claude
wrap the Reichstag, Berlin

2010 Volcanic ash from Iceland causes
havoc on European air space

1986 Chernobyl disaster

1985 1990 1995 2000 2005 2010 2015 2020 2025 2030 2035

SURFACE OF MARS

The red planet has inspired many masters of science fiction, including H. G. Wells, Ray Bradbury, and Orson Welles. But the true nature of the Martian landscape was only revealed in the 1970s, when the first Viking probes photographed the planet's surface. Since then, interest in Mars has moved from literature and film toward real-life documentation.

The literary character of the Martian originates in the nineteenth century, most famously with H. G. Wells' The War of the Worlds. Wells' squid-like monsters travel from the red planet and conquer the Earth, devouring humankind. Only their susceptibility to Earthly diseases prevents the creatures from destroying the planet. Such tales were born, in part, from the earliest maps of Mars in the late 1800s, which showed the planet riddled by channels that people believed contained water and life.

Popular notions of the Martian changed during the space race, however. In 1965, the American spacecraft *Mariner 4* completed the first successful flyby of Mars, using its onboard cameras to take close-up images of the planet. These pictures revealed a dry, barren surface with no clear signs of water. Then, in 1976, the American Viking program landed two vehicles—the *Viking 1* and *Viking 2* probes—on the surface of Mars. The vehicle's cameras transmitted the first "eye-level" depictions of Martian landscapes. Mars' barren, rocky terrain had clear visual parallels on Earth. One could almost see in them the rocky terrain of the ancient Middle East, or the desert lands of southern California— where many of Hollywood's camp science fiction classics were shot. Yet ultimately, the impact of these images was to reduce the output of Mars-based science fiction stories.

Since the days of the Viking mission, other unmanned Mars probes have successfully landed and photographed Mars' surface. In NASA's ongoing Mars Exploration Rover Mission, the rovers *Spirit* and *Opportunity* have proved to be especially durable tools. Both landed on the Martian surface in 2004, and both photographed a great variety of surface features over many years. *Opportunity*, which is still in operation, captured a panoramic shot of the Victoria crater,

a giant depression about 730 meters (2,400 feet) wide that was produced by the impact of space debris. The image is a composite photo, a mosaic of different shots pieced together electronically. *Spirit* took some of the first accurate color images of the Martian surface, capturing the reddish tint of the dry surface (a result of the planet's high iron oxide content) and the yellowish-brown sky (caused by dust particles in the planet's atmosphere). Other regions imaged by *Spirit* include the rocky Seminole area and the broad Bonneville crater. Most remarkably, *Spirit* and *Opportunity* uncovered evidence of silica and other minerals that suggest the past presence of water. Thus the centuries-long quest for Martian life will continue.

1955 First documenta exhibition
in Kassel, Germany

1936 Charlie Chaplin, *Modern Times*

1948 Universal Declaration of Human
Rights before UN General Assembly

1961 Construction of the Berlin Wall

1977 Walter De M
*The Lightning
Field* near
Quemada,
New Mexico

1930 1935 1940 1945 1950 1955 1960 1965 1970 1975 1980

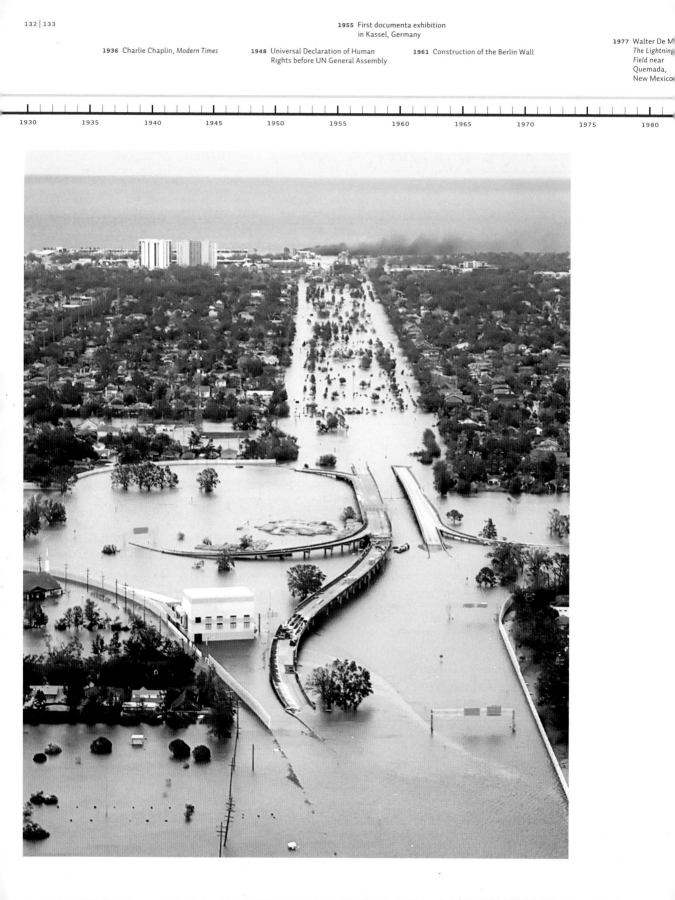

1993–97 Frank O. Gehry,
Guggenheim Museum,
Bilbao

2004 Tsunami catastrophe in Asia

2007–10 Global financial crisis

1989 Fall of the Berlin Wall

1985	1990	1995	2000	2005	2010	2015	2020	2025	2030	2035	

HURRICANE KATRINA

As the floodwaters of Hurricane Katrina slowly inundated New Orleans, they exacerbated a host of long-standing economic, political, and social problems. The city known as the Big Easy—as well as America itself—was forced to deal with its own environmental degradation, inept government action, and racial and class conflict.

New Orleans has always been one of America's most sensitive nerve centers. Its rich cultural traditions have incorporated a tapestry of Spanish, French, Caribbean, and African influences. America's most characteristic form of music, jazz, developed after 1900 from the improvisations of Creole and Black New Orleanians—Jelly Roll Morton, Louis Armstrong, Sidney Bechet, and others. Generations of American tourists flocked to the city to experience its lacy architecture, spicy food, and laid-back attitude, traits that were often at odds with the country's mainstream Puritan culture.

But the unique sights, sounds, and smells of the Big Easy have always been at risk. The city lies in an area at the mouth of the Mississippi River, which is vulnerable to flooding both from the river and from hurricanes that often advance up the Gulf of Mexico. Beginning in the 1920s, decades of complex engineering works have attempted to prevent these natural disasters from damaging the city. Miles of levees and pump systems were built to keep the city dry. Yet these defenses were only designed to protect against hurricanes of a certain intensity.

On August 29, 2005, Katrina hit land on the Louisiana coast as a Category 3 hurricane. Katrina's path was known in advance, and the city of New Orleans had issued evacuation orders. Most of the city was able to escape, but the local government provided inadequate public transportation for people who couldn't leave easily on their own—including the elderly and the poor. Soon after the hurricane blew over the city, it became evident that the storm had knocked out part of the city's levee system, and water from nearby Lake Pontchartrain was slowly flooding New Orleans. The roads within and surrounding the city had been damaged,

trapping residents who had not fled. Waters eventually covered about 80 percent of the town, at a depth of over six meters (twenty feet) in certain areas. Rescue boats were forced to save people stranded in their homes, heroic images that often made the local and national news. But other, more harrowing photos had to be restricted from view, including pictures of dead bodies floating in the streets.

One aerial shot taken on August 30 captured the flooded city early in the day, with sunlight reflecting off the stagnant water. Fragments of trees, houses, and overpasses stick out above the water's glistening surface, emphasizing the fragmented spirit of the distressed city. In the distance can be seen the partially ruined Louisiana Superdome football stadium, where thousands of New Orleans' citizens—mostly poor and black—were packed together for days after the storm. The Superdome became a symbol of the inept handling of the disaster, from the lack of planning by city leaders to the slow, inadequate response of the federal government.

Flooded roads in New Orleans caused by Hurricane Katrina, August 2005

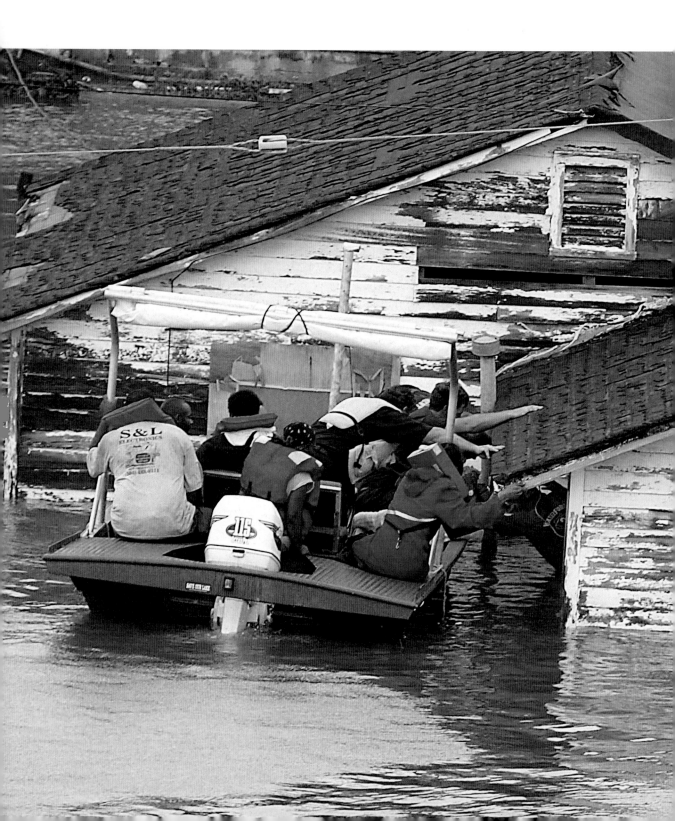

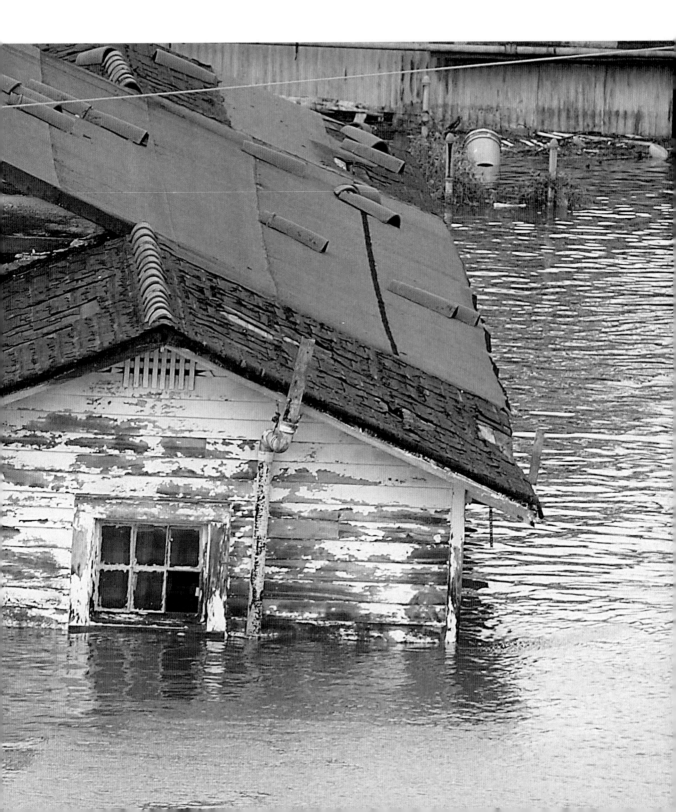

An inhabitant is rescued from his home in New Orleans, Louisiana

1942 Edward Hopper, *Nighthawks*

1955–68 Civil rights movement
in the U.S.

1973 Picasso dies

1969 Georg Baselitz, *The
Forest Upside-Down*, first
upside-down painting

| 1930 | 1935 | 1940 | 1945 | 1950 | 1955 | 1960 | 1965 | 1970 | 1975 | 1980 |

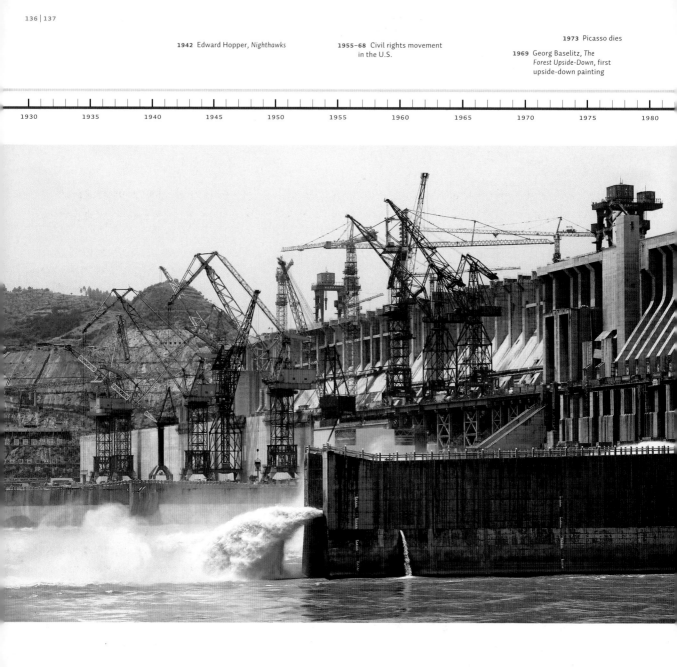

Three Gorges Dam, June 25, 2006

2003 Human genome
decoded

1996 First cloned mammal:
Dolly the Sheep

1990 Reunification of Germany

2009 Barack Obama awarded
Nobel Peace Prize

2010 "Arab Spring" begins
with protests in Tunisia

1985 1990 1995 2000 2005 2010 2015 2020 2025 2030 2035

THREE GORGES DAM

The massive, sprawling architecture of China's Three Gorges Dam evokes engineering "marvels" of the industrial age—the Panama Canal or the Brooklyn Bridge. Yet the dam also embodies the successes and contradictions of a new China, and the role of that nation in a postindustrial world.

The mighty Yangtze River flows from the mountainous region of Tibet all the way to the East China Sea at Shanghai, a distance of about 6,275 kilometers (3,900 miles). China created some of the world's earliest irrigation systems along the river, including the more than 2,200-year-old system at Dujiangyan, in Sichuan province. The Yangtze was also one of the main inland transportation routes that connected the country's vast land mass and made a unified Chinese culture possible. But the Yangtze has been the source of human tragedy as well, with periodic flooding often killing tens of thousands.

Since the Chinese overthrew their ancient monarchy in 1912, several plans to dam the Yangtze have been developed. Yet the many twentieth-century wars in China, and the repressive era of Mao Zedong, held back actual construction. Beginning in the 1970s, China began moving forward on many economic and social fronts. The government relaxed Mao's cultural and economic restrictions. Private businesses were established, and Western corporations began setting up branches in Shanghai and other cities. China had come to enjoy one of the highest economic growth rates in the world. Increased economic prosperity and improvements in engineering expertise enabled the Chinese government to resuscitate plans for the Yangtze Dam. In 1992, those plans were finally approved.

The Three Gorges Dam was designed not only to "tame" the Yangtze and prevent flooding, it was also engineered to produce huge amounts of hydroelectric power for the nation. This power source would reduce the country's reliance on more expensive, and more environmentally harmful, coal. The dam was begun in 1994 and took over ten years to complete. Photographs of its construction often reminded people of the massive infrastructure projects of earlier generations—the dams, canals, and bridges that facilitated the first industrial age in the West.

Since the dam's completion in 2008, the Three Gorges has had mixed effects on people and the environment. Increased use of hydroelectric power has reduced the need for coal in Chinese industry, resulting in lower emission levels of sulfur dioxide and other harmful gases. The dam has also shown a capacity to prevent flooding and flood-related damage. Yet the dam's construction submerged the homes of more than a million people, forcing massive relocation efforts. It also inundated areas of cultural importance, placing unexcavated archaeological sites under water. In addition, environmentalists believe that the dam could cause erosion and the loss of biological diversity. They criticize the dam as an unsustainable project foisted on the Chinese people by an undemocratic, single-party government. Yet the dam has become a major tourist site in China, and many consider it a symbol of Chinese independence and industrial might. The true value of the dam—and its ultimate assessment by the Chinese people—may not be known for years to come.

1955 First documenta exhibition
in Kassel, Germany

1969 Neil Armstrong lands
on the moon

1980 John
Lenn
shot

1954–62 Algerian War

1962–68 Ludwig Mies van der Rohe,
Neue Nationalgalerie, Berlin

1930 1935 1940 1945 1950 1955 1960 1965 1970 1975 1980

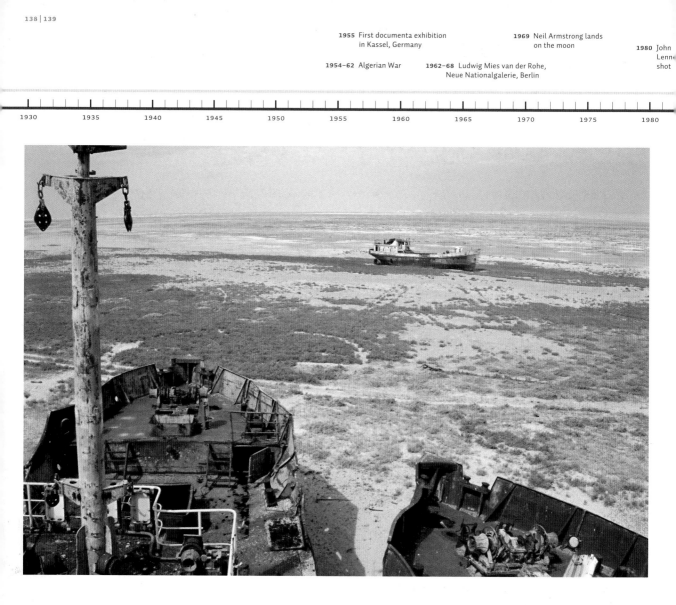

Ship's graveyard near Aralsk, on seabed due to water loss, Aral Sea,
Kazakhstan, Central Asia

2004 Tsunami catastrophe in Asia

1995–99 Herzog & de Meuron,
Tate Modern, Bankside, London

2010 Disastrous oil leak in
the Gulf of Mexico

1991 Soviet coup d'etat attempt

| 1985 | 1990 | 1995 | 2000 | 2005 | 2010 | 2015 | 2020 | 2025 | 2030 | 2035 |

THE DISAPPEARING ARAL SEA

Stranded ships on a desolate landscape stand as reminders of humankind's effect on the environment.
The Aral Sea, once one of the largest lakes in the world, has nearly disappeared due to misguided agricultural
expansion and climate change.

The Aral Sea lies between the Central Asian countries of Kazakhstan and Uzbekistan, both former republics of the Soviet Union. And just as the power of the Soviet state has faded and disappeared from the area, so the formerly massive lake is also disappearing.

The salt-water body of the Aral used to have an area of more than 68,000 square kilometers (26,300 square miles). It was fed by two rivers, the Amu Darya and the Syr Darya, both of which have their origins more than 2,200 kilometers (1,300 miles) to the east. Russian military fleets began taking control of the sea in the 1840s, and they were followed by commercial vessels that established the sea's lucrative fishing industry. During the Soviet era, the Aral was one of Russia's most important sources of fish, employing tens of thousands of workers. Yet in the 1960s, the Soviet government set its sights on exploiting the farm-land of Uzbekistan and Turkmenistan. They built a series of dams and interconnected canals that diverted water from both the Amu Darya and Syr Darya. The newly irrigated regions enjoyed an agricultural boom, especially in the production of lucrative cotton. But the effort also destroyed the main source of fresh water for the Aral.

Almost overnight, the Aral Sea began to shrink dramatically. By the late eighties, the sea split into two sections: the North (or Lesser) Aral Sea in Kazakhstan and the South (or Greater) Aral Sea, largely in Uzbekistan. With lower water levels, the seas' salinity increased, killing off both the fish and the lucrative fishing industry. After the Soviet Union's collapse, the newly independent country of Uzbekistan continued to rely heavily on its cotton produc-tion, and efforts to revive the lake largely failed. By the new millennium, the sea had lost more than 75 percent of its

area and 85 percent of its water volume. Vivid images of the Aral's fate often depict stranded fishing vessels, which resemble metal tombs in the middle of an arid land. The people who live on this land are now experiencing the harmful effects of dramatic climate change, suffering through dust storms and lower levels of healthy drinking water. Recent dam construction in the North Aral has brought some increase in the water volume. Yet satellite photos from 2010 show how the once mighty lake has been reduced to two tiny slivers of water.

1955–68 Civil rights movement in the U.S.

1966–73 Construction of the World Trade Center in New York

1978 The Galápagos Islands are the item on the UNESCO World Heritage list

1930 1935 1940 1945 1950 1955 1960 1965 1970 1975 1980

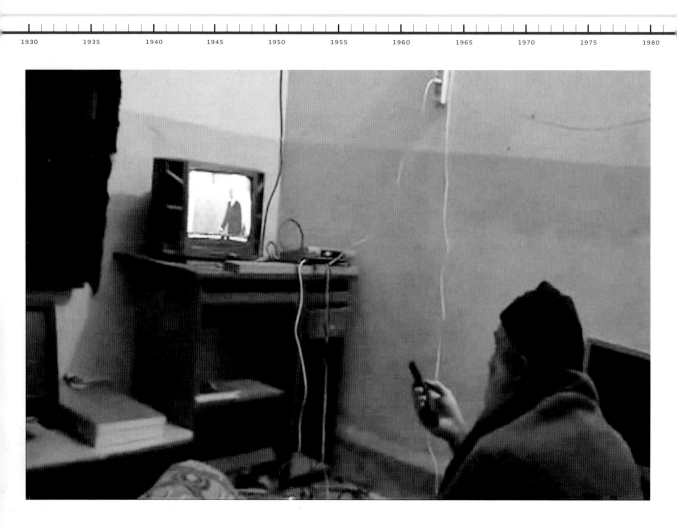

Osama bin Laden watching TV in his hiding place in Abbottabad

right page
A general view of the final hiding place of Osama bin Laden in Abbottabad, May 5, 2011

1 First space shuttle, *Columbia*

1995 Christo and Jeanne-Claude
wrap the Reichstag, Berlin

2010 "Arab Spring" begins with
protests in Tunisia

1989 Fall of the Berlin Wall

2006 Saddam Hussein
condemned to death

1985 1990 1995 2000 2005 2010 2015 2020 2025 2030 2035

THE LAST DAYS OF OSAMA BIN LADEN

With remote control in hand and a beard whitened by age, the world's most famous terrorist watches himself on television. Photos of Bin Laden taken before his death show a small, diminished man in humble circumstances—an ironic denouement to the visual drama of 9/11.

Osama bin Laden was born into one of the wealthiest Saudi families. His father, Mohammed bin Awad bin Laden, had risen from poverty to run the country's most lucrative construction company. He built freeways, palaces, and entire military cities for the Saudi army and royal family. Yet Mohammed bin Laden also remained a strictly devout Muslim. Osama bin Laden was only one of his father's fifty-four children, but he inherited a sizable portion of Mohammed's conservatism and his monetary wealth—probably around $25 million.

After graduating from university in 1979, Osama bin Laden soon began using his time and fortune to promote the interests of Muslim nations in conflict. He and his mentor, the Palestinian theologian Abdullah Yusuf Azzam, helped fund and support Afghanistan's war with the Soviet Union. Near the end of the war, Bin Laden split from Azzam and founded a new organization called al-Qaeda, with the goal of organizing military efforts in the cause of Islam. Soon afterward, Bin Laden would divert his energies from combating the Soviet Union to fighting the United States and the West.

The Persian Gulf War (1990–91) involved open conflict between America and a Muslim nation, as U.S. troops pushed Saddam Hussein's Iraqi forces out of Kuwait. Though the U.S. action was successful, the stationing of American troops on Saudi soil during the war—close to the Muslim holy cities of Mecca and Medina—enraged Bin Laden. In a few years, the al-Qaeda leader would become known as a leading terrorist. The U.S. Federal Bureau of Investigation (FBI) linked him to the 1998 bombings of U.S. Embassies in Dar es Salaam and Nairobi. The FBI also placed him on their "ten most wanted fugitives" list.

Yet few people knew much about Bin Laden on the morning of September 11, 2001. When the apocalyptic images of that day were linked with him, the obscure Saudi terrorist was transformed into the world's most famous criminal—a bearded mastermind of eerily calm demeanor and satanic genius. Wars in Afghanistan and Iraq, as well as a decade of intelligence, failed to locate him. Tapes of his speeches mysteriously appeared at auspicious times, near 9/11 anniversaries or U.S. presidential elections. Then, on May 2, 2011, Bin Laden's invincible reputation was suddenly shattered. The al-Qaeda leader was found and killed in Abbottabad, a well-to-do suburb fifty kilometers (thirty-one miles) from the Pakistani capital, Islamabad. Though Western governments refused to show pictures of Bin Laden's dead body, they did release newly found images taken before his death. Photos of the Bin Laden compound showed a simple, comfortable dwelling with a courtyard and small, tended garden. Other snapshots depicted the aging terrorist as a depressingly ordinary man, not above watching his own image on a rickety TV.

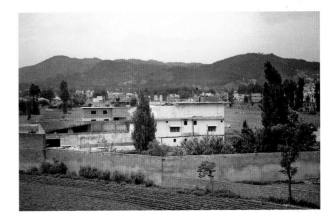

1954 First commercial nuclear power
plant in Obninsk near Moscow

1973 Yom Kippur War

1930 1935 1940 1945 1950 1955 1960 1965 1970 1975 1980

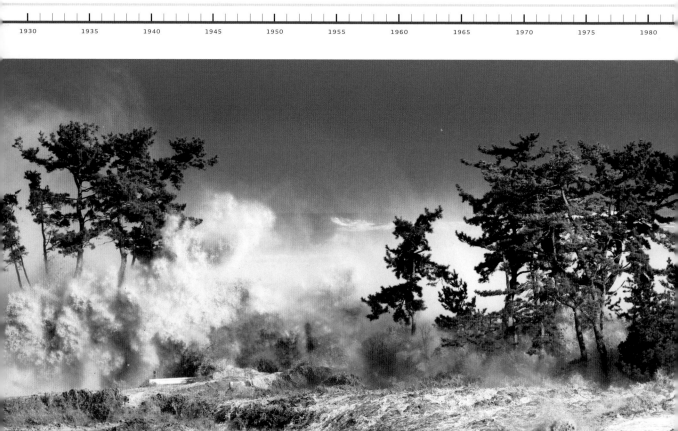

Tsunami waves hitting the coast of Minamisoma in Fukushima prefecture, March 11, 2011

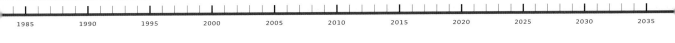

1986 Chernobyl disaster

1983 Discovery of the AIDS virus, HIV

1989 Massacre in Tiananmen Square
in China

2004 Tsunami catastrophe
in Asia

1997 UN climate conference
produces the Kyoto Protocol

2005 Hurricane Katrina
devastates New Orleans

2010 Earthquake in Haiti kills 220,000

1985 1990 1995 2000 2005 2010 2015 2020 2025 2030 2035

TOHOKU EARTHQUAKE AND TSUNAMI

Japan is a nation familiar with its unpredictable sea, and its tsunami defenses are among the most advanced in the world. Yet the unprecedented Tohoku earthquake and tsunami of March 11, 2011 shattered the Japanese sense of security. Photographs of the ensuing destruction revealed entire towns that had been reduced to massive junkyards.

The tsunami has a mythic status in Japanese culture. Images of tsunamis abound in woodblock prints and painted silk. Japan's most famous printmaker, Hokusai, created the archetypal tsunami image in his *Great Wave off Kanagawa* (ca. 1830). But during the twentieth century, Japanese governments attempted to demythologize the tsunami and curb its destructive power. Several innovative defense systems were established. The Japan Meteorological Agency began setting up seismic sensors in the 1950s, as well as a procedure for alerting Japanese radio and television stations if a tsunami-causing earthquake was detected. These early systems were updated over the years as the ability to predict earthquakes became more sophisticated. Japan also constructed thousands of miles of sea walls and other defenses to repel or slow the advance of tsunami waves. Yet the height of these walls was often less than four meters (thirteen feet) tall, making them relatively useless against the fiercest tsunami waves.

On March 11, 2011, Japan was hit by the strongest earthquake ever recorded. Registering a magnitude 9.0 on the Richter scale, the force of the quake moved the entire Japanese coastline nearly 2.4 meters (8 feet) eastward. Quake-induced tremors could be felt around the country for several minutes. Cameras captured remarkable images of soil liquefaction in Tokyo, in which the stress of the quake turned parts of the soil into bubbling liquid pools. Yet despite the earthquake's strength, Japan's rigid building standards prevented damage to most city structures.

But just as Hurricane Katrina did most of its damage in New Orleans after the initial storm, the tsunami that followed the Tohoku earthquake caused widespread and long-lasting misery for the Japanese people. Television

cameras caught a massive wave, a giant wall of water kilometers wide, advancing toward the coast. The wave overwhelmed tsunami walls at the city of Sendai, flooding the town's coastal areas and nearly destroying its airport. Over the next several hours, aerial television cameras captured the floodwater advancing into the Japanese countryside, picking up soil, vehicles, buildings, and human beings as it moved inexorably along. This water now resembled a huge mass of blackened sludge, the ooze of death.

Over the next twenty-four hours, the full extent of the damage was revealed. Entire towns had turned into junkyards of debris. Surreal images pictured stranded ships, many kilometers inland, perched on top of buildings. Worst of all, a tsunami wave of about fifteen meters (fifty feet) had flooded the Fukushima I Nuclear Power Plant, destroying the plant's cooling systems and causing the reactors to experience meltdown. Radioactive material was released into the environment. Areas up to fifty kilometers (thirty miles) from the plant were measured to have unacceptably high radiation levels, affecting people and animals and devastating crops. Overall, the Fukushima disaster was the worst nuclear accident since the Chernobyl incident twenty-five years earlier. Despite decades of careful planning, Japan had failed to protect its people from the full force of the ancient sea.

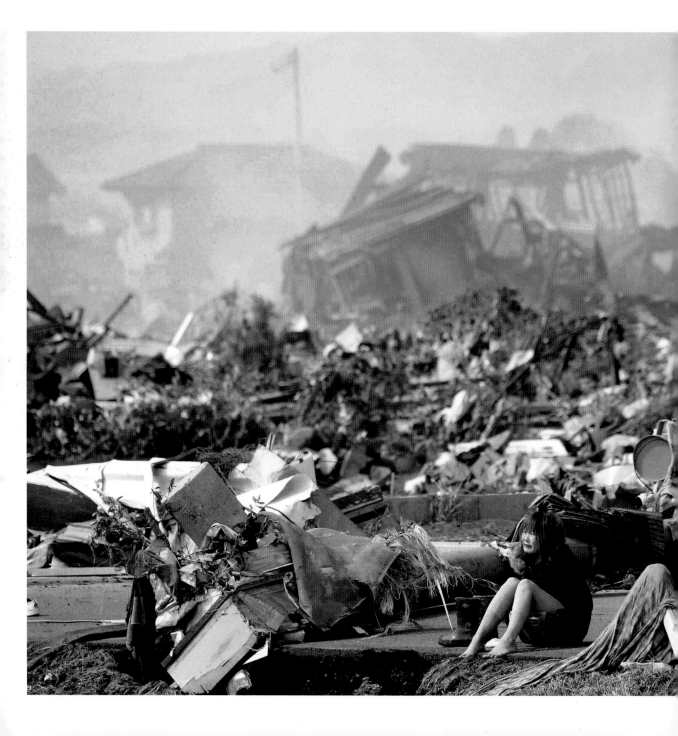

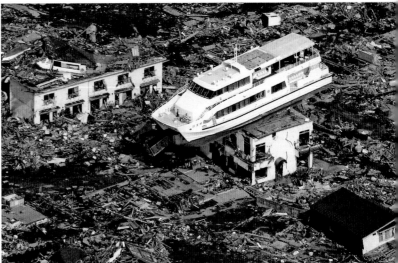

left page
Woman crying amid the destroyed city of Natori, Miyagi Prefecture in northern Japan,
March 13, 2011

above
Pleasure boat sitting on top of a building amid a sea of debris in Otsuchi town in Iwate
Prefecture, March 14, 2011

1954–62 Algerian War

1955 Beginning of Pop Art

1947 India gains independence
from the United Kingdom

1973 Chilean coup d'état; elected
president Salvador Allende d|

1976 Apple
Computers
founded

| 1930 | 1935 | 1940 | 1945 | 1950 | 1955 | 1960 | 1965 | 1970 | 1975 | 1980 |

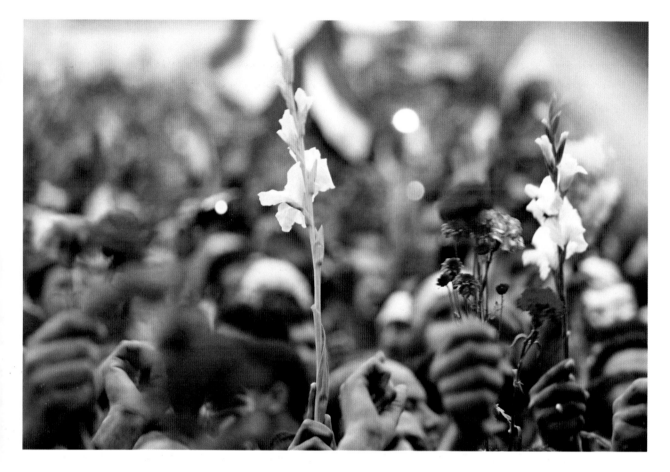

Egyptian anti-government protesters hold flowers in Cairo's Tahrir square on day 12 of
mass protests against Egyptian President Hosni Mubarak's regime, February 5, 2011

following double page
Demonstrators at Cairo's Tahrir Square, February 4, 2011

1993–97 Frank O. Gehry, Guggenheim
Museum, Bilbao

2 Michael Jackson
releases *Thriller*

2000–05 Second Palestinian Intifada

2003 U.S. invasion of Iraq

| 1985 | 1990 | 1995 | 2000 | 2005 | 2010 | 2015 | 2020 | 2025 | 2030 | 2035 |

CAIRO REVOLUTION

The Arab Spring of 2011 was a feast for the eye. Cairo's Tahrir Square bloomed with colorful flags, face paint, and idealistic protesters. But though the events in Cairo helped depose an Egyptian government, the full consequences of the Arab Spring remain in question.

The Arab world has never forgotten its history. For centuries, Arab culture promoted learning and achieved significant discoveries in astronomy and mathematics. Yet the modern history of Arab states has often involved an unequal relationship with the West. At the beginning of the twenty-first century, many Arab economies were still tied to Western corporations, and autocratic Arab leaders were often tin-eared when it came to the desires of their citizens.

On December 17, 2010, Mohamed Bouazizi, a produce vendor in the Tunisian city of Sidi Bouzid, ran afoul of the local authorities. He reportedly had not paid the requisite bribe money to ply his trade. One of these officials—a middle-aged woman—physically beat him in public and confiscated his equipment. When Bouazizi tried to recover his property at the government office, he was summarily dismissed. Enraged, he ran back into the street, covered himself in gasoline, and set himself on fire. Subsequent attempts to save his life failed, and Bouazizi died in hospital on January 4, 2011. But by then his story had spread around Tunisia and ignited another kind of fire—that of political revolution. The protests that followed Bouazizi's death eventually forced Tunisian president Zine El Abidine Ben Ali to flee the country, ending a rule of twenty-three years.

Soon demonstrations broke out in other Arab countries, including Yemen, Algeria, and Bahrain. But the most dramatic show of "people power" came in Cairo. Like Ben Ali, Egyptian president Hosni Mubarak had led his country for decades. A deal-maker with the West and with Israel, Mubarak was long seen as a stable ruler in an unstable "neighborhood." But Mubarak also limited free speech and political dissent. By 2011, high unemployment and inflated food prices caused growing unrest among Egyptians.

Further anger was directed at Mubarak's son, Gamal, who was seen as his father's handpicked successor.

On January 25, demonstrations broke out around the country, most prominently in Cairo's Tahrir Square. This "liberation" square had been the site of earlier demonstrations, but the protesters of 2011 were armed with new technology. Smart phones and Twitter posts spread news of the protests worldwide. They also kept demonstrators aware of Mubarak's reactions and of responses from the international community. Images of the huge crowds often had a joyous quality, with Egyptian flags flying overhead and faces painted with the country's national colors. Young women, both "covered" and "uncovered," seemed to coexist peacefully with men in the crowd, offering hope of a new Egypt freed from gender-based social restrictions. These pictures appeared in stark contrast with videos of pro-Mubarak troops who, on February 2, rode into the square on camels and attacked the crowd with swords. Such images helped destroy any hope for Mubarak's rule. On February 11, the Egyptian president became the second Arab leader to resign from office.

Subsequent Arab Spring uprisings eventually toppled Muammar Gaddafi's forty-one-year regime in Libya. Yet the movement also raised somber questions about the future of North Africa and the Middle East. Images of idealistic youth were soon replaced by those of military leaders who took advantage of the power vacuum. The Muslim Brotherhood and other conservative religious groups often enhanced their standing in the new political environments. Glimpses of a new Muslim world tantalized the West during the Cairo uprisings, but the future of the Arab Spring may take years to resolve.

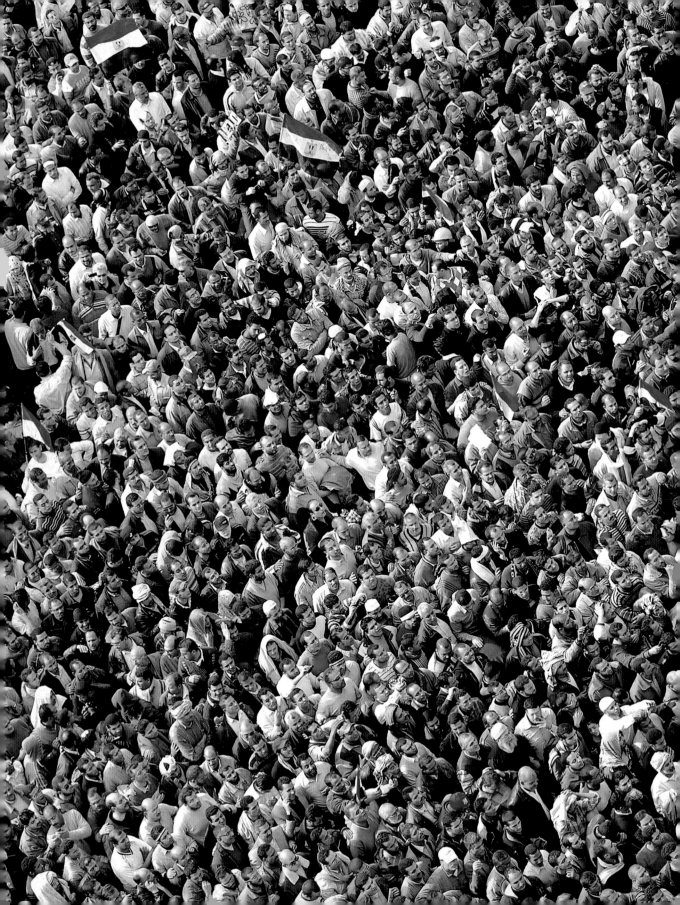

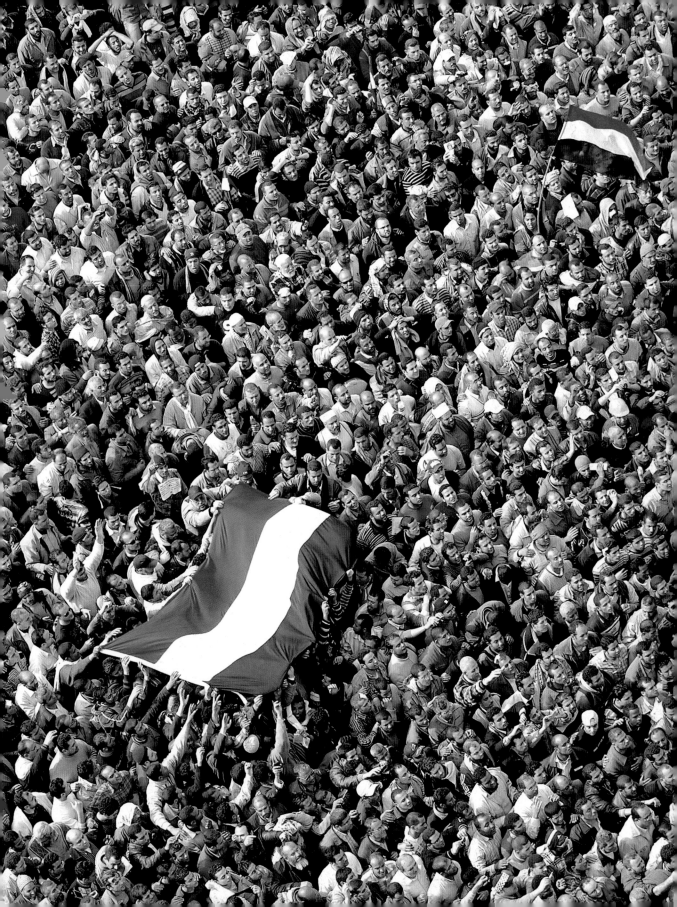

1961 Founding of Amnesty
International

1970 British rock band
Queen forms

1955–68 Civil rights movement
in the U.S.

1930 1935 1940 1945 1950 1955 1960 1965 1970 1975 1980

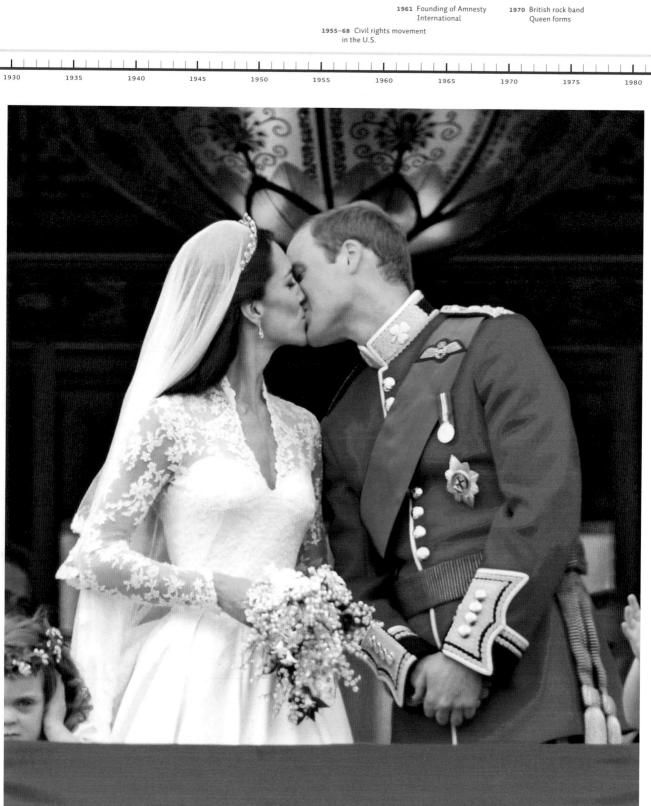

2001 Terrorist attacks on World
Trade Center (9/11)

1991 Damien Hirst, *The Physical
Impossibility of Death in the
Mind of Someone Living*

79–89 Soviet-Afghan War

2007–10 Global financial crisis

1995–99 Herzog & de Meuron,
Tate Modern, Bankside, London

2009 Barack Obama becomes first
African American U.S. president

1985 1990 1995 2000 2005 2010 2015 2020 2025 2030 2035

ROYAL WEDDING

The royal wedding is a centuries-old tradition in England. But since the 1920s, photography and film have helped transform it from a somber religious ceremony to a worldwide media event. Images of the "royal kiss" have become key tools in marketing British culture and the royal family.

In 1923, grainy black-and-white newsreels captured the wedding day of the Duke of York, second son of British King George V, and his bride, Lady Elizabeth Bowes-Lyon. Cameras followed the couple as they arrived and left Westminster Abbey, and as they stood on the balcony of Buckingham Palace to thank "their multitude of friends." The parade route was lined with proud onlookers and soldiers as the horse guards and royal carriages passed by. For the first time, these events were presented as a newsreel—an opening act before a feature film. The presence of British royalty alongside the stars of the silver screen would initiate a decades-long process of "rebranding." By the twenty-first century, British and other European royal families would more closely resemble the celebrities of moviedom than they would their somber ancestors.

In 1948, the Duke of York had become King George VI, and his daughter and heir, Elizabeth, would marry Philip Mountbatten, Duke of Edinburgh. This time the royal wedding would be filmed more extensively. British citizens who were lucky enough to own a television set saw an edited compilation of the day's activities. But church officials refused to let TV cameras record the marriage ceremony, which was only broadcast on radio.

As the century progressed, cultural upheavals would weaken the traditional links between the royal family and their subjects. Young Britons came to see the institution as stuffy and anachronistic. Queen Elizabeth's eldest son, Prince Charles, was often presented in the tabloids as a celebrity bachelor rather than an heir to the throne. Yet Charles' 1981 marriage to Lady Diana Spencer, a twenty-year-old aristocrat with movie-star good looks and an easy-going demeanor, rekindled enthusiasm for the monarchy.

Television cameras now broadcast the ceremony live around the world, and many international viewers stayed up half the night to catch the pageantry as it happened. Photos of the couple's romantic kiss at Buckingham Palace became iconic. Yet Charles and Diana's subsequent divorce once again raised levels of cynicism about the monarchy—and the monarchy's traditional role as a standard-bearer for British values.

In 2011, a new royal wedding gave the palace and the British media another chance to "get it right." Since Diana's tragic death in 1997, Charles and Diana's son, William, had inherited his mother's looks and informal manner. William also followed the "democratic" path of other twenty-first-century European royals, choosing a commoner, Catherine Middleton, as his bride. Will and Kate's wedding would have a similar worldwide appeal as their parent's ceremony. Yet certain aspects of that earlier event, including the choice of St. Paul's Cathedral, were strictly avoided. The new couple would not be seen as mimicking the nuptials of their star-crossed parents. Instead, the traditional venue of Westminster Abbey hosted a wedding with many modern touches. Trees lined the cathedral's nave, reflecting contemporary notions of environmentalism. And the links between royalty and celebrity were strengthened—with Elton John and David and Victoria Beckham playing key supporting roles in the grand visual spectacle. However, other rituals on that day remained the same, including the new royal couple's balcony kiss.

Prince William, Duke of Cambridge and Catherine, Duchess of Cambridge kiss
on the balcony of Buckingham Palace, April 29, 2011

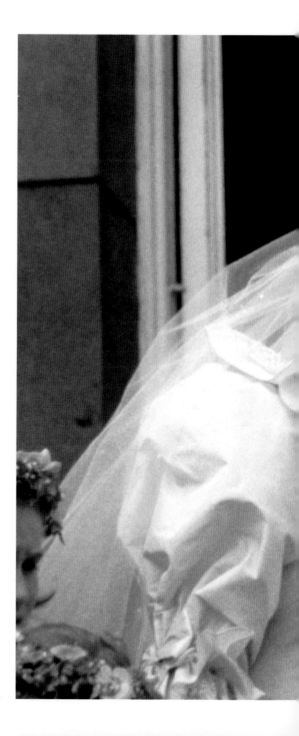

Prince Charles, the Prince of Wales kissing his wife, Princess Diana (1961–1997),
on the balcony of Buckingham Palace in London after their marriage

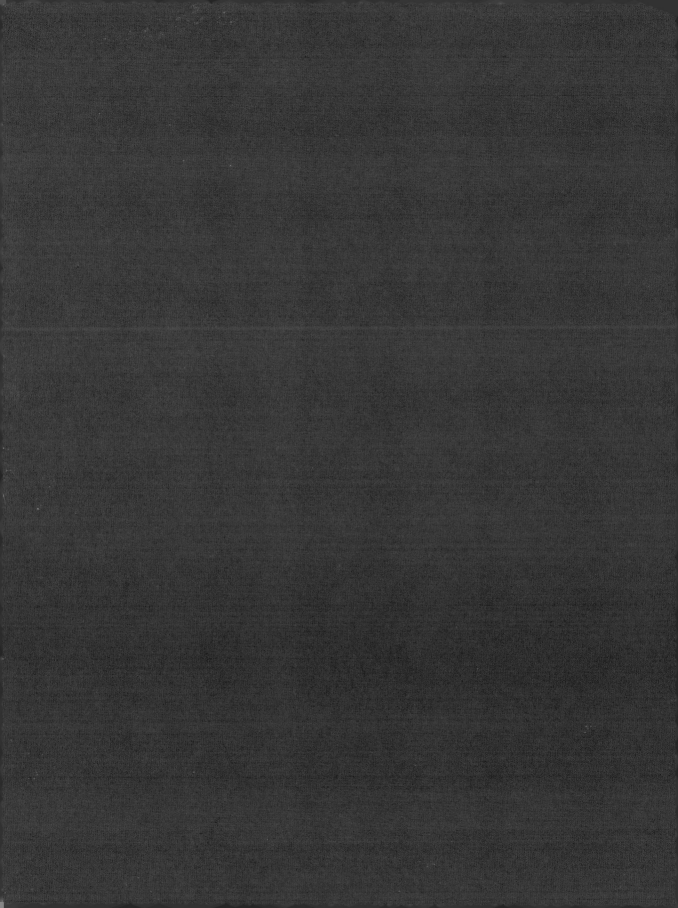

PHOTO CREDITS

The illustrations in this publication have been kindly provided by the museums, institutions and archives mentioned in the captions, or taken from the Publisher's archives, with the exception of the following:

Getty Images: pp. 6, 10/11, 14/15, 19, 22/23, 26–27, 28, 30, 32, 36, 42, 44/45, 46, 48/49, 50, 51, 58, 64, 70, 72, 78, 80/81, 86, 88/89, 92, 94, 96, 98–99, 106, 108, 112–116, 119 right, 120, 122, 128/129, 130, 132, 134/135, 136, 138, 141, 142, 145 right, 146, 148/149, 150, 152/153
Imperial War Museum (Q 71234): p. 24
© Teo Allain Chambi: p. 40
The Israel Museum, Jerusalem, Israel / The Noel and Harriette Levine Collection / Bridgeman Berlin: p. 52

© Henri Cartier-Bresson / Magnum Photos / Agentur Focus: pp. 54, 56–57
© Victoria and Albert Museum, London: p. 60
© Lee Miller Archives, England 2011: p. 62
Library of Congress, Prints & Photographs Division, FSA/OWI Collection: (LC-USF34-018262-C) p. 66, (LC-DIG-ppmsca-10055) p. 69
© Ansel AdamsPublishing Rights Trust / Corbis: p. 68
ullstein bild: pp. 74, 76, 110 (Nowosti)
SLUB Dresden / Deutsche Fotothek / Walter Hahn: p. 77
Royal Geographic Society: p. 82

ddpimages/AP: pp. 84/85; ddpimages/AP/Bill Hudson: p. 90; ddpimages/AP/Carmen Taylor: p. 126 ddpimages/AP/DoD: p. 140; ddpimages/AP/Eddie Adams: 104; ddpimages/AP/Greg English: p. 103; ddpimages/AP/Itsuo Inouye: Cover, p. 102; picture-alliance / dpa / London express: p. 100
© Peter Leibing, Hamburg: p. 118/119
REUTERS/Asahi Shimbun: p. 144/145

INDEX